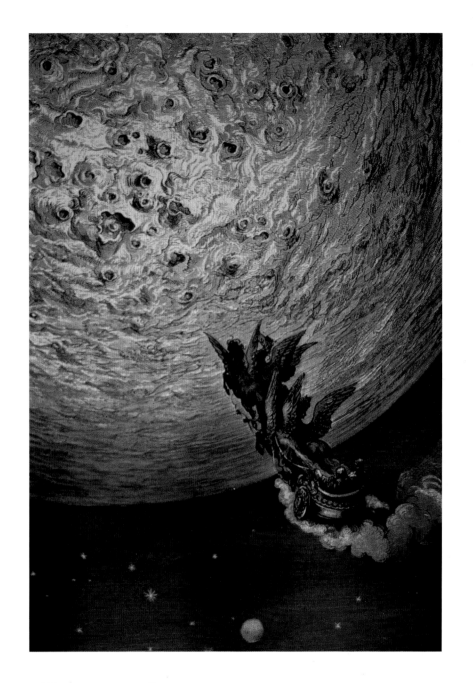

VISIONS OF SPACEFLIGHT

IMAGES FROM THE ORDWAY COLLECTION

FREDERICK I. ORDWAY III

VISIONS OF SPACE

FLIGHT

IMAGES FROM THE ORDWAY COLLECTION

FREDERICK I. ORDWAY III

FOUR WALLS EIGHT WINDOWS
NEW YORK

Dedication . . .

To astronomical and spaceflight artists, past and present, whose images have inspired generations of dreamers

. . . and Appreciation

To my parents, who encouraged an adolescent inclination to read and collect books, and who, for my 11th birthday, presented me with what I most desired: a copy of Roy Rockwood's juvenile novel Lost on the Moon.

And to my loyal and understanding wife Maria Victoria ("Maruja"), who for decades has patiently helped me search for, organize, photocopy when appropriate, and file the thousands of images from which this selection was made.

My old and close friend Robert Lawrence is responsible for this book. It was his idea that I publish selections from my extensive archives, that I relate how I had collected the images in the first place, and that I tell the reader something about them. He then proceeded to set up a meeting with Four Walls Eight Windows publisher John Oakes who enthusiastically embraced the proposal. And, as they say, the rest is history. Thank you, Bob Lawrence, for your confidence, your expertise, and your collaboration during the entire process that turned your idea into reality.

My deep thanks also go to Jon Glick, the book's designer, who has long been interested in my collection. It was a pleasure to work with him and to benefit from his experience.

<div align="right">

Frederick I. Ordway III
September 2000
Arlington, Virginia
Huntsville, Alabama

</div>

CONTENTS

Many years ago, an American magazine (my first two guesses would be *The New Yorker*) published a brilliant cartoon datelined approximately 500,000,000 B.C. It showed a primeval beach, up which a strange-looking fish was crawling on clumsy fins. It was looking back at a nervous companion still hesitating in the shallows and was saying, "Because this is where the action is, Baby."

We are fortunate enough to live at a time when we face a similar situation, and are about to accept its challenge. Yet perhaps the human race has been unconsciously aware of this for at least 2,000 years—as Fred Ordway demonstrates in this fascinating book, the result of a lifetime's research.

It has brought back many memories, for I was able to get to know several of the pioneers of astronautics. Hermann Oberth was my house guest in 1951, and I brainwashed Wernher von Braun into scuba diving during a Washington weekend in 1954. (Though I did not know it at the time, he was then involved in secret negotiations that might have given the United States the first satellite, and the Army didn't want the Air Force to hear about it: in any event, the Russians beat them both.)

Though I never was acquainted with Robert Goddard, I have long been puzzled by a curious coincidence. His initial experiments were conducted at Roswell, N.M. — now, alas, the home of the U.F.O. industry. Can he be blamed posthumously?

I wonder if, 100 years from now, our own space technology will look as bizarre as many of the anticipations in this book. Few people now remember that back in the 1920s, most experts believed that the future of aviation belonged to the airship and the flying boat. The rocket may play the same role in the conquest of space that the balloon did in the atmosphere: it got us there, but was quickly superseded.

After the rocket, what? Antigravity—as foreseen in some of these illustrations? Space drives? Wormholes? We can be sure something will turn up.

Because this is where the action is, Baby!

Arthur C. Clarke
Colombo, Sri Lanka
3 September 2000

THE CHINESE TELL US that a picture is worth more than ten thousand words. I believe it. When barely a teenager, I chanced upon a copy of *Amazing Stories* magazine. So spectacular was its cover and so fascinating the stories inside that I quickly searched for back issues of it and other pulp-paper magazines ("pulps") that were widely circulated in the late 1920s, 30s and on into the 40s and 50s. Their images made a lasting impression on me, one that completely affected my day-by-day interests and later professional career.

It wasn't long before my room was filled with lots of *Amazing Stories* along with other pulps that I had begun buying at secondhand magazine stores. The titles reveal their orientation: *Astonishing Stories, Astounding Stories, Captain Future, Comet Stories, Cosmic Stories, Dynamic Science Stories* and so on down the alphabet to the *Wonder Stories* series.

I never tired of looking at their covers, often front and back, by such artists as Frank R. Paul, Leo Morey, J. Allen St. John, H.W. Wessolowski (later, simply Wesso), Howard V. Brown and Earle Bergey. I had become hooked on science fiction. And especially on stories of flight to the Moon and planets that the pulps almost always offered.

At some point early in my collecting career, I began to acquire books that I had learned about, mostly through exposure to the pulps. Soon, my shelves proudly displayed such exotic titles as *Brigands of the Moon, The Mastermind of Mars, Planet of Peril,* and *By Spaceship to Saturn.* Many of the books were also illustrated with intriguing jacket art and interior plates, though not to the same extent as the pulps.

I kept reading and collecting, always on the lookout for titles with exciting illustrations. At some point, I began collecting print reproductions of subjects that interested me; and, much later, original paintings of space-related themes.

As I was immersing myself ever deeper into the world of science fiction, I began to wonder if there were other, presumably more reliable, sources of information about flight through space. So I began to collect whatever I could

find in the nonfiction literature. Making the rounds of secondhand bookshops, I turned up two interesting titles. One was David Lasser's *The Conquest of Space* and the other P.E. Cleator's *Rockets Through Space: or, The Dawn of Interplanetary Travel*. These books, dated 1931 and 1936 respectively, inspired a permanent interest in space travel and the rocket propulsion systems that one day would make it possible. In fact, I was so inspired, that in January 1941 I became a student member of the American Rocket Society (now the American Institute of Aeronautics and Astronautics). I maintain my membership to this day.

To fill out my growing collection, I recall visiting the Seven Bookhunters bookshop in Manhattan as part of my search for novels by Edgar Rice Burroughs, Ray Cummings, Otis Adelbert Kline, Roy Rockwood, and other authors of pre-World War II space fiction. On one occasion, a salesclerk who had become well acquainted with my interests asked if I might like to see some titles of somewhat earlier vintage—he was thinking in terms of the late 19th century. All along, I had looked upon stories of going to the Moon and planets as a rather recent 20th -century genre except, of course, for the novels of Jules Verne and H.G. Wells, all of which I knew were readily available in reprints.

As I followed him along rows of bookshelves, we came upon several books that impressed me immediately. One, *The People of the Moon* by Tremblett Carter, seemed ancient as I spotted its 1895 publication date. And right beside it was Mark Wicks' 1911 *To Mars via Moon*, 20th century to be sure, but still old to me. And its illustrations were in perfect condition. These and similar works offered delights ranging from interplanetary flying machines to anti-gravity devices to unearthly creatures. While still in my early teens, whenever possible I would continue my search for books and magazines, principally in New York and Washington. Parallel to visiting secondhand book and magazine shops, I had also entered a network of collectors in other areas of the country with whom I corresponded. From time to time, I would buy books and magazines through the mail and sell or trade duplicates.

I didn't have much time for collecting during my college years, though I did keep alive my interest in space by taking astronomy courses—in addition to my principal studies in mining and petroleum geology and geophysics and chemistry. I remember making summer trips to the Lowell Observatory in Flagstaff, Arizona and the Hale Observatory at Mount Wilson near Pasadena, California. As it turned out, much sooner than I could ever have imagined, the allure of spaceflight would take a practical and very much down-to-Earth twist.

By 1950, I had a respectable collection of late 19th to mid-20th century space fiction as well as serious nonfiction works on spaceflight and lunar and planetary astronomy—all obtained in the United States. I now set my sights on Europe. From time to time on educational leave from my work in the rocket and guided missile fields, my wife Maruja and I visited a number of European countries. During this period, I pursued studies in dynamic geology and upper atmosphere physics at the University of Paris and took short courses at other European universities. In June 1953, we were present at the coronation of Queen Elizabeth in London. In later years, I regularly attended scientific congresses in Britain and on the Continent.

Naturally, I took full advantage of these opportunities in my search for books and prints. At first, I concentrated on antiquarian book dealers in Paris and London. Later, I widened the net to include Brussels, Antwerp, Frankfurt, Edinburgh, Madrid, Lisbon, Rome, Stockholm, and dozens of smaller cities and towns. Material was plentiful in those postwar years, prices were low (especially if one had American dollars), and demand was slack. Europe was rebuilding from the war and expeditions to the Moon and planets were not on most people's agendas.

In the years ahead, usually during travel tied to my expanding career in astronautics, I extended my search in bookstores throughout North and South America, Australia and New Zealand, and beginning in the 1970s, the Soviet Union. During my stays in the latter country, I couldn't find anything of interest in bookstores whose prices for hard-to-find, out-of-print books were controlled by the government. Since open-market prices were unrealistically low, the books I wanted were unavailable. But I did obtain several titles from individual dealers who came to my hotel room where on-the-spot haggling led to what we mutually felt was a fair price. My several trips to the Soviet Union were made at the invitation of the USSR Academy of Sciences and allowed me to visit and lecture in Moscow, Leningrad and other sites. In December 1988 in Kaluga, birthplace of Russian spaceflight pioneer

Konstantin E. Tsiolkowsky, I was honored to receive a diploma and medal presented by the board of directors of the K.E. Tsiolkowsky State Museum of the History of Cosmonautics.

While traveling, I carried the latest edition of the *International Directory of Antiquarian Booksellers* as well as country-specific listings and city maps. These allowed me to lay out a bookstore-by-bookstore campaign, augmented by a companion listing of galleries where I hoped to find prints and paintings of interest. I often met with frustration, finding nothing at all, or perhaps an item of but modest interest. But on occasion, a treasure would turn up.

Another constant traveling companion was a 13-by-9-by-6-inch, well-worn, grey metal filing case full of 8-by-5-inch cards. I placed information on these cards about the books I was hunting—the result of countless hours spent at the New York Public Library, the Boston Public Library, the Widener Library at Harvard, the Library of Congress in Washington, the Bibliothèque Nationale in Paris, the British Museum (now, British Library) in London, and dozens of other collections. I always checked the dates of first and later editions of books I hoped to find, and made whatever notes I felt useful for my acquisition plans. Often, my cards incorporated information obtained from recent auctions in New York, London, and elsewhere, and from dealer catalogues, all important in getting a feel for prices and for establishing bargaining positions. And I made some interesting purchases of my own at auction houses in both cities.

My card files were of little value in my continuing search for prints. So upon entering a print or art gallery, I simply asked for anything on flight, astronomy, recreational pyrotechnics, and military subjects, hoping that something useful would turn up. On occasion, it did. Moreover, from time to time, I chanced upon a gallery that offered a limited stock of illustrated books, a fact that led to a number of unexpected purchases. One title in particular impressed me: Gabriel Mourey's *Le livre des fêtes français*, a profusely illustrated source of images depicting the use of fireworks at French royal entries, weddings, and other occasions from the 16th through the early 19th centuries.

I had long since owned modern reprints of Jules Verne's classic Moon travel novels. But, as my collection became more sophisticated, I decided I had to find the illustrated 19th century editions published by Hetzel in Paris. Not unexpectedly, it was in that city that I turned up the first of several copies of both *De la terre à la lune* and *Autour de la lune*. That happened in September 1966 at the Librairie Bonaparte. Later, in October 1983, at a small bookshop in Hay-on-Wye, Gloucestershire, England, I came upon the first English-language

edition (1873) of the classic. Both novels were bound together under the title *From the Earth to the Moon Direct in 97 Hours 20 Minutes and a Trip Round It*. For many years, my first illustrated edition of *De la terre à la lune*, published in 1872, has been on display at the U.S. Astronaut Hall of Fame in Titusville, Florida, close to the Kennedy Space Center. It contains forty-one images and a map by de Montaut.

One of my most exciting finds occurred in 1966 when my wife and I entered the Librairie Thomas-Scheler in Paris. There, its proprietor, Lucien Scheler, led me to a mint-condition thirty-six-volume set of *Voyages imaginaires, songes, visions, et romans cabalistiques* compiled by Charles-Georges-Thomas Garnier between 1787 and 1789. The pages of the three dozen books—all lavender-colored softcover—had never been cut. Back at our hotel, we were soon carefully cutting open the pages, allowing us to be the first people in nearly two centuries able to read the collection and to look at the long-undisturbed figures by Pierre-Clement Marillier that were engraved by Berthet, Borgnet, Croutelle, Delignon and others.

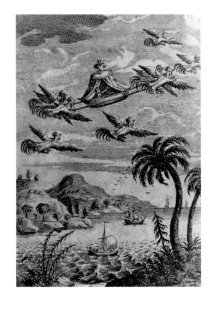

The set, which had been published in Amsterdam and Paris, contained many works of interest, including a little-known novel by Marie-Anne de Roumier entitled *Voyages de Milord Céton dans les sept planettes ou le Nouveau Mentor*. The story, set in mid-17th century England, tells of the title character and his sister Monime's visit to the seven planets on the wings of Zachiel.

Another happy find was Samuel Brunt's *A Voyage to Cacklogallinia* that had eluded me for years. Finally, in 1969, I located a clean copy at Maggs Brothers in London with its handsome frontispiece in excellent condition. Some scholars speculate that the pseudonymous Brunt was in reality Daniel Defoe or even Jonathan Swift. Whoever he may have been, the author employed the lunar flight theme in this 1727 work as a framework within which to satirize the recent collapse of the South Sea Company and the losses of many English speculators.

All the while, I continued to search for and locate prints, some dating back to the 16th century. In the painting department, I managed to turn up in London a couple of oils, one by James Lonsdale painted in 1839 of the 19th century rocket pioneer William Congreve, and the other by an unknown artist of an astronomer gazing at the heavens through an early telescope. Lonsdale was a student of George Romney and one of the founders of the Society of British Artists.

The most treasured addition to my library was made at Sotheby's in 1966 in London: the 1638 first edition of Bishop John Wilkins's *The Discovery of a World in the Moone, or A Discourse tending to prove, that 'tis probable there*

may be another habitable World in that Planet. It has a splendid, partly illustrated, title page. The author, who was a member of the Royal Society of London and the Philosophical Society of Oxford, considered his book speculative science rather than fiction; in the 1640 edition, which I located somewhat later, he added a subtitle *A Discourse concerning the possibility of Passage thither.* I eventually found the 1684 edition of Wilkins' work as well as the only edition in French, which was published in 1655.

I continued acquiring fictional works about the Moon, such as Daniel Defoe's *The Consolidator* (1705) and Aphra Behn's *The Emperor of the Moon: A Farce* (1687); and nonfictional ones as well, including James Nasmyth and James Carpenter's *The Moon Considered as a Planet, a World and a Satellite* (1874) and Edmund Neison's *The Moon* (1876). This latter and other late 19th and early 20th century astronomical books often contained illustrations of what other worlds might look like.

I was thrilled when I finally found in London Giovanni Virginio Schiaparelli's *Osservazioni Astronomiche e Fisiche...sulla Topografia del Pianeta Marte*, released in six parts between between 1878 and 1899. The *canali* had been first observed 1877 by the Milan-based astronomer who considered them as naturally-occurring grooves or channels. I enjoyed studying the network of lines reproduced in the plates contained in Schiaparelli's reports.

To the Italian astronomer, *canali* were a product of geological processes. But to Percival Lowell of Boston, they were artificial constructs—canals designed and built by intelligent beings to transport summer meltwater from the polar caps to parched equatorial regions of the red planet. As he wrote in his book *Mars* published in 1895, "It is by the very presence of uniformity and precision that we suspect things of artificiality...the better we see these lines [the canals] the more regular they look...the intrinsic improbability of such a state of things arising from purely natural causes becomes evident on a moment's consideration." Over the years, I acquired *Mars* as well as Lowell's *The Solar System, Mars and its Canals, The Evolution of Worlds,* and *Mars as the Abode of Life.* His drawings of purported canals were even more fascinating than those of Schiaparelli's canali.

Society's reaction to what quickly became the "canal controversy" had a lasting literary fallout. Even before Lowell turned his attention to Mars, and just three years after Schiaparelli announced his *canali,* author Percy Greg came out with a two-volume novel entitled *Across the Zodiac,* which, after a long search, I eventually bought in Louisville, Kentucky. His planet Mars was scientifically advanced, governed by a monarch, and boasted a capitalistic

economy. Some years later, in 1891, Robert Cromie's *A Plunge into Space* describes a Mars-bound, globe-shaped spaceship, illustrated in the frontispiece, that is powered by "...the law of gravitation [which] may be diverted, directed, or destroyed"—in short, some kind of anti-gravity propulsion device. Jules Verne himself wrote the preface.

With the canal debate in full swing, H.G. Wells' *War of the Worlds* caused a sensation. Martians invading the planet Earth! Could such an event actually occur? In the light of Lowell's "discovery" of canals on Mars, one reviewer felt it "...less unreasonable to think that Mars is inhabited than it is not." And "...thus quite within the bounds of legitimate speculation..." to suppose that Martians might "...look towards our Earth with longing eyes..." Serialized in 1897 in *Cosmopolitan* magazine, the novel appeared in book form a year later.

I mentioned earlier that my search for books and prints took me as far off as Australia and New Zealand. During the course of several trips in the former country I had searched the holdings of the state libraries of Victoria and New South Wales, which are located in Melbourne and Sydney, respectively. My research revealed a curious—and presumably very rare—work by Joseph Fraser entitled *Melbourne and Mars: My Mysterious Life on Two Planets, Extracts from the Diary of a Melbourne Merchant.* The book, my notes told me, was 104 pages long and dated 1889, and had been published by Pater & Knapton in Melbourne. In 1992, I finally found it in the same city. As far as I know, the book remains virtually unknown to collectors of the genre, but it is listed in John Ferguson's *Bibliography of Australia.*

During January-February 1970, I traveled to the Antarctic with a team from the National Science Foundation. Briefings about, and outfitting for, the trip to the "Ice" were conducted at the U.S. Antarctic Research Program's facility in Christchurch, New Zealand, so I had an opportunity to wander around that lovely city. After the trip, which took me to the McMurdo Base, the South Pole Station, the Byrd Station and other locations—including a remote nunatak known as Carapace—I enjoyed more free time in and around Christchurch.

As usual, I kept my eye out for books and prints and did, in fact, turn up an interesting astronomical title. Just as I was leaving the little bookshop, whose name I have unfortunately forgotten, I spied a whole shelf devoted to Antarctic exploration books, many quite old. Realizing that the closest analog to lunar exploration on Earth was the Antarctic—hostile environment, located at the end of a long and complex logistic chain, etc.—I decided I had better bargain for the lot. But I hadn't reckoned on buying several dozen quite rare books that day, and did not have enough money with me. The bookdealer said

to just give him a check for the U.S. dollar-equivalent of the amount owed, and so I wrote a check on my bank back in Huntsville, Alabama, and of course offered to show my passport as identification. "Oh," he reproached me, even appearing slightly offended, "that's not necessary. I hope you enjoy the books."

But I digress.

Schiaparelli's and Lowell's theories aside, how was one ever to know what conditions were really like on Mars, the Moon, and other worlds? Soon after my interest in space travel had blossomed, I became aware that the key to space travel lay in the rocket. Rockets, as far as I then knew, were devices that for the most part dated back to amateur experimenters active in the 1920s and 30s in Europe and the United States. I soon learned better.

Around 1950, I discovered two routes to follow in studying the history of the rocket. One involved seeking out military texts, particularly those dealing with gunnery and artillery, and the other called for keeping a lookout for works on recreational fireworks.

I got started with Lieutenant Colonel Henry R. L. Himes' *Gunpowder and Ammunition: Their Origin and Progress* (1904), followed eleven years later by his *The Origin of Artillery*. Another guiding source was Henry B. Faber's three-volume *Military Pyrotechnics* published in Washington in 1919. Once I had absorbed these books' content, I began to collect everything I could find on the use of rockets. The 1729 English-language edition (the first was in Latin) of *The Great Art of Artillery* by Casimir Simienowicz at London's Francis Edwards bookstore in 1973 was an exciting find. It, like many other such books, illustrates all manner of rockets and pyrotechnic devices. Other additions to my collection included Claude-Fortuné Ruggieri's *Pyrotechnie militaire* (1812) and William Moore's *A Treatise on the Motion of Rockets* (1813). The latter, a pioneering mathematical dissertation on rocket dynamics, proved exceptionally hard to find.

Critical 19th century works include William Congreve's *A Treatise on the General Principles, Powers, and Facility of Application of the Congreve Rocket System, as compared with Artillery*, which contains many plates illustrating the military use of rockets. Congreve's rockets were inspired by, and developed from, rockets used in the late 18th century in India against British colonial forces. I was thus fortunate when, one day in 1953, I entered a small bookstore in York, England, and almost immediately stumbled upon the *Journal of a Route across India, through Egypt, in the Latter End of the Year 1818*, by Lieutenant-Colonel George Augustus Frederick Fitzclarence, first Earl of Munster. On page 34, I found a color plate entitled "Rocket Corps and Dromedary Corp, Bengal Army, 1817."

A particularly valuable work in this portion of my collection is *Battista della Valle's Vallo Libro continente Appertinentie a Capitunii.... Fortificare una Città co Bastioni, con novi artificie di fuoco...*, published in Venice in 1529. Chancing upon it one afternoon at Quevado's in London in October 1982, I learned that it is probably the earliest printed description of military pyrotechnics, or at least one of the earliest. Some years previously, I had purchased another important work, John Babington's 1635 *Pyrotechnia or, A Discourse of Artificiall Fire-Works*. It was the first book in English on display pyrotechnics and a landmark publication in the history of technology. Many more early books on pyrotechnics soon lined my bookshelves. And by now I had built up quite a collection of fireworks prints, including several dating to the 1600s found in Munich.

Events leading to the paintings I eventually collected hark back to the early 1950s. In September 1951, my father mentioned to me that C. Watson Newhall, whom I had known for years as a close family friend, had recently been assigned by Laurence S. Rockefeller to be executive vice president of the small rocket-engine firm Reaction Motors, Inc. in Rockaway, New Jersey. He explained to me that Rockefeller would invest in small but often financially struggling research and development firms, temporarily put in financial and administrative personnel like himself, watch the firms prosper, and eventually sell out and move on to other investments.

At the time, my work experience had been in Venezuela in the petroleum and mining fields, a far cry from rocket development, Reaction Motors' speciality. I had been part of a small exploration team at the newly-discovered Cerro Bolívar "iron mountain" south of the Orinoco river port Ciudad Bolívar and earlier had been in charge of a wildcat well north of the Mene Grande Oil Company compound in San Tomé.

The invitation from Watson Newhall to visit Reaction Motors excited me, and I ended up spending two days there in mid-September 1951. I remember talking to most of the department heads and touring the rocket test area. At the end of the visit, I was about to thank Mr. Newhall for his kindness when he suddenly asked me if I would like to work there, as I seemed to know a lot about "this rocket business."

Stunned, I explained that although I had read about the subject and had collected everything I could lay my hands on, I was not trained in the field. He replied that almost no one was, that we were all on a learning curve, and that I seemed quite knowledgeable. I couldn't resist the unexpected offer and agreed on the spot. And so it was that I accepted a job as assistant engineer, engineering department, at America's pioneering rocket-engine development company.

Being relatively close to New York City in my new job, I became increasingly active in the New York Section of the American Rocket Society. I came to know many individuals active in the growing field of rocketry, and, that November, attended a gala dinner in Atlantic City where I further widened my contacts. Everything seemed to be going my way.

I don't recall exactly how it happened, but back at Reaction Motors, I was named Engineering Department editor of the company publication *Rocket*, for which I subsequently prepared a column on rocket-related events around the world. Even though I was working at a rocket-development company, many of its employees were only vaguely interested in the potential application of rocketry to spaceflight. I recall one of my associates saying that he didn't care whether he was designing rocket engines or bathtubs as long as he got a paycheck! My first article, "Where Liquid Propellants May Lead Us," attempted to awaken fellow employees to the potential and promise of flight into space. Bathtubs!

Somehow, my piece came to the attention of Charles Federer, editor of *Sky and Telescope* magazine at the Harvard College Observatory, who asked that I expand and illustrate it. My "The Advance of Rocket Science" appeared in the October 1952 issue of the popular astronomy magazine—the first of what would became hundreds of articles to appear in the open literature. I was ecstatic.

That month, a seminal event for me took place in New York City: the Hayden Planetarium's Second Symposium on Space Travel. There, I found myself mingling with such luminaries as author and former rocket experimenter Willy Ley, Harvard astronomer Fred Whipple, space medical expert Fritz Haber, sounding rocket pioneer Milton Rosen, and—most importantly to me—Wernher von Braun, then Technical Director, U.S. Army Ordnance Guided Missile Development Group at Redstone Arsenal in Huntsville, Alabama. As I got to know him over the years, von Braun became a major influence on my career and my passion for collecting as well.

Unfortunately, neither von Braun nor I had been able to attend the first Hayden space symposium held the year before on Columbus Day. But it unleashed a chain of events important to both of us. Though I couldn't be on hand, I was able to obtain a copy of the program and a collection of press releases. I knew that the speakers were all acknowledged leaders in rocketry and missile development, astronomy, the biological and medical aspects of spaceflight, and related fields. As the proceedings of that first symposium were not to be published, it was principally through the press that the public became aware of what had gone on at Hayden that day.

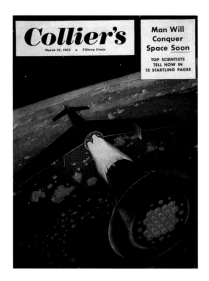

Among the press representatives were two reporters from *Collier's*, one of the four major, wide-circulation, large-format magazines of the period—the others being *Life*, *Look* and *The Saturday Evening Post*. Managing editor Gordon Manning was so impressed that the very next month he sent associate editor Cornelius Ryan to San Antonio to cover the Air Force-sponsored "Symposium on the Physics and Medicine of the Upper Atmosphere." There, von Braun, Whipple, and UCLA physicist Joseph Kaplan convinced Ryan that spaceflight could come about much sooner than anyone expected.

Back in New York, Ryan presented his findings to Manning, who proposed holding a mini-symposium of space experts at *Collier's* offices. And so it was that von Braun, Whipple, Kaplan, space medical expert Heinz Haber (brother of Fritz), science writer Willy Ley, and UN lawyer Oscar Schachter joined the staff is laying out an ambitious program to educate the American public about space. Also part of the team were three artists brought in by art director William Chessman, Chesley Bonestell from California, Rolf Kelp from Oregon and Fred Freeman from Connecticut.

The result of the New York gathering was the appearance, between March 1952 and April 1954, of eight issues of *Collier's* dedicated to spaceflight. Von Braun, Whipple, Ley and others wrote the articles, all edited by Ryan, and the three artists produced a series of spectacular but technically plausible illustrations, many based on original pencil sketches by von Braun. The success of the *Collier's* series exceeded the most optimistic expectations and led to three derivative books: *Across the Space Frontier*, *Conquest of the Moon*, and *The Exploration of Mars*. Three Walt Disney space films soon followed that roughly tracked the *Collier's* series and featured von Braun and several associates. Aired on television between 1955 and 1957, they further prepared the American public for the coming Space Age.

During the 1952-1954 period of the *Collier's* series, I became active on several fronts. In August 1953, I attended the Fourth International Astronautical Congress in Zurich, and, in August 1954, the Fifth in Innsbruck, Austria representing the newly founded American Astronautical Society. Back in 1950, I had been the only American present at the First Congress in Paris, and in 1952 had been elected a fellow of both the British Interplanetary Society and the British Astronomical Association. Through these various connections, I got to know Arthur C. Clarke, whose first letter to me of 15 October 1951 remains a treasured possession.

In November 1954, I was recruited by the Guided Missiles Division of Republic Aviation Corporation. In spite of a tempting salary increase, I

somewhat reluctantly left Reaction Motors and moved to Long Island, New York. My new job took me to work at Republic's Hicksville plant, not far from its main facility in Farmingdale. My wife, young son Fred, and I lived in a lovely house overlooking Oyster Bay.

As my new career got started, I became ever more active with the American Astronautical Society and soon found myself on its board of directors and editor of the *Journal of Astronautics*. In this context, I became more involved with von Braun who was also a board member. In December 1955, I served as chairman of the society's second annual meeting in New York City that featured von Braun speaking on "Problems of Guided Missile Development." Our relationship had now progressed to the point where, in early February 1956, he asked me to join him at Redstone Arsenal in Alabama. We discussed the matter in detail over breakfast at the Harvard Club of New York on 28 March—my notes remind me that we talked for two and a half hours. The thought of working for the distinguished rocket and spaceflight pioneer excited me no end.

I flew off to Huntsville on 4 April 1956, coincidentally my birthday. For two days I toured the facilities of the Army Ballistic Missile Agency on Redstone Arsenal where I met and talked with von Braun, Ernst Stuhlinger, and other associates. The upshot of that trip was that soon afterwards I began working in a consultant role under contract with the General Astronautics Research Corporation, of which I was co-founder. Then, in mid-February 1957, I joined the von Braun team as a full-time member of ABMA's Saturn Systems Office under Oswald Lange.

With Maruja, my two boys Fred and Albert (Albert had been born on Long Island during my Republic days), and collie Rocket, we settled into a house on Monte Sano overlooking farmlands below. The dog later became famous by accompanying my three children (daughter Aliette Marisol was born in Huntsville nine months after our move from New York) every day to school and meeting them promptly at closing time. Several years later, Rocket received a school award for attendance and punctuality, an event that attracted a local TV crew for the evening news. After that, kids seeing me walk by would say, "There goes Rocket's father." I had become a celebrity!

It was in von Braun's Huntsville home that I first saw a number of original Chesley Bonestell paintings that had earlier appeared in *Collier's* magazine—a gift from the artist. I later got to know Bonestell. In early 1967, with my good friend Carsbie C. Adams, we managed to acquire from him more than forty original paintings that had first appeared in a variety of publications. In time, the collection passed into my hands. With additional acquisitions, at one

time I came to own some fifty originals. During the course of twenty-five years, the collection toured the United States, Australia, Indonesia and Japan.

From time to time, I sold individual Bonestells and purchased others. Eventually, I pruned my collection to the major paintings that the artist had earlier executed for the *Collier's* space series. Throughout the process, I was assisted and encouraged by my close friend, colleague and Bonestell confidant Frederick C. Durant III. Helped by another friend, Randy Liebermann, I purchased the paintings that artist Fred Freeman had done for both the *Collier's* series and for von Braun's lunar (1958-59) and Mars (1960) contributions to *This Week* magazine. I also acquired many drawings by Freeman and von Braun himself. Still another friend, artist-author Ron Miller, stepped in to reproduce three lost Bonestells needed to flesh out the collection for an exhibit that Liebermann and I were in the process of developing. Meanwhile, Bonestell scholars Melvin Schuetz and the Rev. Dennis Bauder have long been faithful guides and sources of details about the artist.

"Blueprint for Space," the name we gave the exhibit, was put together at the U.S. Space & Rocket Center in Huntsville with financing provided by IBM. From the Smithsonian's National Air and Space Museum and from the University of Oregon in Eugene we borrowed paintings by Rolf Klep, the third *Collier's* series artist. This done, we could now recreate the *Collier's* and the *This Week* experiences for a new generation. By the time the exhibit opened in New York City in January 1992, Liebermann and I had produced a book (*Blueprint for Space: Science Fiction to Science Fact*), an hour-long video, and a narrated slide set of the same name.

In the United States, Chesley Bonestell is acknowledged to be the father of space art. While working on the "Blueprint for Space" exhibit, I was reminded that there was a French grandfather of the genre who died in 1947. Lucien Rudaux was a professional astronomer and one-time director of the Observatoire de Donville. He was also an accomplished artist of astronomical, and on occasion, astronautical, themes. My prized copy of his classic *Sur les autres mondes*, published by Larousse in 1937, was dusted off and made ready for exhibit. I also had Rudaux's *Sur les autres planètes* published by the University of Paris in 1943 based on a conference given at the Palais de la Découverte in April of that year—right in the middle of World War II.

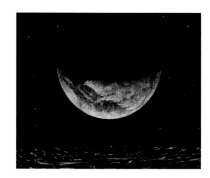

The two books were fine, but I wanted more for "Blueprint." First, I determined to locate a copy of a third book that had long eluded me: the large-format, profusely illustrated *Le Ciel* by Alfonse Berget. Published by Larousse in 1923, I had seen it at the Bibliothèque Nationale and knew that it

was "illustrated under the direction of Lucien Rudaux, astronomer." It was clearly a must. Secondly, I wondered if some of Rudaux's original paintings had survived the war; and, if so, where they might be stored.

With these two objectives in mind, in October 1989 my wife and I flew to Paris where, over a period of two days, we visited virtually every antiquarian bookshop in the city. Miraculously, in the late afternoon of our last day we discovered a copy of *Le Ciel* at the small La Poussière du Temps bookshop across from the Jardins du Luxembourg. What luck! As we were congratulating ourselves, the salesman announced that he couldn't let us have the book as it hadn't been priced. The owner was the only one who could do so, and he was out of town until the next day. But that very next morning we were to fly back to the States! Could we be staring at failure after having come so close?

Fortunately, shortly before boarding time, I rang the store from the airport and found La Poussière du Temps' owner had just come in. We were able to negotiate a price over the phone and a promise to dispatch *Le Ciel* immediately without advance payment; I of course paid him immediately on arriving home. First mission accomplished. *Le Ciel*, opened to reveal an early Rudaux planetary scene, went on view from the day "Blueprint for Space" premiered several years later. The exhibit took that long to prepare and mount.

The second mission, locating original Rudaux paintings, got quite involved, gave early promise of success, and ended in disappointment. Earlier during the same Paris trip, I had arranged a couple of meetings with Rudaux's widow, his second and younger wife. Madame Rudaux was most pleasant and cooperative. Over tea at her home, she showed me documentation that she had prepared of her late husband's work as both astronomer and artist.

In addition to sessions with Madame Rudaux, I met several times with Philippe de la Cotardière, Larousse's chief archivist and science expert. I had established what I thought were positive relations with Larousse in connection with the publication in 1968 of von Braun's and my book *Histoire mondiale de l'astronautique* (*World History of Astronautics*). A joint Larousse-*Paris Match* endeavor, it later won for us a coveted Aéro-Club de France award.

After much research, M. de la Cotardière and I were led by a security employee into the publisher's subterranean storage area on the rue Montparnasse. Our guide unlocked door after door as we walked down a long corridor. We finally entered a room where illustrations of books published in the 1920s and 30s were stored. For about an hour we pored over shelf after shelf, from floor to ceiling along all four walls, until, as luck would have it, I turned up the images from *Sur les autres mondes*. I must have shouted

something like "Eureka!" There they were, dozens of carefully wrapped Rudaux originals that had apparently not been examined since the late 1930s. I felt as if I had stumbled on a treasure in a previously undiscovered tomb.

But to no avail. Despite the encouragement of Madame Rudaux and the professed interest of M. de la Cotardière, those in charge at Larousse headquarters decided against lending original Rudaux art for our "Blueprint for Space" exhibit. So the two big books, *Sur les autres mondes* and *Le Ciel* had to make do—we would have no Rudaux originals to hang beside the paintings of Bonestell, Freeman and Klep. Later, I learned that Larousse and Madame Rudaux went on to exhibit the late astronomer-artist's paintings along with some documentation at several sites in France. Tant pis pour moi!

We took the Rudaux reversal in stride, delighted that NASA had now designated "Blueprint for Space" as an official educational component of the International Space Year 1992. Not only did it premiere that January at the IBM Gallery of Science and Art in New York City, but it went on to spend a year at the Smithsonian's National Air and Space Museum in Washington, D.C. and tour museums associated with major NASA space centers in Huntsville, Houston, Cape Canaveral, and Hampton, Virginia. Dozens of rare books, prints, science fiction magazines, and other materials from my collection were also placed on view as part of the exhibit which, before closing in 1995, was seen by millions. Most recently, during the summer of 1999, on the thirtieth anniversary of the Apollo 11 landing on the Moon, portions of the collection were displayed at the Newseum in Arlington, Virginia across the Potomac from Washington, D.C. The overall exhibit, "Dateline Moon," broke all attendance records at the Newseum.

In the pages that follow, images from my book, print, photograph and painting collection trace highlights of the evolution of spaceflight through the ages. Ancient people's longing to understand the shining objects in the sky focused, quite logically, on the Sun and the Moon. Not only were they much larger and brighter than what we now know to be stars and planets but they were apparently nearer, too. As early as the 1st century A.D., the Greek philosopher Plutarch wondered if there might be life on the Moon. He didn't take the next step, however, and ponder how one might reach it. Except for Lukian of Samosata, who flourished in the 2nd century, few would until the advent of the telescope. Lukian's *True History* told of a sailing vessel swept up by a whirlwind and blown to the Moon.

Spurred by the invention of the telescope in the early 1600s, the theme of lunar travel began to develop. For the next three centuries, authors delighted in

outdoing one another as they conjured up schemes of reaching and exploring the lunar world in the sky. Some suggestions for traveling into space were fairly well thought out, others were simply farcical: birds, catapults, coiled springs, demons, and vials of dew were the stuff of early—and highly imaginative—spaceships.

After centuries of fantasies and dreams, by the late 1800s more practical means to reach the Moon were sought. By then, knowledge had progressed to the point where advances in science and engineering could be called upon by space-minded authors. Most notably, Jules Verne entranced readers with his classic Moon travel novels published in 1865 and 1870. *De la terre à la lune* and *Autour de la lune* tell the story of how members of the Baltimore Gun Club rely on a huge cannon called Columbiad to send a three-man projectile towards and around, but not onto, the Moon. We know today that this was not a practical launch device—the crew could not withstand Columbiad's high initial acceleration. But Verne had raised the theme of lunar travel to a new level of realism; and, in doing so, stirred the imaginations of those who followed.

As I've already noted, before the 19th century had run its course another world clamored for attention: Mars. During the late summer opposition of 1877, the Italian astronomer Schiaparelli detected grooves on the Martian surface, the famous *canali*. In the English-speaking world, they soon became canals—implying an artificial origin. So believed Percival Lowell who, in 1894, opened an observatory near Flagstaff in Arizona Territory dedicated to the study of the canal phenomenon. In books and lectures, he energetically spread his interpretation of conditions on Mars to a worldwide audience.

The idea of canals on Mars inevitably attracted writers of fiction. H.G. Wells stepped forward with his *War of the Worlds*, serialized in 1897 and published in book form the following year. That same year 1897 saw the publication of Kurd Lasswitz's *Auf zwei Planeten* (translated as *Two Planets*) in Leipzig in which Martians establish a space station over Earth's North Pole. Mark Wicks' *To Mars via the Moon* (1911) conjured up a utopia inspired by Lowell, to whom the book was dedicated. On the 4th of August of that same year, the previously unpublished 36-year-old Edgar Rice Burroughs mailed a manuscript to the popular *The All-Story* magazine. Entitled "Under the Moons of Mars," it was enthusiastically accepted and from July through December of the following year appeared in six installments under the pseudonym Norman Bean. Success was immediate. Lowell's vision of an inhabited Mars had triumphed, at least in popular fiction.

A succession of novels set on Mars followed. Among eight from my collection on exhibit at the Virginia Air and Space Center in Hampton are Burroughs's

Synthetic Men of Mars, Stanley G. Weinbaum's *The Martian Odyssey*, and Ray Bradbury's *The Martian Chronicles*.

Beginning at the end of the 19th century, Russian schoolteacher Konstantin E. Tsiolkowsky began to study how one might realistically travel to other worlds. Inspired by Verne and other writers, Tsiolkowsky reasoned that the only means of propelling a vehicle through space would be by reliable and powerful rocket engines. Robert H. Goddard in the United States, Robert Esnault-Pelterie in France, and Hermann Oberth living in a German-speaking enclave of Transylvania independently came to the same conclusion. It was not long before military and political events transported the rocket to the forefront of modern technology.

During World War II, the German Army developed the rocket-powered V-2 ballistic missile. Following its first successful test firing from Peenemünde on the Baltic coast in October 1942, the base's military commander proclaimed that the spaceship had been born: the missile had briefly arched into space along the midpoint of its trajectory.

Emerging from a defeated Germany in 1945, the V-2's technical director Wernher von Braun and more than a hundred teammates transferred to the United States to work for their former enemy. At the end of January 1958, less than three months after the first Soviet Sputnik had ushered in the Space Age, his German-American rocket team orbited Explorer 1 from Cape Canaveral, Florida. It was America's first artificial satellite.

The space race was on.

A decade later, the same team's powerful Saturn V launch rocket began sending Apollo expeditions to the Moon, first around it and, soon afterwards, onto the surface. Apollo 8, the first mission to the Moon, took place between 21 and 27 December 1968 and gained fame as the first manned spacecraft to leave Earth's gravity well and orbit the Moon (ten revolutions).

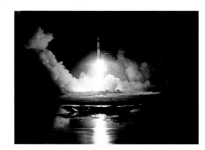

For three reasons, 1968 was particularly significant to me. In April, the Stanley Kubrick-Arthur C. Clarke film "2001: A Space Odyssey" premiered in Washington, D.C. Clarke had recommended me to Kubrick with the result that during 1965 and 1966, I had worked as technical advisor on the project, first in New York City, and later at the M-G-M studios in Borehamwood, England north of London. Secondly, von Braun's and my book *Histoire mondiale de l'astronautique* appeared in France and won an award. And there was the Apollo 8 flight. In a single year, man's first flight to the Moon, a blockbuster space movie, and an award-winning book. Not bad.

Apollo 10 followed in May 1969, making 31 revolutions to check out the Lunar Module. A couple of months later, this crucial element of Apollo accomplished what Jules Verne's spacecraft didn't: an actual landing. At 9:32 A.M. E.D.T on 16 July 1969, witnessed by up to a million people in and around Cape Canaveral and hundreds of millions worldwide via television, Apollo 11 astronauts Neil Armstrong, Buzz Aldrin, and Michael Collins took off for the Moon. I was fortunate to be on hand for the occasion, with an excellent VIP viewing location beside the Vertical (later renamed Vehicle) Assembly Building. Among those present was Hermann Oberth, von Braun's mentor in Germany from the 1930s.

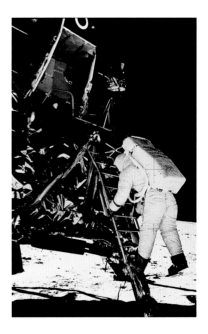

I joined an international group in nearby Melbourne for a celebratory lunch and then flew to Houston to attend a large dinner at the Warwick Hotel. We were highly optimistic that the mission would continue successfully. All the next day I listened to Apollo 11 mission briefings at the Manned Spacecraft Center and talked to many astronauts including John Glenn, Walter Cunningham, Frank Borman and Jim McDivitt. The next day I flew back to the Cape, where my wife and children were waiting for me; they had witnessed the excitement from the beach and were enjoying themselves immensely. As we returned home to Huntsville, Alabama, my wife reminded me that some members of her family had opposed our marriage plans back in 1950. How could a nice girl like Maruja marry a guy who talks all the time about going to the Moon? He must be crazy. Seven years later, when the Russians orbited their first Sputnik, my wife was confronted with another view. How did you end up marrying a guy who let the Russians beat the Americans into space? As if it were my fault!

We arrived home in time to watch on television Apollo 11's successful touchdown on the lunar surface on July 20. What a triumph: centuries of dreams reached fruition in that one stunning moment. The Apollo program continued for a few years before coming to a premature end in December 1972 with the Apollo 17 mission. America had won the race to the Moon. Priorities were shifting.

In the decades since Apollo, the United States orbited a single Skylab space station and dispatched about a hundred space shuttle missions to low-Earth orbit. For their part, the Soviets developed and orbited a series of Salyut and Mir space stations and today, as Russia, has joined the U.S. and other spacefaring nations in constructing the International Space Station. If all goes as planned, it will be completed around the middle of the 21st century's first decade.

Since the beginning of the Space Age, instrumented spacecraft have probed the far corners of the Solar System to the point that by the new

millennium only Pluto remains unexplored. Some probes fly by their objectives, others orbit around them, and still others set down on their surfaces. The Hubble Space Telescope has shed new light on the universe around us and other orbiting observatories have peered into the X-ray, gamma-ray, and ultraviolet regions to complement the former's astonishing findings.

The images in the pages that follow helped inspire and pave the way to the space triumphs of the latter half of the 20th century. As we embark on a new century—and a new millennium—fresh images will illuminate the future promise of space.

Even now, plans are being drawn up for a manned return to the Moon and the establishment of a human presence on the planet Mars. Both are ideal enterprises for the artist's vision. Unmanned missions building on the discoveries by Mariner, Pioneer, Magellan, Viking, Voyager, Galileo, Cassini and other 20th century spacecraft will also capture their imaginations.

And now we are searching for other solar systems to explore. At this, the dawn of the 21st century, some fifty "extrasolar" planets have been discovered (including one the size of Jupiter orbiting the 10.5-light-year-distant star Epsilon Eridani), leading astronomers to believe that such worlds may be the rule rather than the exception in the universe around us. The Nearby Stars Project, funded jointly by NASA and the National Science Foundation, seeks to catalogue stars out to roughly eighty light years from the Sun—our stellar neighborhood, so to speak. Planets found circling these stars will be likely candidates for future robotic exploration. Artists should have a field day imagining the sights that some day may be revealed.

Perhaps as soon as 2005, NASA's Space Interferometry Mission will be able to pinpoint those extrasolar planets that may offer conditions compatible with the emergence and development of life. An even more ambitious effort is the Terrestrial Planet Finder Telescope, now scheduled for launch in 2011. Its mission: search for and study Earthlike planets out to some fifty light years' distance.

The lure of other worlds is taking on a new meaning. First the Moon, then Mars, the other planets and their moons, comets and asteroids. Now our instruments—and our imaginations—are peering far beyond the empire of the Sun. As always, artists will intrigue us with images of things to come. And inspire the continuing search for reality.

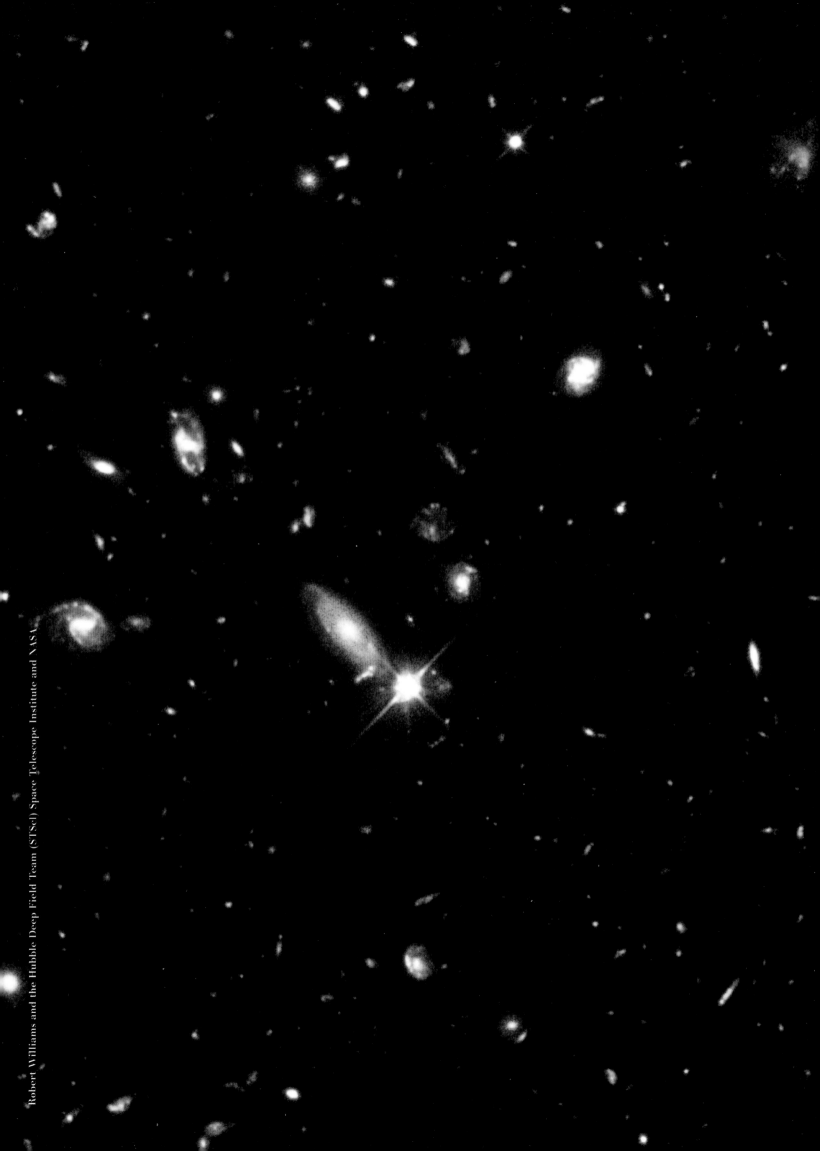

PART I: PRE-1600S

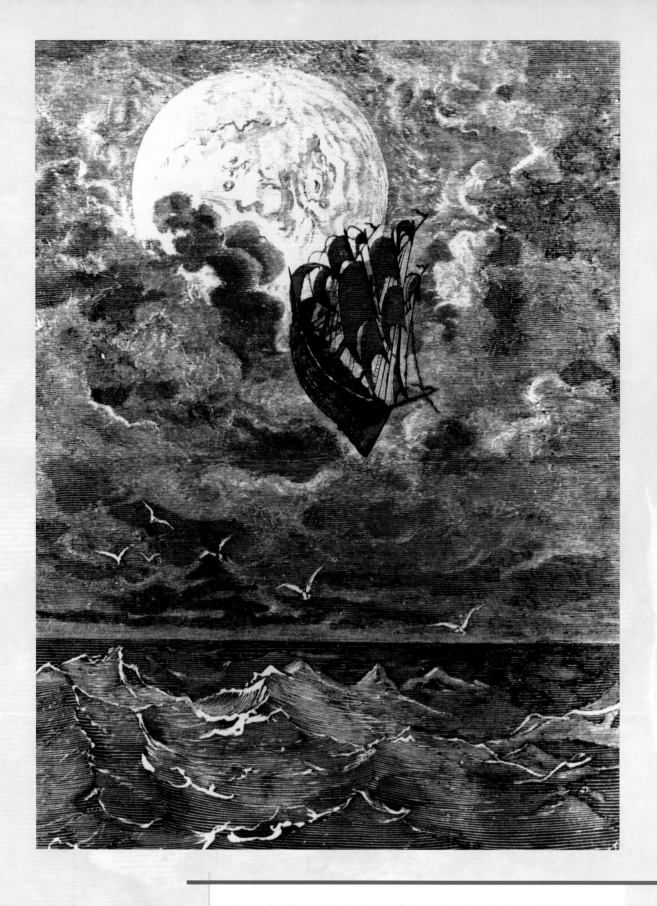

Around 165 A.D. the Syrian sophist and satirist Lukian of Samosata wrote in Greek, the *True History,* often referred to by its Latin translation *Vera historia.* Apparently the first work of space fiction, it tells of a sailing vessel carrying fifty Greek athletes that is suddenly carried up into the heavens by a violent whirlwind. On the eighth day of travel, "...an island, round, shining and remarkably full of light" appears. The travelers have reached the Moon. In this 19th century engraving, Gustave Doré depicts the scene.

In one of many translations of *True History*—the first was by Francis Hicks in 1634—Alfred J. Church offers this scene in *A Traveller's True Tale. After the Greek.* (1880).

THE MOON FOLK SURPRISED BY THE CLOUD CENTAURS.

Centuries later, around 1010 A.D., Firdausi introduces bird-power to loft mythical King Kai-Kaus into the heavens in the Persian epic *Shah-Nama*. The king wonders "...how far it was from this Earth to the sphere of the Moon...Then he fetched four vigorous eagles and bound them firmly to the throne." This rendering dates from the 15th century, early Temurid Period, School of Shiraz. Courtesy The Metropolitan Museum of Art, Gift of Arthur A. Houghton, Jr., 1970. (1970.301.21).

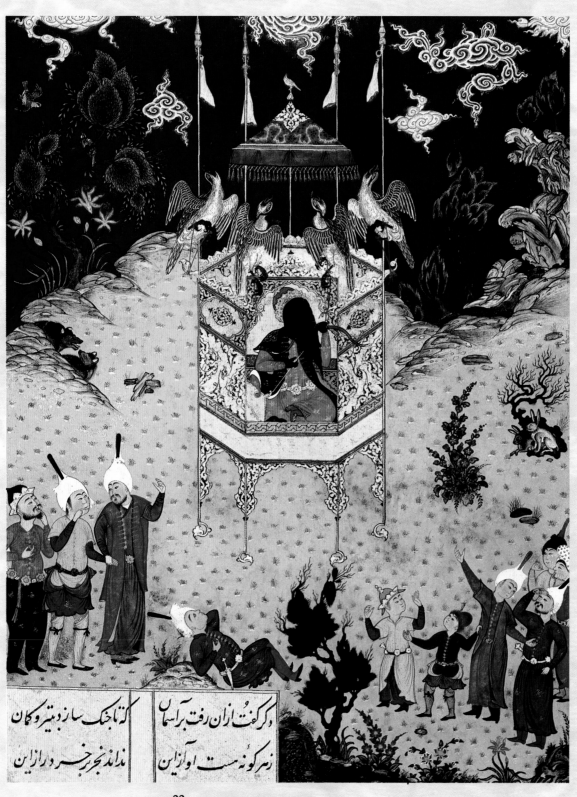

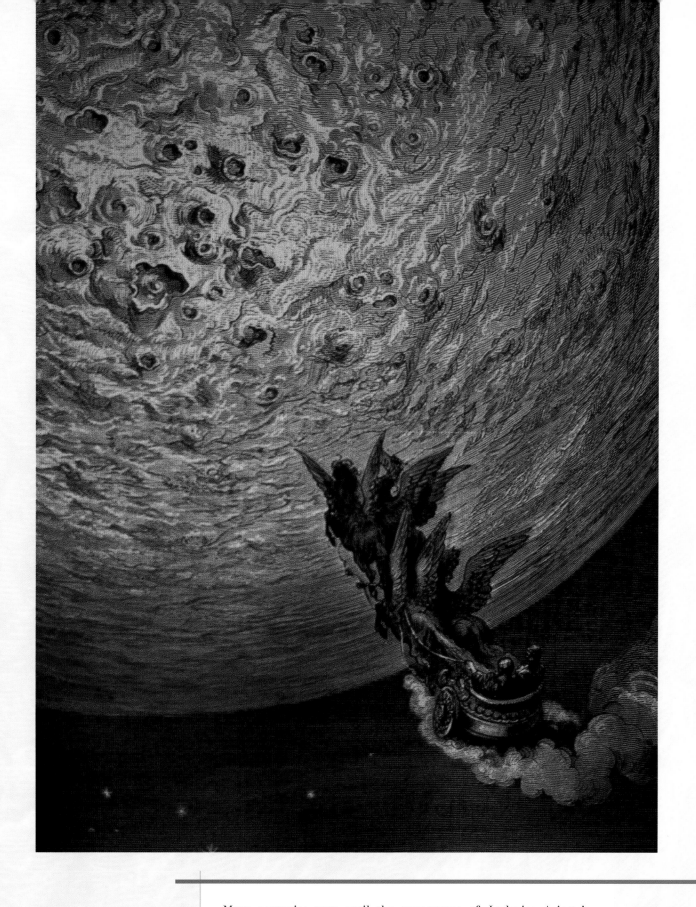

More centuries pass until the appearance of Lodovico Ariosto's *Orlando Furioso* in 1516, subsequently translated into English in 1591 by J. Harrington. On a mountain top, the hero Astolfo meets St. John the Evangelist who urges that "…a flight more daring take to yonder Moon…The nearest planet to our earthly poles." Gustav Doré illustrates the chariot carrying Astolfo to a world that "…seem'd an Earth in size" with rivers, valleys, cities, towns and even castles.

PART II: **1600S**

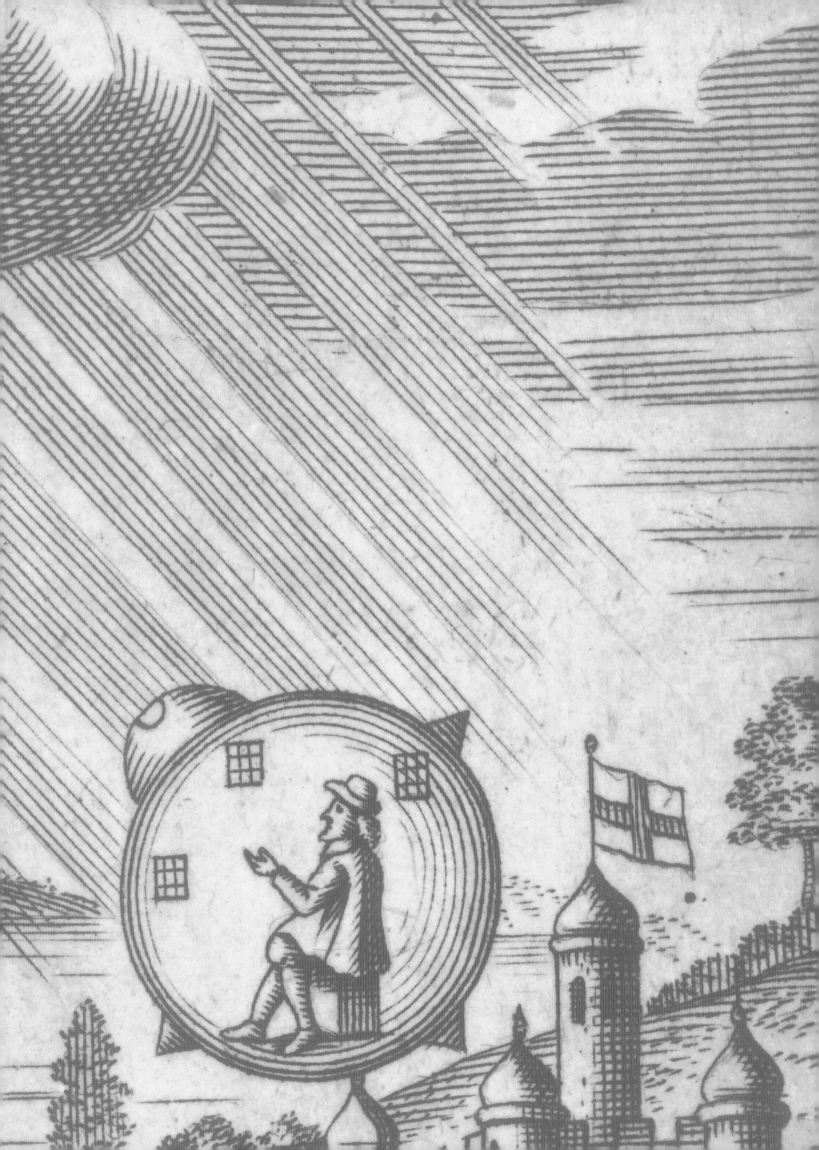

Published in 1624, four years after his death, Johannes Kepler's *Somnium (Dream)* invokes a most unusual method of reaching the Moon. Realizing that the Earth's atmosphere does not extend outward to the Moon and thus can not support any means of flight that he could imagine, Kepler chooses a supernatural alternative: demons. Unable to withstand the light of the Sun, they travel only at night and, on rare occasions, are able to carry humans with them. Kepler's lunar inhabitants live underground, emerging only to sun themselves. This is the opening page of the curious story.

JOANNIS KEPPLERI

In Somnium Aftronomicum

Notæ, fucceffivè fcriptæ inter annos
1620. 1630.

1. SOnus ipfe voeis mihi occurrit ex recorda-
tione Nominum propriorum fimiliter fonantium hiftoriæ
Scoticæ, quæ regio profpeetat Oceanum Islandicum.

2. Lingua noftra Teutonica fonat Terram glacialem. In hac verô
remota infula locum ego mihi difpexi dormiendi & fomniandi; vt i-
mitarer Philofophos in hoc genere fcriptionis. Nam & Cicero traje-
eit in Africam fomniaturus, & Plato Atlanticam in eodem Oceano
Hefperio fabricatus eft, vnde fabulofa virtuti militari fubfidia accerfe-
ret;& Plutarchus denique, libello de facie Lunæ: poft multum fermo-
nem in Oceanum Americanum exfpaciatur, defcribitque nobis fitum
talem infularum, quem Geographus aliquis modernus Azoribus, &
Gronlandiæ & Terræ Laboratoris regionibus circum Islandiam fitis
probabiliter applicaverit. Quem quidem Plutarchi librum quoties re-
lego, toties impenfe foleo mirari, quo cafu factum fit, vt noftra nobis
fomnia feu fabulæ tam accuratè congruerent. Nam ego quidem fat fi-
dâ memoriâ repeto occafiones fingularum commenti mei partium;
quòd ex mihi non omnes fint natæ ex lectione hujus libri. Extat apud
me charta pervetus, tuâ Clariffime D. Chriftophore Befolde manu ex-
arata; cùm thefes circiter viginti, de cœleftibus apparentijs in Luna,
ex meis differtationibus anno 1593. concepiffes, easq; D. Vito Mille-
ro tunc difputationum Philofophicarum ordinario Præfidi, difputatu-
rus de ijs, fi ipfe annuiffet, exhibuiffes. Quo quidem tempore Plutar-
D 3 chi

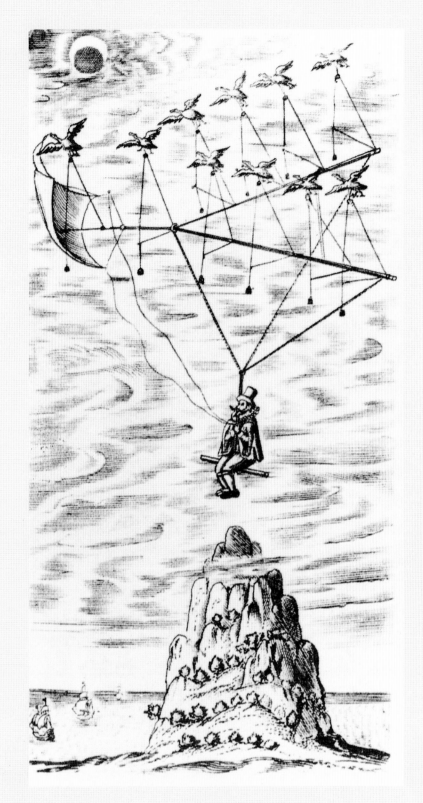

An English bishop, Francis Godwin, pursued the lunar voyage theme, arguing in his preface to *The Man in the Moon: or a Discourse of a Voyage thither* (1638) that "... the Moon Should bee habitable." Domingo Gonsales and his servant Diego find themselves abandoned on the island of St. Helena. Hoping somehow to return to their native Spain, Domingo trains wild geese, *gansas*, to carry him on a platform. Test flights are successful, but then a ship bound for Spain drops by and rescues Domingo and his companions only to be shipwrecked at the Canary Islands. Hoping to complete the journey home, Domingo tethers his birds, who loft him and Diego into the air. Not towards Spain, it turns out, but—where else?—to the Moon. And at a speed of "Fifty Leagues in every hower."

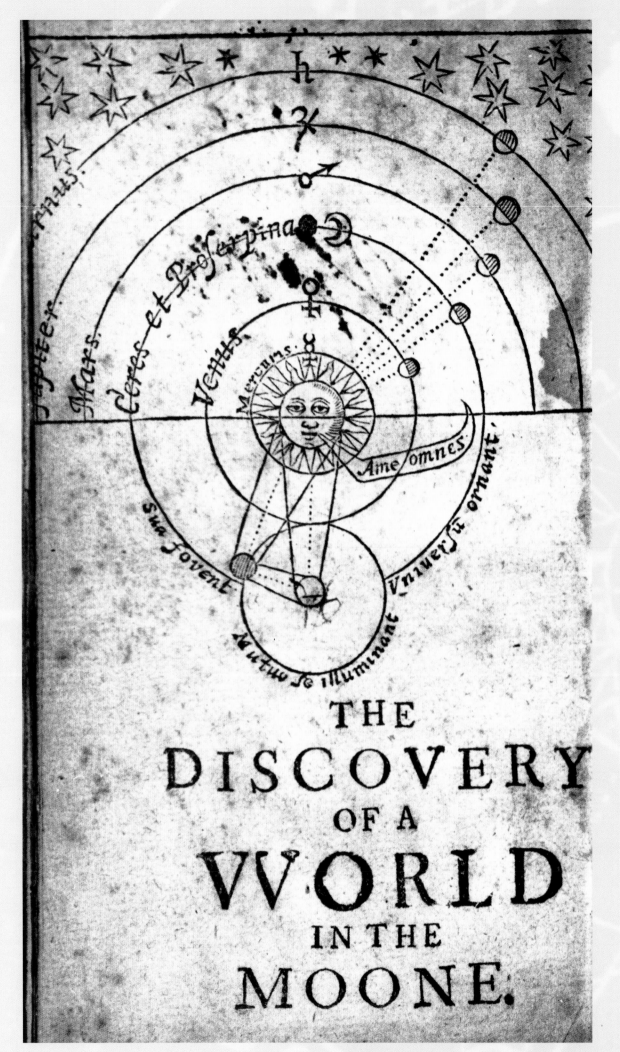

THE
DISCOVERY
OF A
WORLD
IN THE
MOONE.

OR,
A DISCOVRSE
Tending,
TO PROVE,
that 'tis probable there
may be another habitable
World in that Planet.

*Quid tibi inquis ista proderunt ?
Si nihil aliud, hoc certè, sciam
omnia angusta esse.* SENECA.
Præf. ad 1.Lib. N. 2.

LONDON,
Printed by *E.G.*for *Michael Sparke*
and *Edward Forrest,* 1638.

A
DISCOVERY
OF A
New World,
Edw OR, Giddy
A DISCOURSE Tending
to prove, that 'tis Probable there
may be another Habitable WORLD
in the MOON.
With a Discourse concerning the Proba-
bility of a Passage thither. Unto which
is Added, A Discourse concerning a
New Planet, Tending to Prove, That
'tis Probable Our Earth is one of the
Planets.

In Two Parts.

By John Wilkins, *late Lord Bishop of*
Chester.

The Fifth Edition Corrected and Amended.

LONDON,
Printed by *J. Rawlins* for *John Gellibrand,*
at the *Golden-Ball* in St. *Pauls* Church-
Yard. MDCLXXXIV.

The same year, 1638, witnessed the publication of *The Discovery of a World in the Moone. Or, a Discourse Tending, to Prove that 'tis probable there may be another habitable World in that Planet.* Written by another bishop, John Wilkins, it was considered science, not fiction. Not only was he a member of the Philosophical Society of Oxford and the Royal Society of London, but was quite up to date in matters scientific-as understood, or course, in the opening years of the 17th century. In the 1684 edition at right, "corrected and amended," he included ". . . a Discourse concerning the Probability of a Passage thither." Having read Bishop Godwin's tale, Wilkins agrees that birds might indeed be trained to carry man to the Moon where he could discover ". . . the strangeness of the persons, language, arts, policy, [and] religion of those inhabitants . . ."

Very much influenced by the two English bishops, across the channel Savinien Cyrano de Bergerac composes *Histoire comique des Estats et Empires de la Lune* (*Comical History of the States and Empires of the Moon*) that appeared in several editions in the 1650s and 1660s. The first English edition came out in 1659, followed in 1687 by A. Lovell's "newly Englished" version under the title *The Comical History of the States and Empires of the Worlds of the Moon and Sun.* Cyrano experimented with various means of attaining these worlds. Here, he has collected dew in a number of vials and tied them to his body. His logic: since dew is apparently drawn up by the Sun each morning, if one could collect it one could also be sucked upward by the glowing orb.

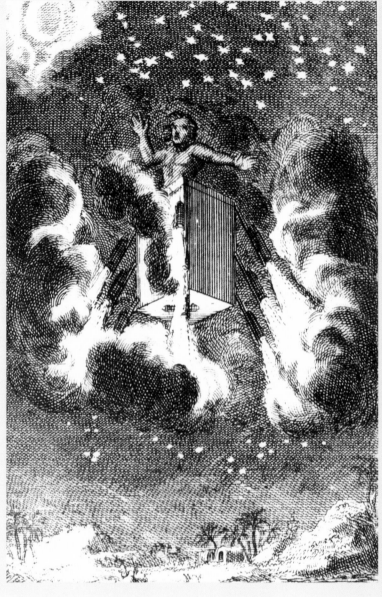

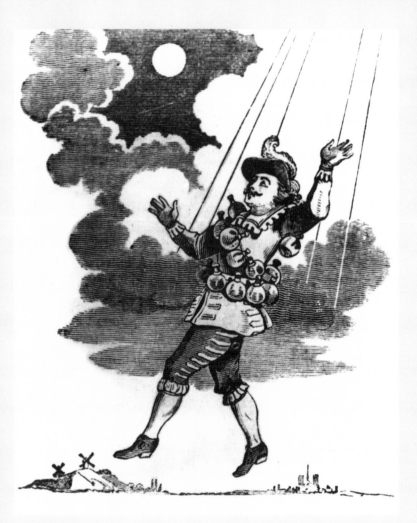

In another scheme, he straps firecrackers to his flying machine. And whoosh, he sails aloft.

Cyrano also comes up with a box-like device with sail, the latter proving quite useless. Six feet high and three feet square, it carries a "Vessel of Christal" device. "When the Sun breaking out from under the Clouds, began to shine upon my Machine..." he begins to explain.

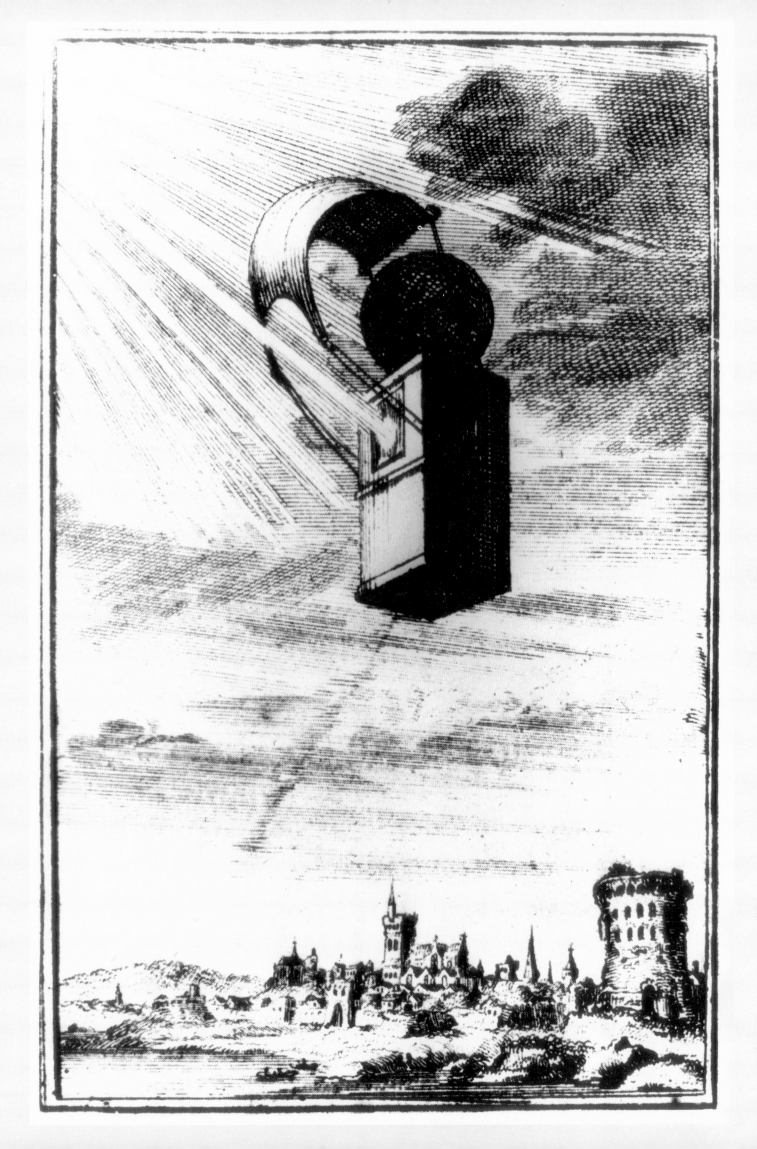

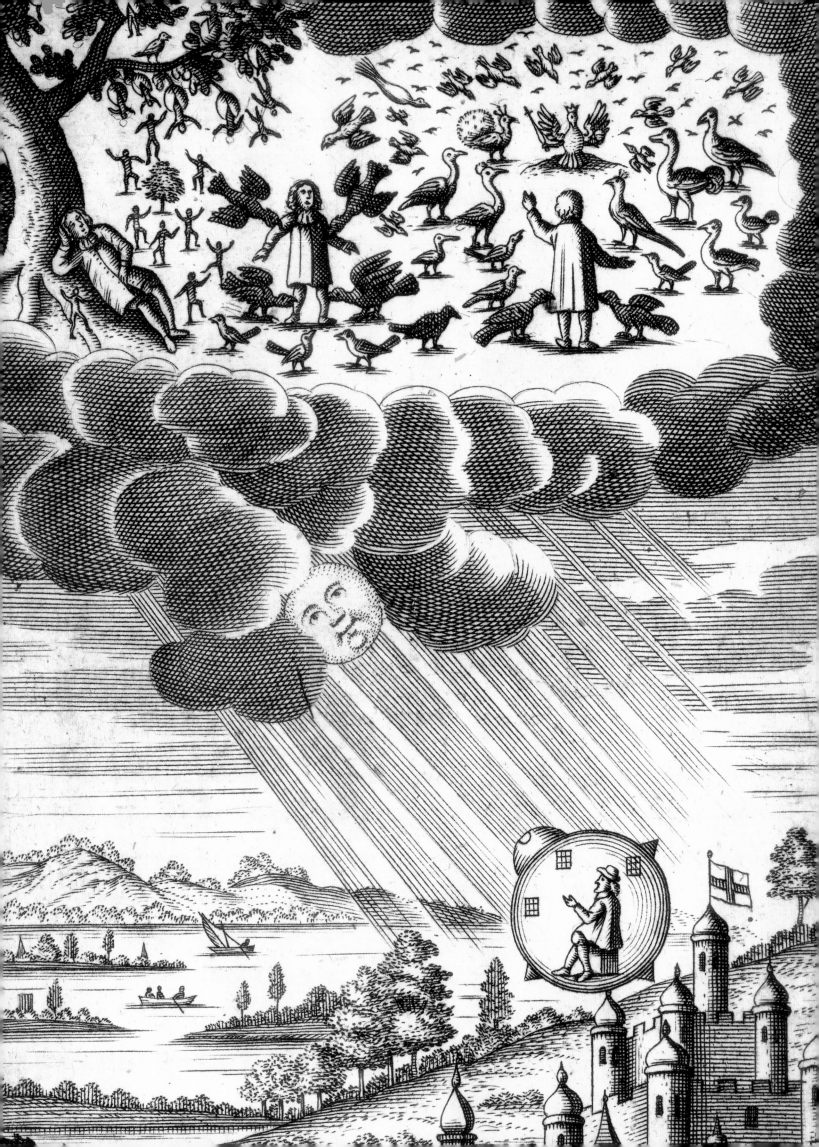

Cyrano's "bowl" spaceship "... shut so close..., that a grain of Air could not enter it, except by the two openings; and I had placed a little very light Board within for my self to sit upon." On his last journey, he passes by the Moon and flies out to the realm of the planets.

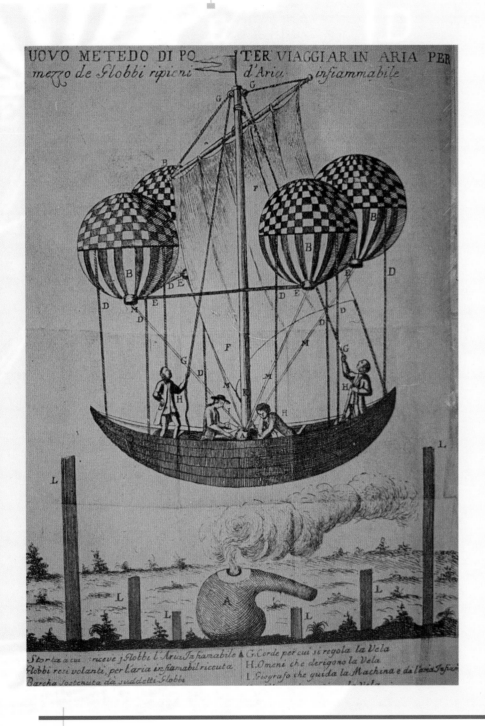

In 1670, Francesco Lana Terzi's *Prodromo overo saggio di alcune inventioni nuove premesso all' Arte Maestra* (*Forecast of the Wisdom of Some New Inventions ...*) is published in which an airship, *La nave volanti*, is described. This flying chariot is fitted with a sail, oars to guide the vessel through the air, and four evacuated globes attached by as many ropes. Lana's basic design is later modified by adding two additional spheres enabling explorers to use the ship for travel to the Moon.

PART III: 1700S

A devotee of Cyrano's tales, David Russen of Hythe, England reviewed proposals of how to reach the lunar world in his *Iter Lunare: or, a Voyage to the Moon* in 1703. In this non-fiction work, Russen proposes the use of powerful springs as a launch device, among other means.

ITER LUNARE:

OR, A

VOYAGE

TO THE

MOON.

CONTAINING

Some Confiderations on the Nature of that Planet.

The Poffibility of getting thither.

With other Pleafant Conceits about the Inhabitants, their Manners and Cuftoms.

———— *Sic itur ad aftra*
Reptet humi quicunq; velit ————

By *DAVID RUSSEN* of *Hythe*.

LONDON,
Printed for *J. Nutt*, near *Stationers-Hall*. 1703.

Jonathan Swift's *Travels into Several Remote Nations Of the World*. In Four Parts, First a Surgeon, and then a Captain of several Ships was published in London in 1726. In "Voyage to Laputa," we are introduced to a "Flying Island" that Gulliver describes as "...a vast opaque body between me and the sun... about two miles high...it appeared to be a firm substance, the bottom flat, smooth, and shining very bright...The reader can hardly conceive my astonishment, to behold an island in the air, inhabited by men..." The magnetism of a powerful lodestone held it aloft. While not a station in space, the beginnings of an idea are apparent.

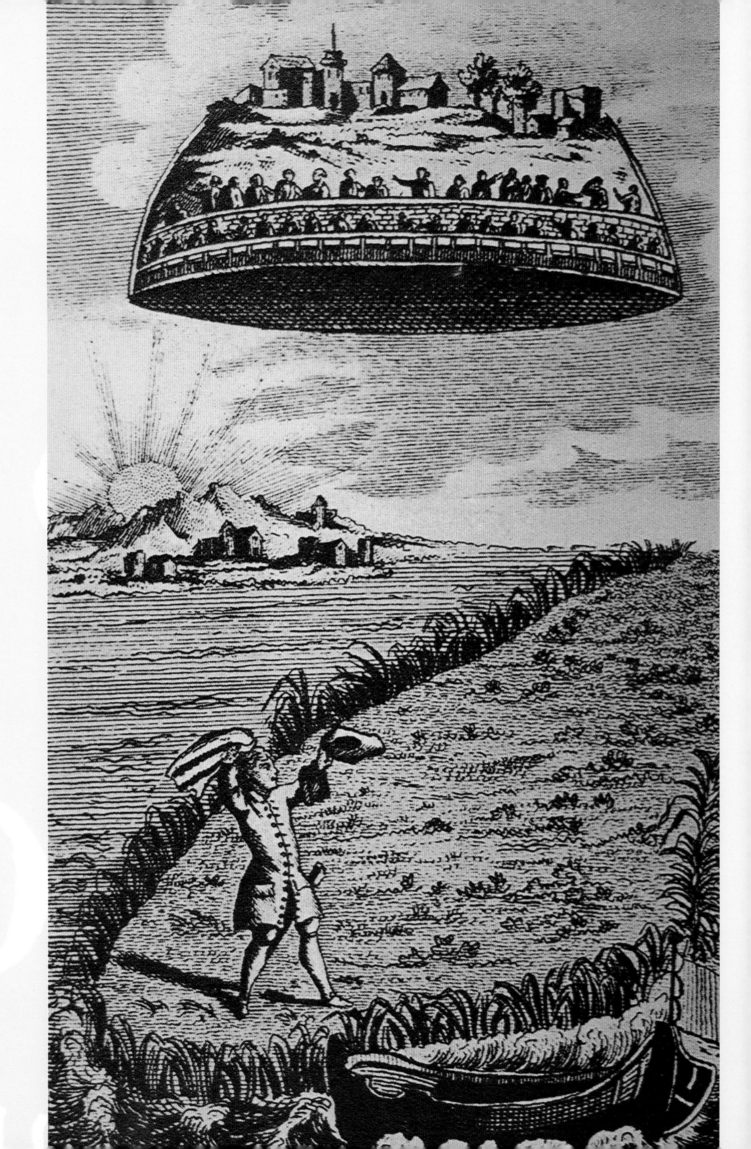

The very next year, Captain Samuel Brunt pseudonymously offers his *A Voyage to Cacklogallinia* (1727). Scholars have never identified Brunt, though both Swift and Daniel Defoe have been suggested as possible authors. Brunt harks back to the Domingo Gonsales tale and harnesses birds to lift a contraption to the Moon. The story is satiric, involving a speculative plan to find and mine gold there.

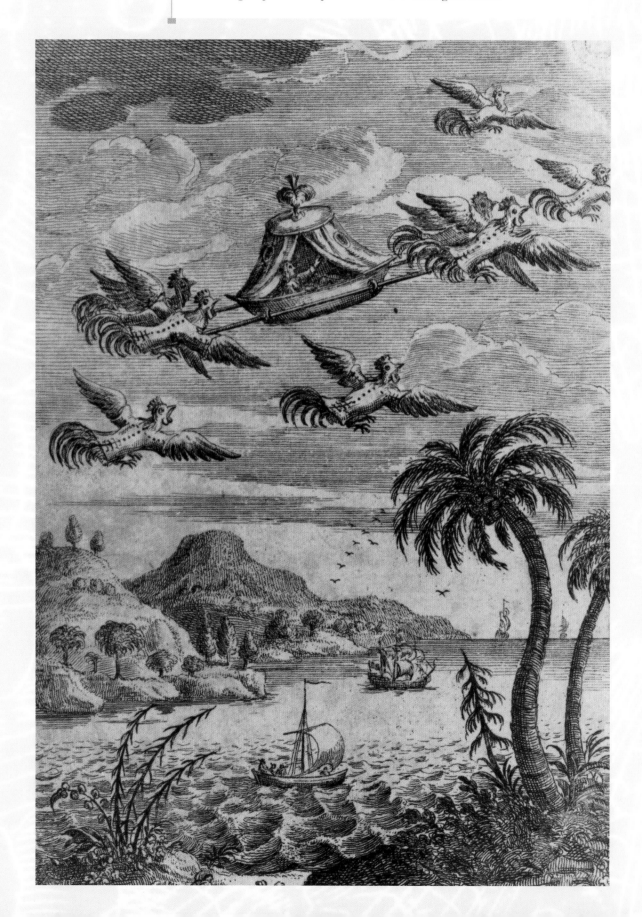

1 Mercury, 2. Venus, 3. the Earth, 4 Mars, 5. Jupiter, 6. Saturn.

A.
Week's Conversation
ON THE
PLURALITY
OF
WORLDS.

By Monſieur *FONTENELLE.*

Tranſlated from the laſt PARIS *Edition, wherein are many* IMPROVEMENTS *throughout ; and ſome* NEW OBSERVATIONS *on ſeveral* DISCOVERIES *which have been lately made in the* HEAVENS.

By WILLIAM GARDINER, *Eſq;*

The SECOND EDITION.

To which is added,

Mr. Secretary ADDISON'S
ORATION, made at *Oxford,*
in Defenſe of the *New Philoſophy.*

LONDON:
Printed for E. CURLL in the *Strand.* 172ʃ.
(Price 2ʃ. 6 d.)

In this environment of increasing popular interest in, adventures on, and speculation about, the Moon and beyond, Bernard Le Bouvier de Fontenelle's writings on the plurality of worlds were gaining new audiences. First published in France in 1686 as *Entretiens sur la pluralité des mondes,* it was repeatedly reprinted, enlarged, and translated. By 1728, William Gardiner's translation (*A Week's Conversation on the Plurality of Worlds*) had appeared in its second edition which, in turn, contained improvements and new observations. Fontenelle visits the Moon and planets not by bird-power or other mechanical means but in his imagination. He does this by introducing a philosopher who explains to his lady that the Moon and planets are other worlds and that they may be inhabited and perhaps visited.

In the garden the philosopher explains that "Whole Nations live in these vast Caverns [on the Moon]; and I doubt not but there may be Passages under ground, for the communication and commerce of one People and Nation with another. You are pleas'd to laugh, Madam, at my Fancy, do so with all my Heart, I agree you should; and yet you may be more mistaken than I: For you believe, that the Inhabitants of the Moon dwell upon the Surface of their Globe, as we do on that of the Earth..."

Glum habillé vu par devant.

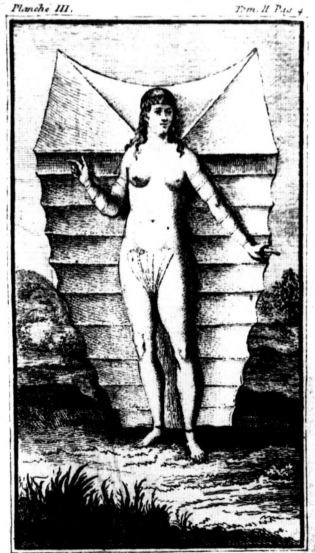

Gawry prête a voler.

The "other worlds" theme occasionally meant a new and unexplored world beneath, rather than above, our own. Robert Paltock's *The Life and Adventures of Peter Wilkins. A Cornish Man* (1751) tells of a mariner whose ship is drawn into an eddy and sent to a subterranean world. There, among other marvels, he finds glums (left) and gawries (right), flying men and women.

n.º 6.

THIS PAGE AND OVERLEAF: Set of four. Sometime between 1764 and 1766, a delightful picture book of engravings by Filippo Morghen appeared. The first edition's extended title page explains that it is a collection "of the most notable things seen by Cavalier Wild Scull and Signor de la Hire on their famous voyage from the Earth to the Moon." In the second edition released somewhat later, La Hire is replaced by Giovanni [John] Wilkins; this is the version illustrated here. Morghen's lunarians have pumpkin boats, live in treehouses, and appear in many bizarre forms.

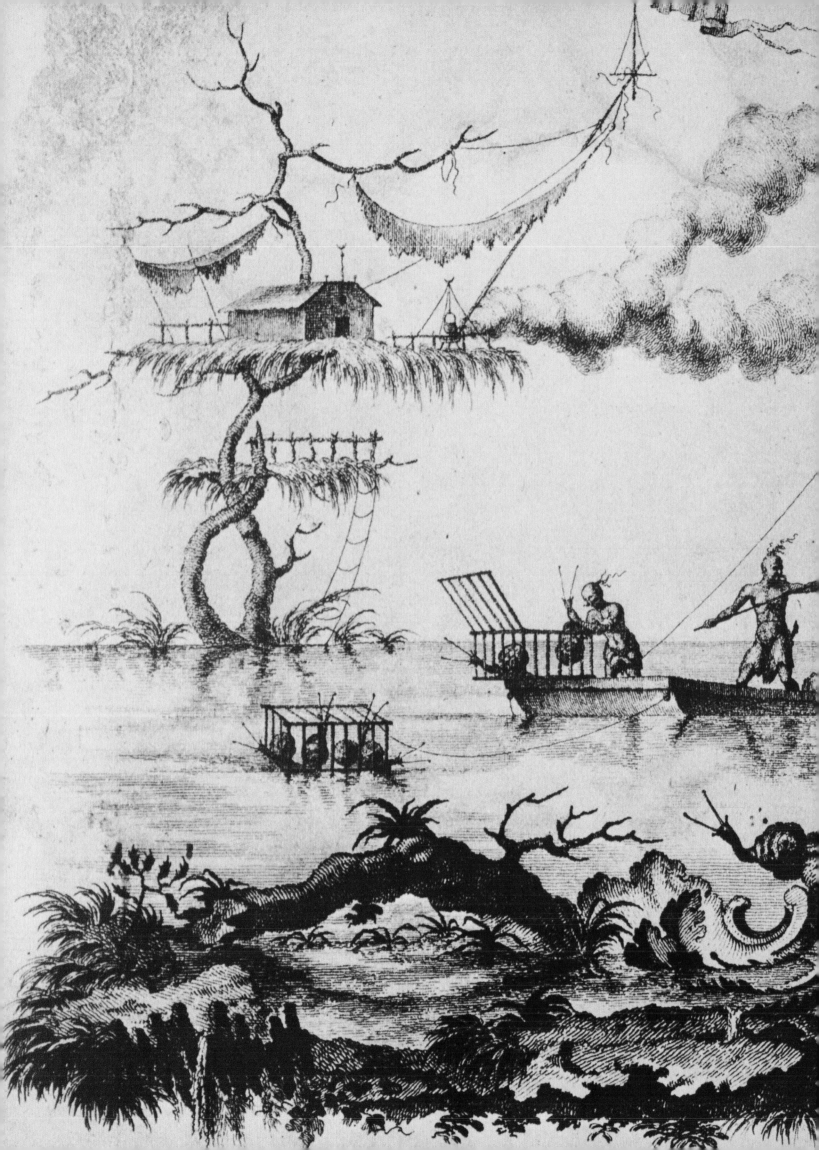

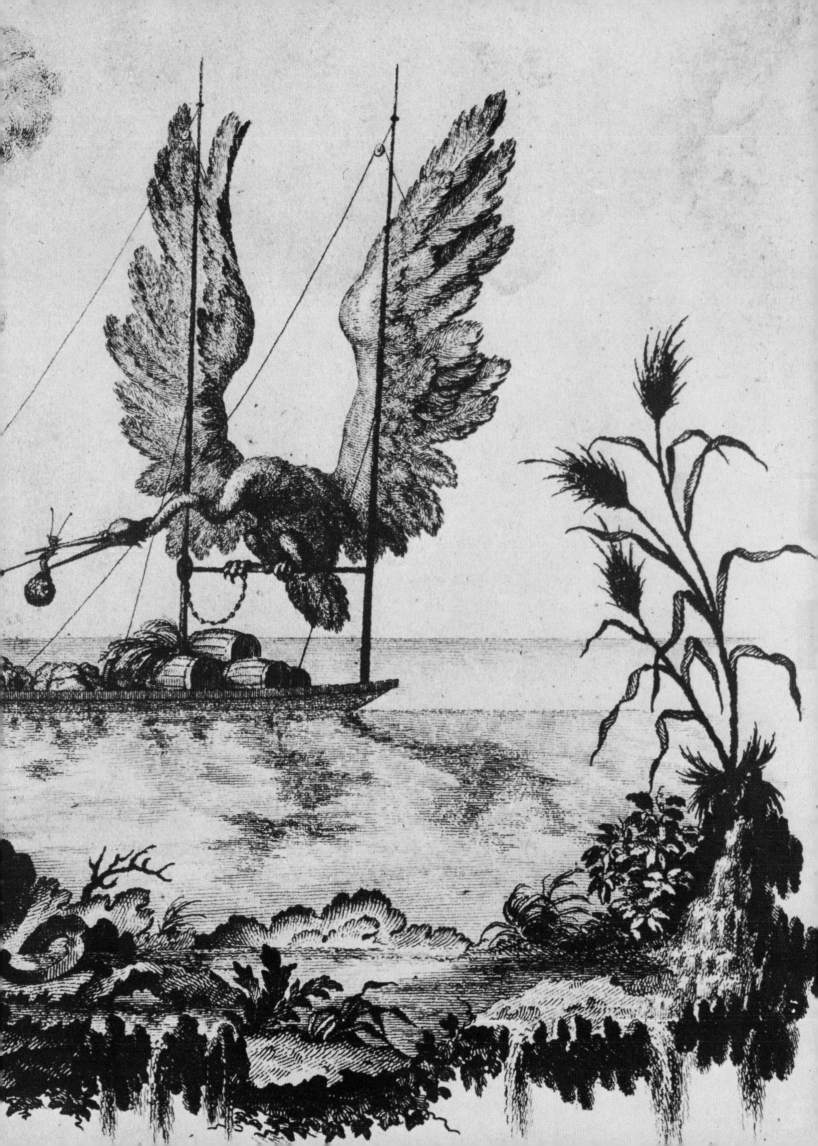

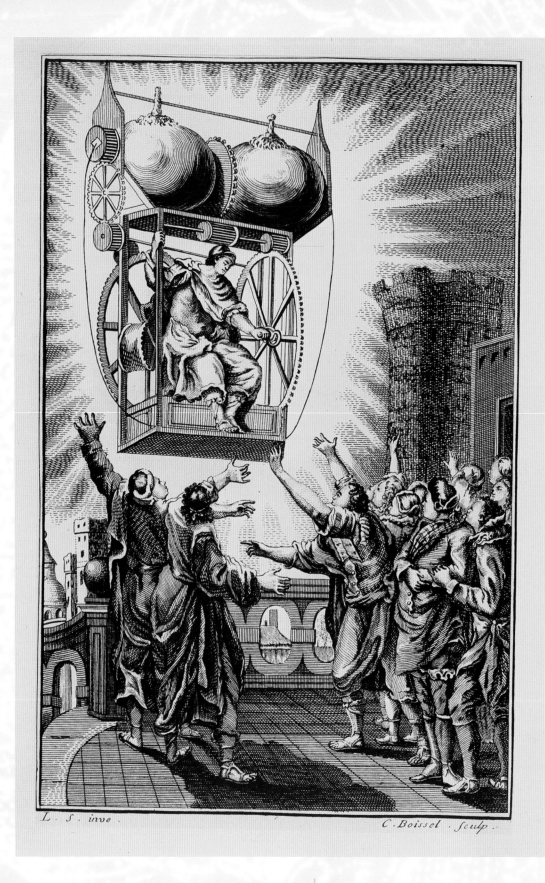

L. S. inve. C. Boissel. sculp.

In a switch from the past, the hero Ormisais in Louis Guillaume de La Follie's *Le philosophe sans prétention* (*The Philosopher without Ambition*, 1775) hails from a far-off world, Mercury, and flies to Earth. Arriving here, we learn that Scintilla from that innermost planet has invented an electric flying machine capable of crossing space.

GULLIVER REVIVED;

CONTAINING SINGULAR

TRAVELS, CAMPAIGNS, VOYAGES,
AND ADVENTURES

IN RUSSIA, the CASPIAN SEA, ICELAND,
TURKEY, EGYPT, GIBRALTAR, up the
MEDITERRANEAN, on the ATLANTIC
OCEAN, and through the centre of
MOUNT ETNA into the SOUTH SEA:

ALSO

An Account of a Voyage into the MOON and
DOG-STAR, with many extraordinary Particulars relative to the Cooking Animal in those
Planets, which are here called the Human
Species,

BY

BARON MUNCHAUSEN.

THE FIFTH EDITION,

Considerably enlarged, and ornamented with a variety
of explanatory Views, engraved from
Original Designs.

LONDON:

Printed for G. KEARSLEY, in FLEET-STREET,
M DCC LXXXVII.

LEFT: This fifth, enlarged edition of Rodolf Erich Raspe's Baron Munchausen tale. *Gulliver Revived* ... (1787), contains "An Account of a Voyage into the Moon and Dog-Star ..." along with numerous engravings. One of these is a frontispiece folded out from the title page.

BELOW: Munchausen encounters this inhabitant of the Moon who nestles his head under his arm.

An Inhabitant of the MOON.

PART IV: 1800S

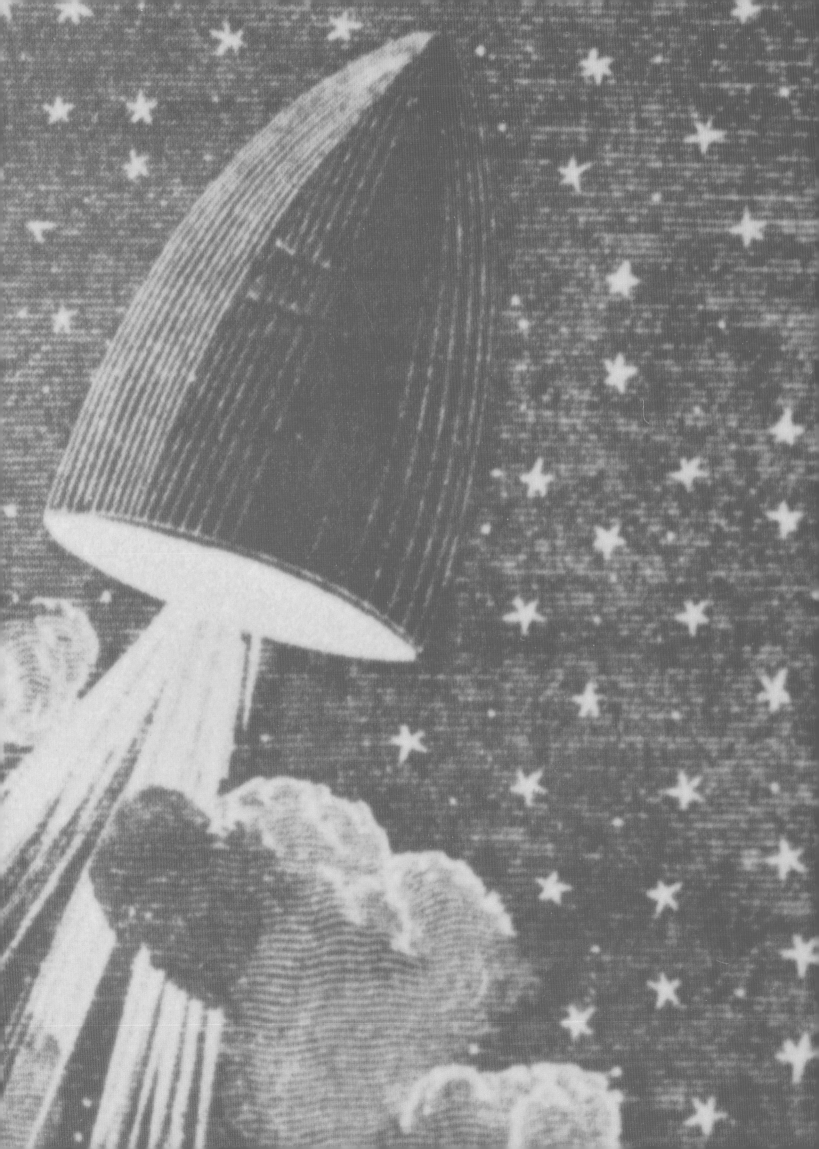

By the 19th century, many descriptions were circulating about the Moon and planets. In 1835, Richard Adams Locke of New York City's *Sun* newspaper reports the results of supposed astronomical discoveries on the Moon. On 31 August of that year, his newspaper prints that astronomer Sir John Herschel, working at an observatory near the Cape of Good Hope in South Africa, had made some remarkable discoveries based on observations with a new and powerful telescope. Four days later, what today we know as the Great Moon Hoax begins. All kinds of vegetation are described in the *Sun*, animals such as lunar bison, and bat people whose behavior "...would but ill comport with our terrestrial notions of decorum." In the coming days, circulation rises to nearly 20,000 as the series continues, making the *Sun* the most widely read newspaper in the world. Many illustrations were inspired by the hoax, including a series published in Naples, Italy the following year. The *Sun* articles were first reprinted in pamphlet form, then as *The Celebrated Moon Story* in 1852 and seven years later as *The Moon Hoax; or, A discovery that the Moon has a Vast Population of Human Beings*. Sir John Herschel was amused when he learned of what was going on in New York, all the while hoping that he would be better remembered as the author of *Results of Astronomical Observations made during the Years 1834, 5, 6, 7, 8 at the Cape of Good Hope*, published in London in 1847.

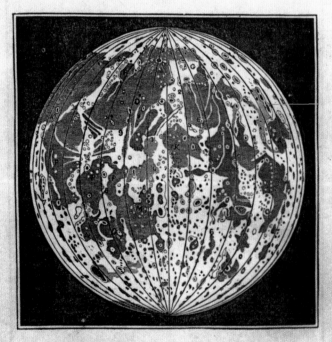

THE MOON,

AS SEEN BY

LORD ROSSE'S TELESCOPE.

1856.

THE

MOON HOAX;

OR,

A DISCOVERY THAT THE

MOON

HAS A VAST POPULATION OF

HUMAN BEINGS.

BY

RICHARD ADAMS LOCKE.

Illustrated with a View of the Moon,

AS SEEN BY LORD ROSSE'S TELESCOPE.

"The clouds still rested on one half of it, insomuch that I could discover nothing in it; but the other appeared to me a vast ocean planted with innumerable islands, that were covered with fruits and flowers, and interwoven with a thousand little shining seas that ran among them. I could see persons dressed in glorious habits with garlands upon their heads, passing among the trees, lying down by the sides of fountains, or resting on beds of flowers; and could hear a confused harmony of singing birds, falling waters, human voices, and musical instruments. Gladness grew in me upon the discovery of so delightful a scene. I wished for the wings of an eagle, that I might fly away to those happy seats; but the genius told me there was no passage to them except through the gates of death that I saw opening every moment upon the bridge."

ADDISON.

NEW YORK:

WILLIAM GOWANS,

1859.

A VIEW OF
THE INHABITANTS OF THE MOON,
AS SEEN THROUGH THE TELESCOPE OF SIR JOHN HERSCHEL.

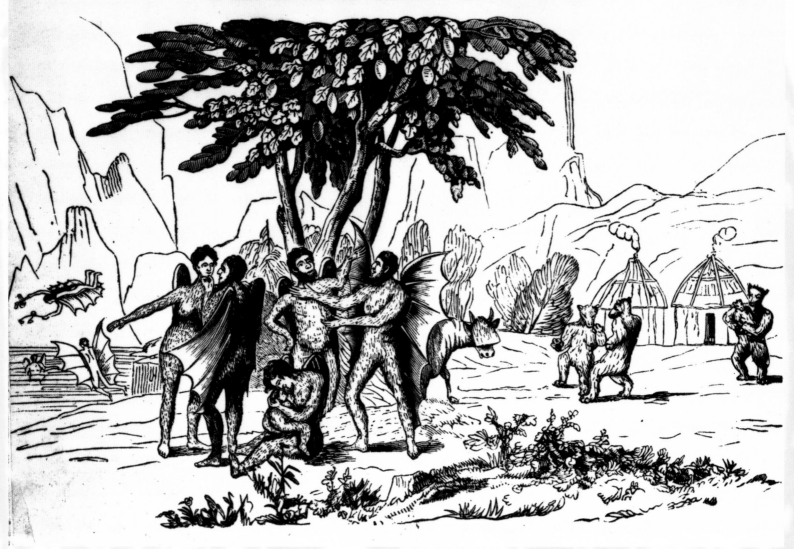

The inhabitants of the Moon as seen through the telescope of Sir John Herschel as interpreted by the *Sun*.

LEFT: Lunar scene, inspired by the hoax, published in Naples in April 1836.

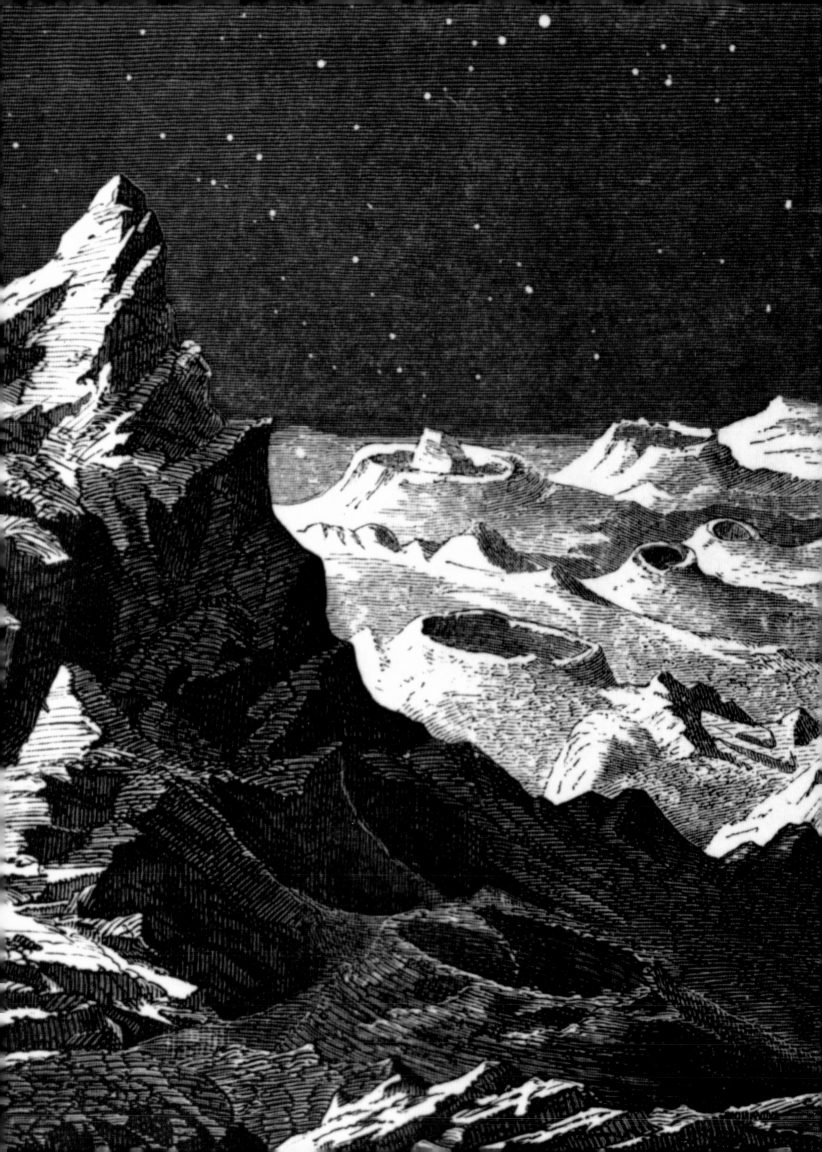

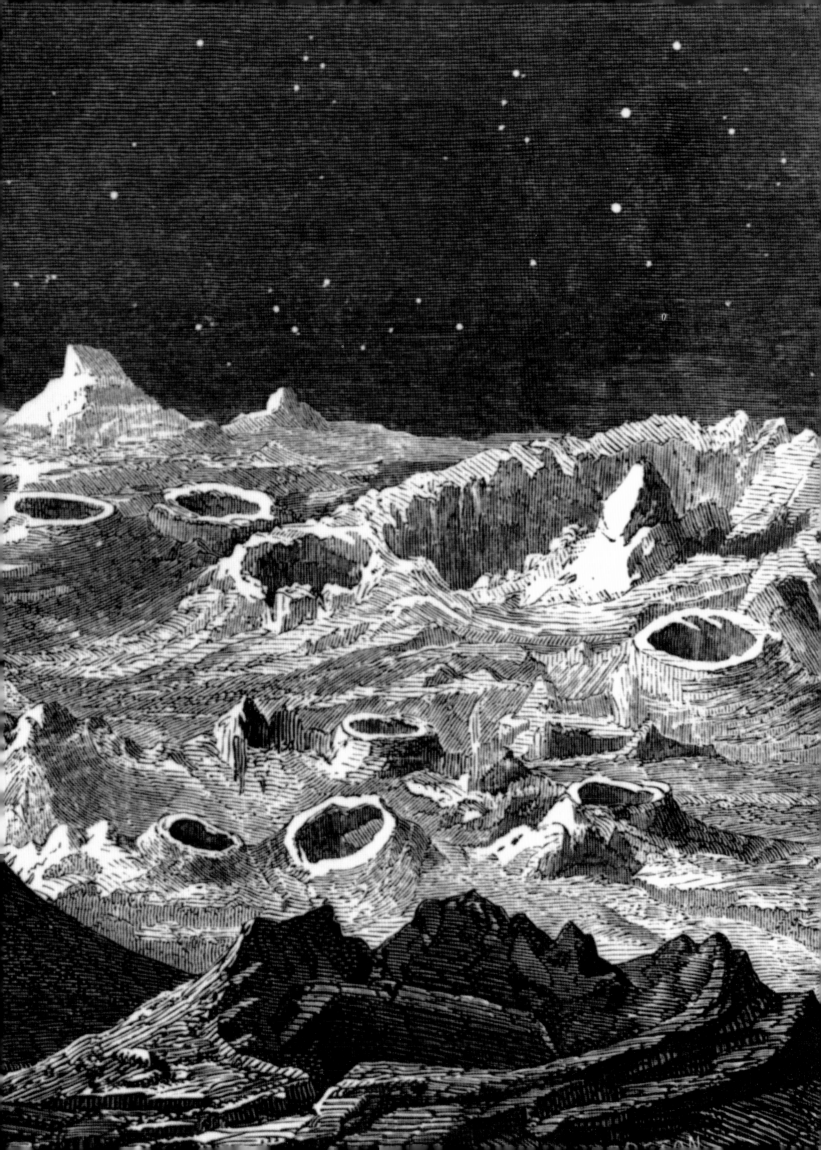

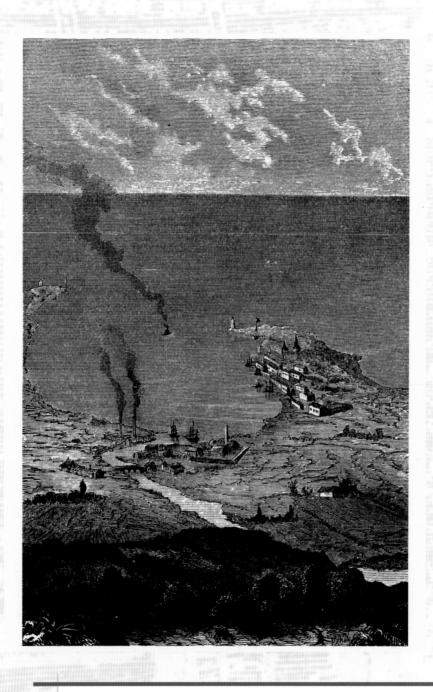

In 1865, Jules Verne publishes his *De la terre à la lune* (*From the Earth to the Moon*) and in 1870 the sequel *Autour de la lune* (*Around the Moon*). His plan was to build an enormous cannon called the Columbiad and place it vertically in a 900-foot-deep shaft completely lined with stonework. The location: Stony Hill (now North Port), east of Tampa-Town, Florida (today, simply Tampa). Verne's launch site for the Moon voyage is less than 140 miles from the site of Apollo launches at Cape Canaveral during the 1960s and '70s.

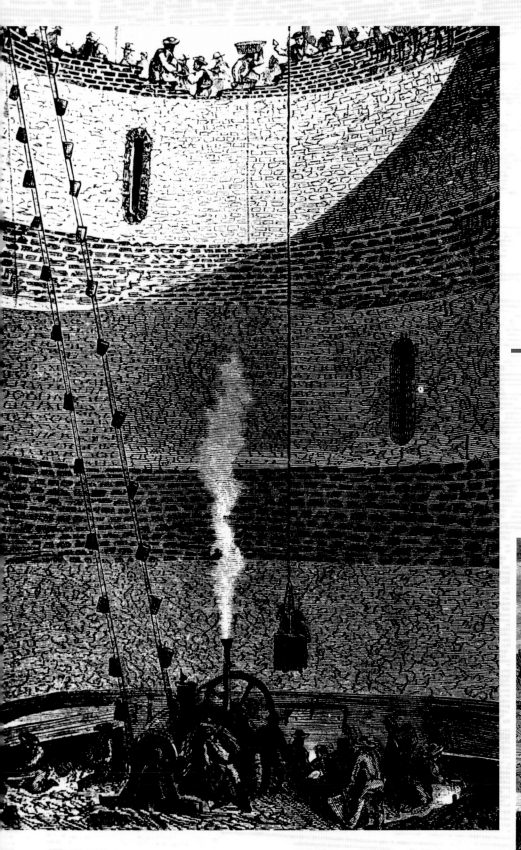

Preparing the shaft into which Columbiad will be placed.

"I want a cannon a half-mile long at least!" Ultimately, a length of 900 feet is approved.

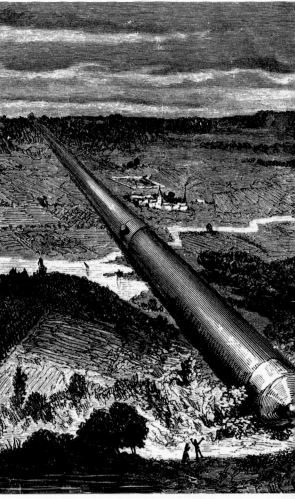

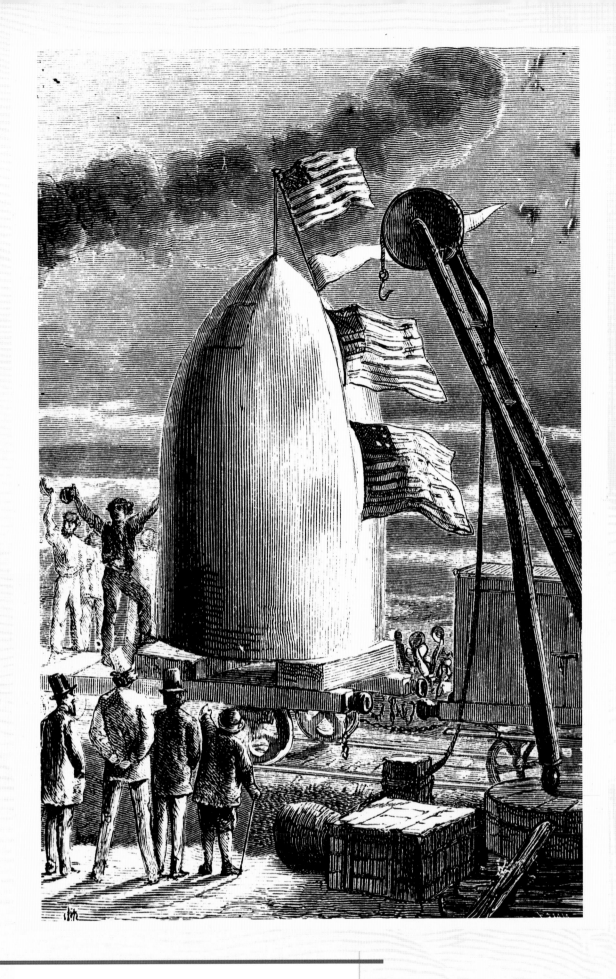

"No one could deny . . . it was a beautiful piece of metal." The completed vehicle-projectile (*wagon-projectile*) ready to carry three adventurers into space.

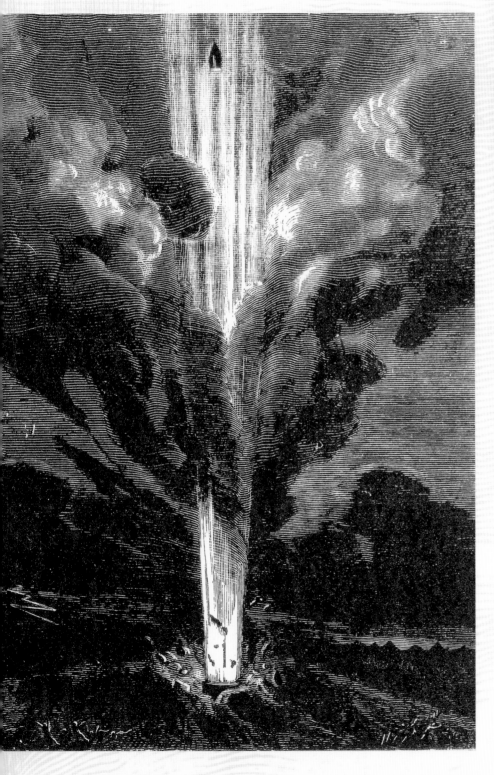

" ... They had to load the vehicle-projectile with all the things they needed for the trip."

"An awesome silence fell over the scene. Not a breath of wind on the face of the earth! Not a breath escaped from any chest! Hearts stopped beating. Every anxious eye was fixed on the gaping mouth of the Columbiad." The count-up to forty had begun: "Thirty-five!-Thirty-six!-Thirty-seven!-Thirty-eight!-Thirty-nine!-Forty! Fire!!!" A century later, count-downs to zero would become the rule.

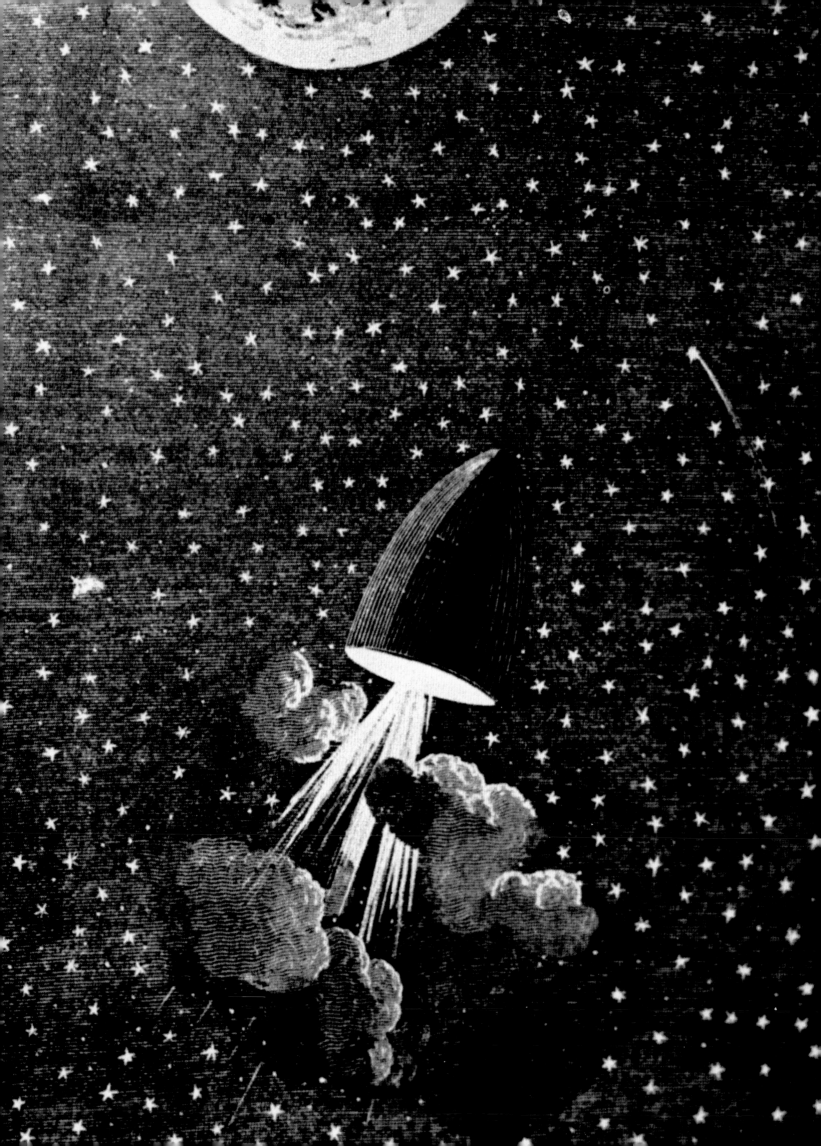

As the vehicle-projectile nears the Moon, passengers Impey Barbicane, Michel Ardan, and Captain Nicholl fire rockets to make the desired course adjustment. The craft later approaches to within 3,000 miles of the surface, loops around the Moon, and splashes down into the Pacific Ocean much like Apollo capsules a century later. The impact point is some 250 miles off the Californian coast.

Recovery of the spacecraft is accomplished by a small boat lowered from the U.S. Navy corvette *Susquehanna* in the background. The voyage is over!

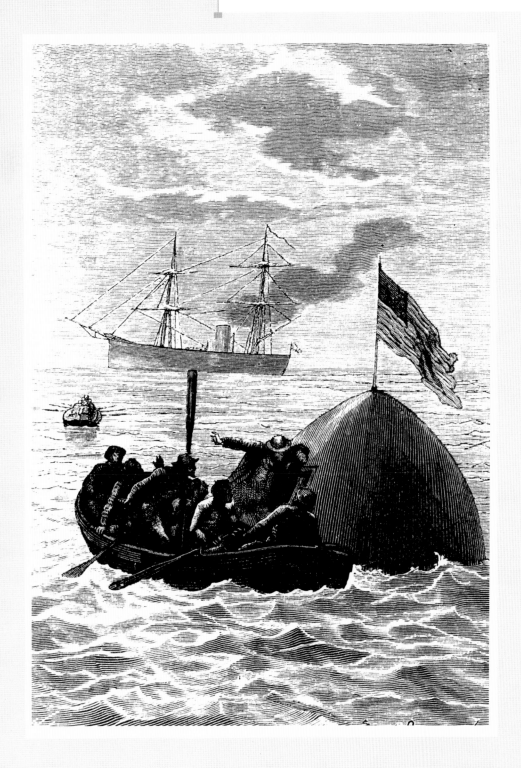

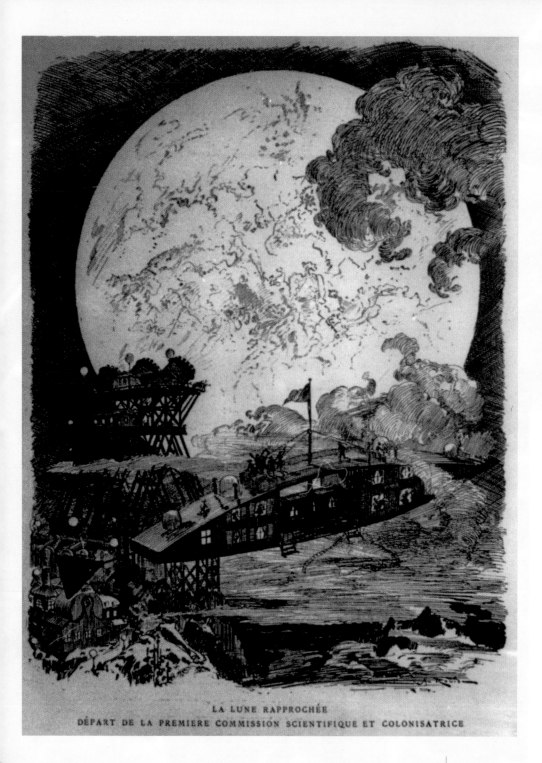

LA LUNE RAPPROCHÉE
DÉPART DE LA PREMIÈRE COMMISSION SCIENTIFIQUE ET COLONISATRICE

THE

ATLANTIC MONTHLY.

A Magazine of Literature, Science, Art, and Politics.

VOL. XXIV. — AUGUST, 1869. — NO. CXLII.

THE BRICK MOON.

[From the Papers of Captain Frederic Ingham.]

I.

PREPARATION.

I HAVE no sort of objection now to telling the whole story. The subscribers, of course, have a right to know what became of their money. The astronomers may as well know all about it, before they announce any more asteroids with an enormous movement in declination. And experimenters on the longitude may as well know, so that they may act advisedly in attempting another brick moon or in refusing to do so.

It all began more than thirty years ago, when we were in college; as most good things begin. We were studying in the book which has gray sides and a green back, and is called "Cambridge Astronomy" because it is translated from the French. We came across this business of the longitude, and, as we talked, in the gloom and glamour of the old south middle dining-hall, we had going the usual number of students' stories about rewards offered by the Board of Longitude for discoveries in that matter, — stories, all of which, so far as I know, are lies. Like all boys, we had tried our hands at perpetual motion. For me, I was sure I could square the circle, if they would give me chalk enough. But as to this business of the longitude, it was reserved for Q. to make the happy hit and to explain it to the rest of us.

I wonder if I can explain it to an unlearned world, which has not studied the book with gray sides and a green cambric back. Let us try.

You know then, dear world, that when you look at the North Star, it always appears to you at just the same height above the horizon or what is between you and the horizon: say the Dwight School-house, or the houses in Concord Street; or to me, just now, North College. You know also that, if you were to travel to the North Pole, the North Star would be just over your head. And, if you were to travel to the equator, it would be just on your horizon, if you could see it at all through the red, dusty, hazy mist in the north, — as you could not. If you were just half-way between pole and equator, on the line

Albert Robida, a contemporary of Jules Verne, himself wrote in the same genre and prepared his own illustrations. Here, we witness the departure of the "First Scientific and Colonizing" expedition to the Moon (early 1870s).

While Verne is sending his space travelers to the Moon, the American Edward Everett Hale tells his readers about a "Brick Moon," a manned satellite placed into orbit around the Earth using two huge flywheels. Published in *Atlantic Monthly* in 1869-70, Hale's brick satellite is 200 feet in diameter and is placed in a polar orbit 5,000 miles high to serve as a navigational aid for sailors. Opening page in the August 1869 issue of the magazine.

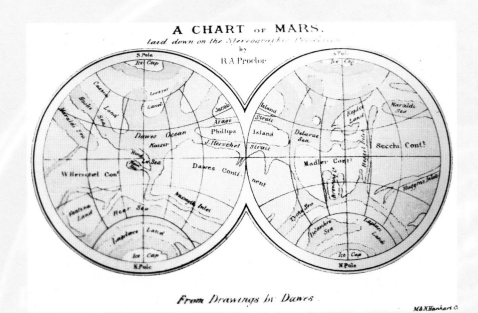

A CHART of MARS.
laid down on the Stereographic Projection
by
R.A.Proctor

From Drawings by Dawes.

By the time we reach the 1870s, another planet begins to attract our attention: Mars. In 1872, astronomer R.A. Proctor publishes this map based on a drawing by Dawes.

Then, during the Mars opposition of 1877-88, the Italian astronomer Giovanni Virginio Schiaparelli detects what he calls *canali*—naturally appearing channels or grooves. This is his *mappa aerographica* of the planet.

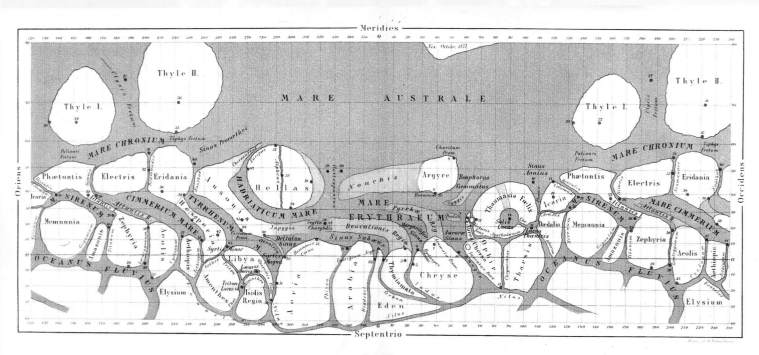

Tab. III

MAPPA AREOGRAPHICA
Exhibens Planetæ Martis Chorographiam inter Polum Australem et Parallelum 40°
Latitudinis Borealis;
Ex propriis Observationibus atque Mensuris ope Tubi Merziani decempedalis
in Speculâ Braydensi Mediolani habitis
composuit, supputavit, atque delineavit J.V. Schiaparelli

1877 — 1878.

MARTE

secondo le osservazioni fatte col Tubo Equatoriale della Specola di Brera, Settembre 1877 _ Marzo 1878.

I . ω = 0° II . ω = 90°

This drawing of the planet is based on observations at Schiaparelli's Brera Observatory in Milan conducted between September 1877 and March 1878.

Inspired by the Schiaparelli observations, Camille Flammarion gave his readers a series of fascinating landscapes of Mars and other worlds in his *Les terres du ciel* (*Earths of the Heavens*, 1884). Here we see sunrise over the canals of Mars ...

... and witness the formation of Martian clouds from a manned balloon.

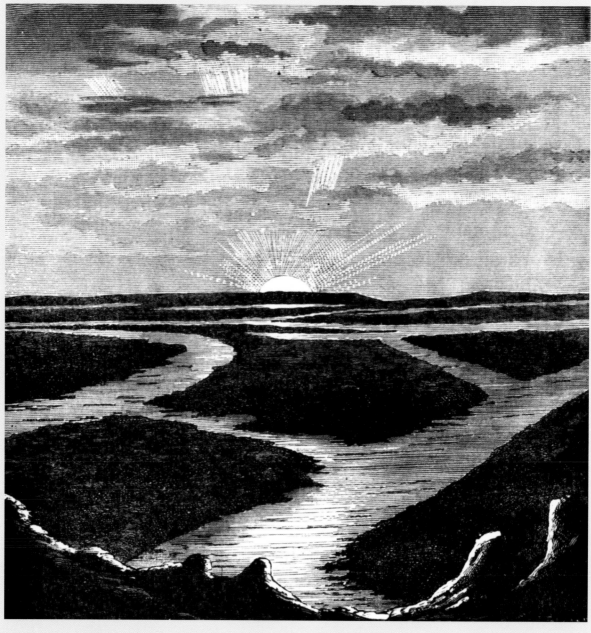

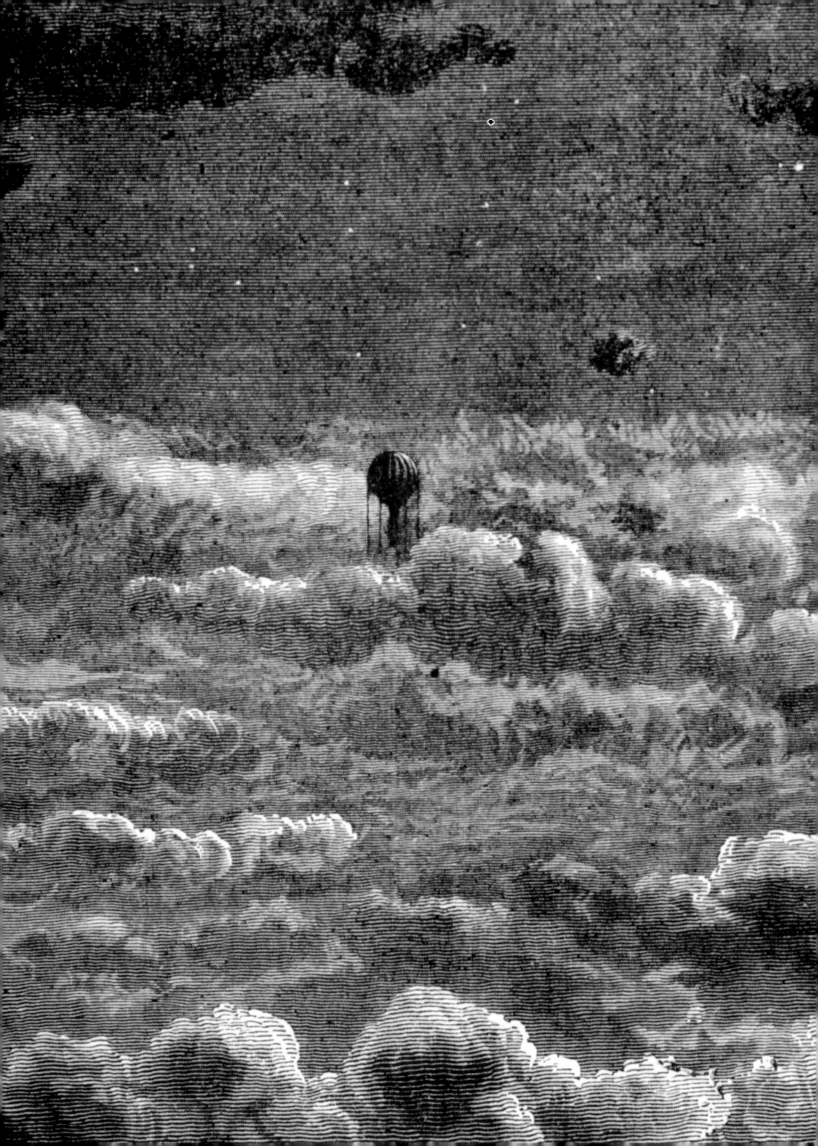

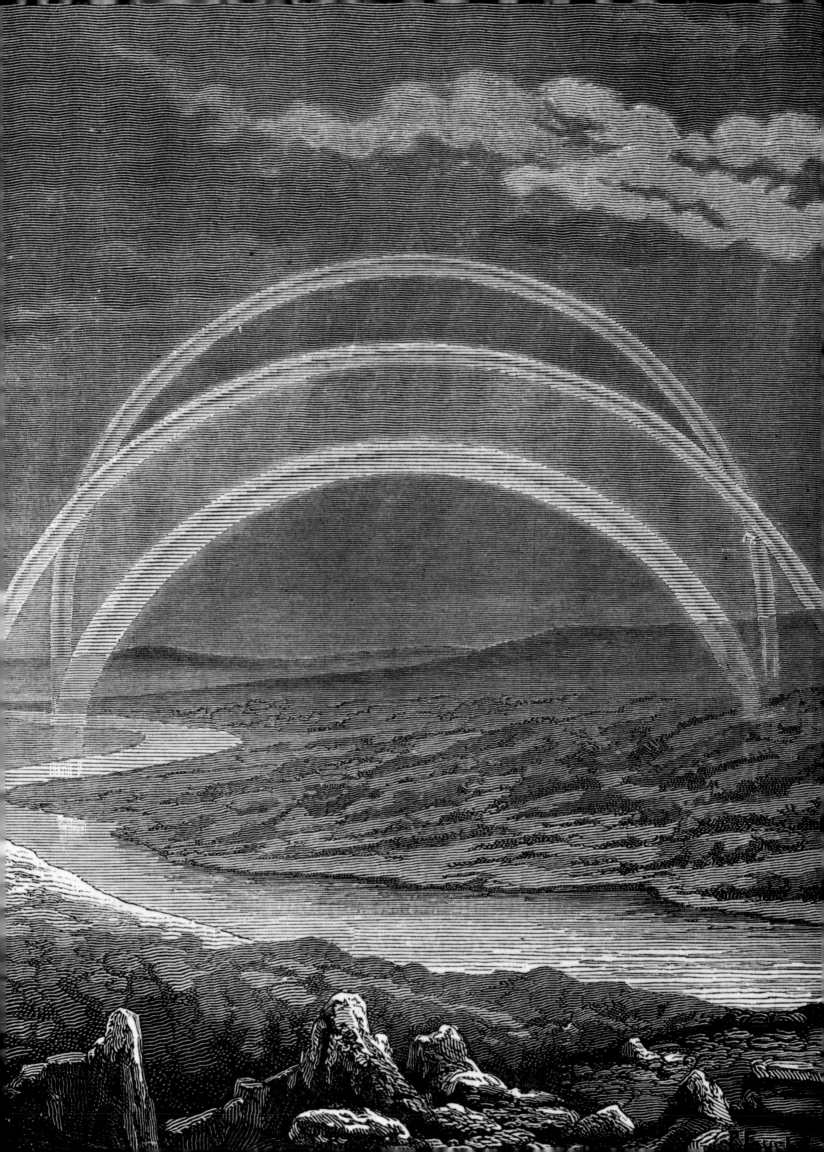

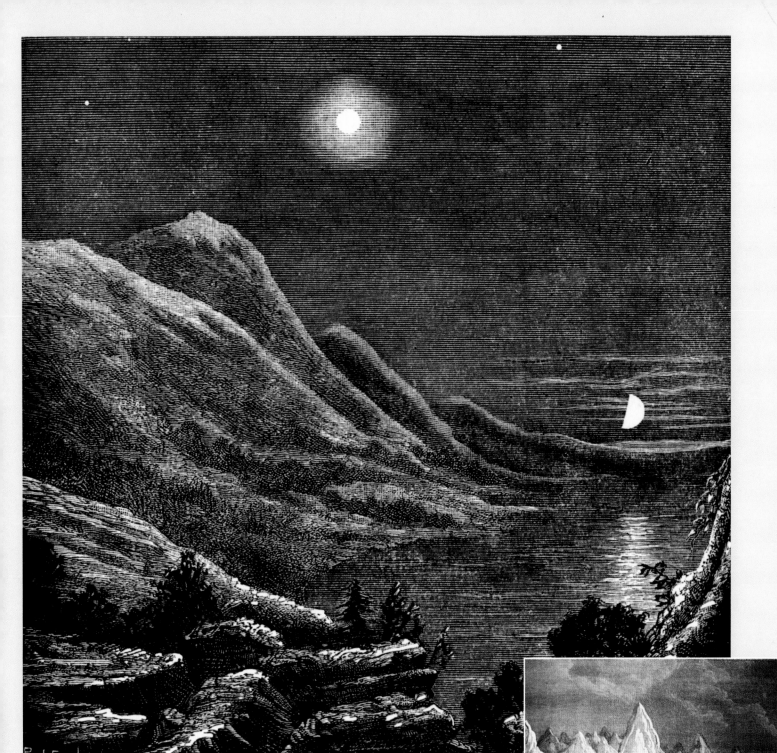

Going further into space, we see what Flammarion calls
"aerial optical effects" on Mercury

"Nights on Jupiter always have moonlight, and are often
illuminated by two or three moons." (Flammarion) . . .

. . . And a scene on the surface of Venus.

Two views of the lunar surface, with "new"
and "full" Earths hanging in the sky.

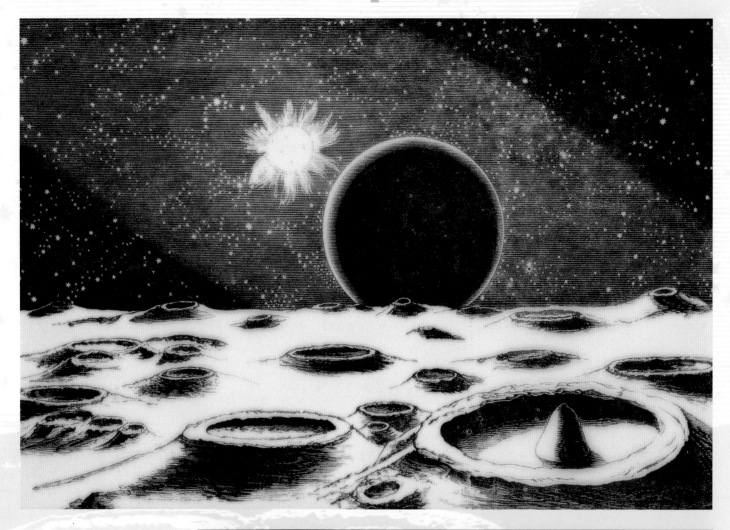

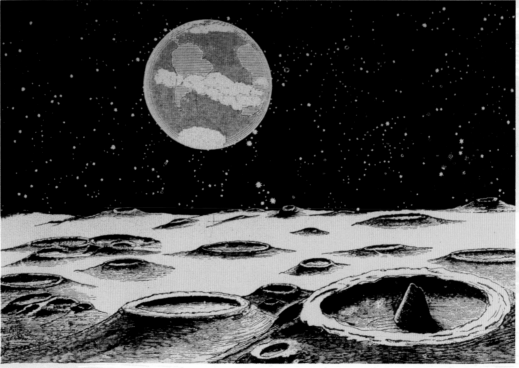

mite, la panclastite, **la forcite, la roburite,** le picrate, **la mé-**
linite.......

— **Tous ces noms vont nous faire sauter!** interrompit Tom.

— Je serai fier, continua le professeur, de faire connaître à
l'Académie de Boston un agent explosif bien supérieur à tous
ceux que nous connaissons..........

L'Obusier et le projectile.

— **Et comment le nommerez-vous?** demanda Landal.

— **La Vénusite!**.... en souvenir de ce monde merveilleux.....
Ce que je veux surtout faire connaître, c'est l'application de cet
agent comme force motrice à la place de la vapeur.

— **Votre découverte ne sera pas absolument neuve sur Terre,**
reprit Landal: on a déjà pensé à faire marcher un bateau au
moyen d'un mélange explosif. Un de mes compatriotes, M Just
Buisson, est l'inventeur de cet appareil qui était mis en mou-
vement par une force de recul que fournissait une série d'explo-
sions successives. Sa machine a d'abord parfaitement fonc-
tionné; et s'il a péri victime de son invention, c'est à la suite
d'une simple imprudence.

— **Je connais ces tentatives,** dit Samuel Dixton; je sais même

During the closing years of the 19th century, many novels appear, inspired and influenced by Jules Verne. In 1887, André Laurie (Paschal Grousset) publishes his *Les exilés de la terre* (*Exiles from the Earth*) The novel's protagonists rely on an immense electromagnet in the Sahara to pull the Moon downward to give it an Earthlike atmosphere and at the same time make it more accessible to explorers.

A year later, Charles Guyon's *Voyage dans la planète Vénus* appears. As in Verne's tale, a giant cannon fires a projectile into space.

COUPE DU WAGON CÉLESTE L'*OSSIPOFF*.

A. Fourneau du laboratoire. — B. Batterie de piles électriques. — C. C. C. Hamacs roulés et accrochés aux parois. — D. Appareils de chimie. — E. Porte-bouteilles d'oxygène. – F. F. F. Caisses, provisions, etc. — K. Lustre électrique. — L. Bureau. — M. Bibliothèque. — N. Commode, toilette et armoire. — R. Compartiment à air comprimé. — T. Divan avec couchettes roulées. — V. V. V. Hublots pour voir au dehors.

24 24

Between 1889 and 1891, Georges Le Faure and Henry de Graffigny (Raoul Marquis) publish a remarkable series of books under the overall title *Aventures extraordinaires d'un savant russe* (*The Extraordinary Adventures of a Russian Savant*). Vol. I (1889) is subtitled *La Lune* (*The Moon*), Vol. II (1889) *Le Soleil et les petites planètes* (*The Sun and the Small Planets*), and Vol. III (1891) *Les planètes géantes et les comètes* (*The Giant Planets and Comets*). A fourth volume, announced by the publisher Edinger in 1891 as *Les mondes stellaires* (*Stellar Worlds*) did not appear; but, in 1896, did from another publishing house as *Le désert sidéral* (*The Sidereal Desert*). It is extremely rare. In cross section we see the L'Ossipoff, the lunar-bound spacecraft from Vol. I.

Paysage vénusien.

81 81

A Venusian landscape from Vol. II.

A scene on Uranus from Vol. III.

79

We turn to Wilhelm Meyer's *Diesterwegs Populäre Himmelskunde*, a popular astronomy published in 1890, for this lovely view of Jupiter from one of its moons.

At about the same time, also in Germany, Hermann Ganswindt had designed a spaceship whose passenger cabin is at the bottom and engine above; the exhaust passing through an opening in the middle of the cabin. A rather unlikely configuration.

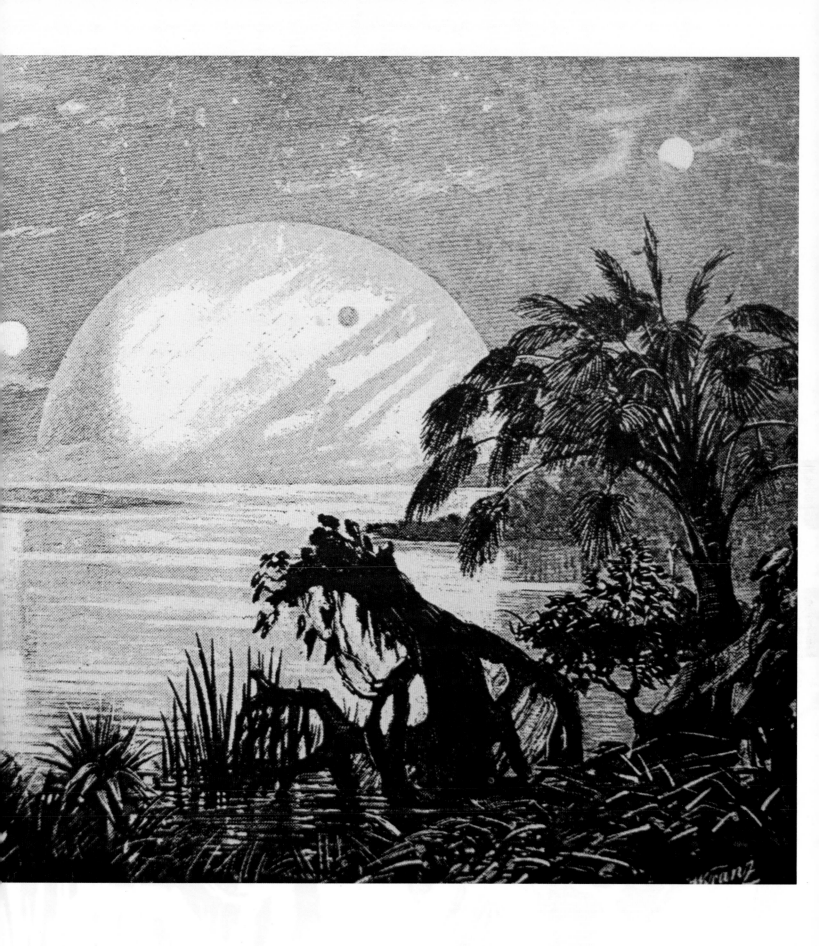

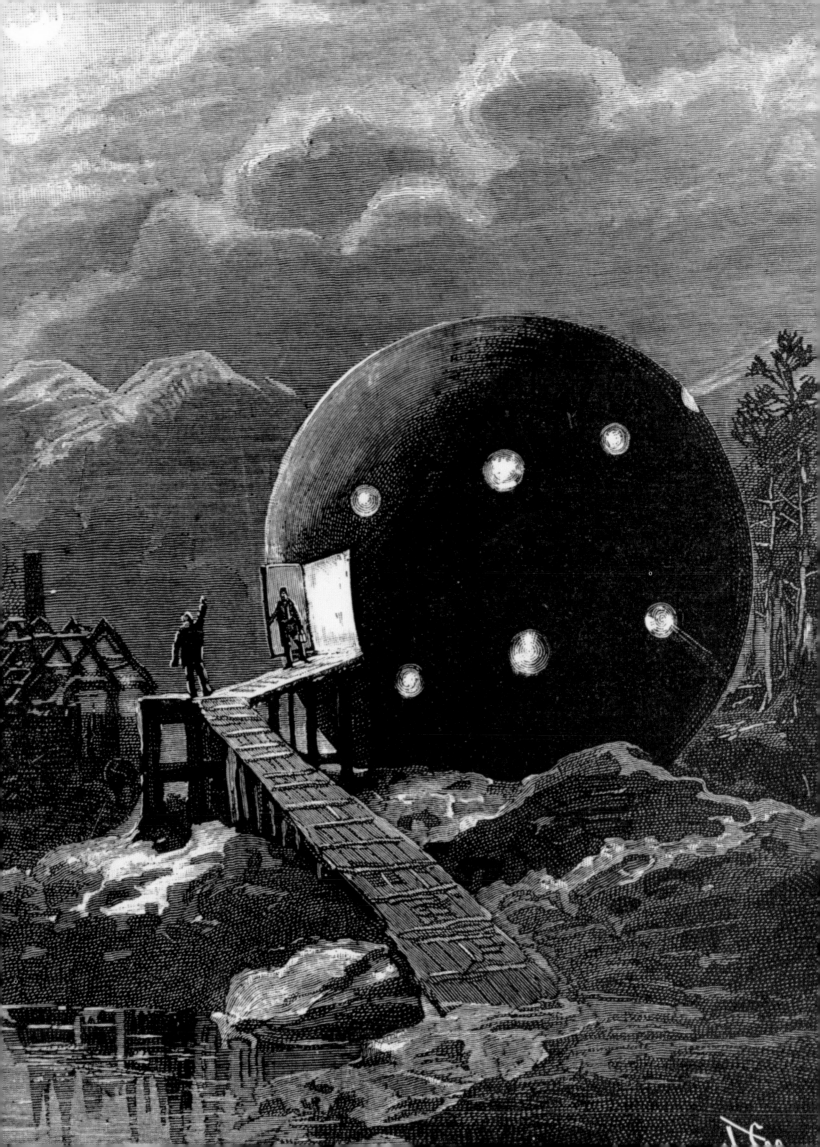

In 1891, Robert Cromie's *A Plunge into Space* is published with a frontispiece illustrating a steel-globe-shaped spaceship. Designed for travel to Mars, it relies on an anti-gravity scheme for propulsion. The globe is 50 feet in diameter, painted black, and fitted with portholes.

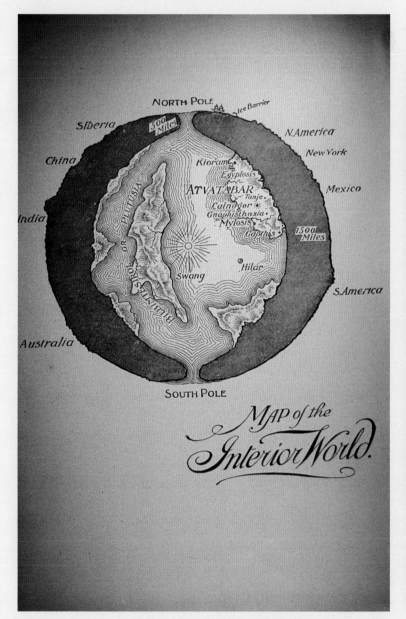

In *The Goddess of Atvatabar* by William R. Bradshaw (1892), a race of people inhabiting a hollow Earth is discovered. LEFT: a map of the interior world; RIGHT: a ship flies through a canyon with large waterfall. Stories like this hark back to Paltock and were inspired by the search for new worlds in space.

Four scenes from A. de Ville d'Avray's *Voyage dans la lune avant 1900*
(*Travel to the Moon Before 1900*), which was published in Paris in the early
1890s. In this children's book, a dream voyage to the Moon in a balloon takes
place where the travellers find all manner of strange creatures and sights.

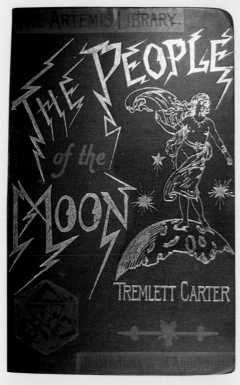

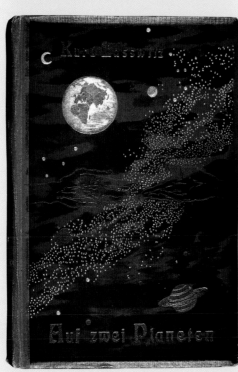

The People of the Moon by Tremblett Carter (1895) featured all manner of flying machines used by people who live in the interior of our satellite.

The novel that inspired Wernher von Braun and other 20th century German spaceflight enthusiasts is Kurd Lasswitz's *Auf zwei Planeten* (*On Two Planets*), published in Leipzig in 1897. It is the Martians who come to Earth, not the other way around. Not only do they have a base at the North Pole but a space station 3,800 miles above it.

Pierre de Sélènes's (A. Bétolaud de la Drable) story of two years on the Moon *Un Monde inconnu: Deux ans sur la lune* (1896). It contains numerous illustrations by Gerlier, including this one of an observation platform with the Earth in the lunar sky.

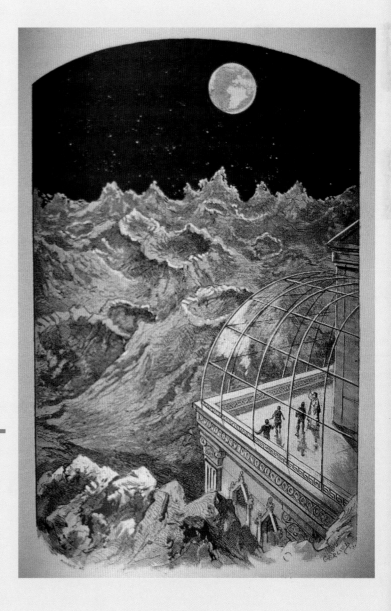

John Jacob Astor's spaceship Callisto is powered by "apergy," an anti-gravity material, in his 1894 book *A Journey to Other Worlds*. Here, the ship soars above New York en route to Jupiter and Saturn. Fifteen feet high and 25 in diameter, it is enclosed with windows adorned with shades and lace curtains. Launch is planned for December 2000.

Livre

Premier

L'arrivée des
Marsiens

H.G. Wells' famed *The War of the Worlds* first appeared serialized in *Pearson's Magazine* between April and December 1897 and came out in both English and American book form a year later. Martians invade Earth in huge cylinders, here seen advancing towards Windsor Castle.

Nearly a decade later, in 1906 in Brussels, a large-format French-language edition appeared entitled *La Guerre des mondes* with 28 plates and 101 text illustrations designed by Henry Alvim-Corrêa. Here is the image for the first section, "The Arrival of the Martians."

Departure of a Martian space vehicle whose destination is our unsuspecting planet.

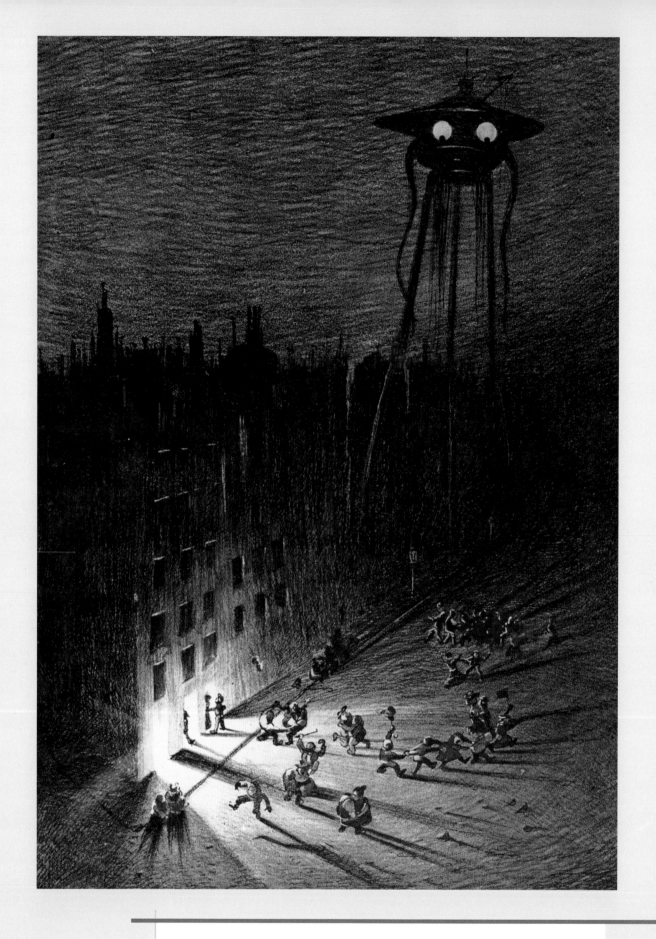

Martian invaders armed with death rays and poison-gas tubes terrorize the citizenry in the Regent Street/Picadilly area of London.

Eventually the Martian machines are dismantled after their fragile crews succumb to terrestrial bacterial infections for which they have no defense.

Between 1895 and the first decade of so of the 20th century, Percival Lowell promoted the idea that Schiaparelli's *canali* were artificially constructed canals designed to move polar meltwaters to the supposedly inhabited equatorial and mid-latitude regions of Mars. This view, from his Mars (1895), shows a typical network connecting what he described as a "singularly correlated system of spots," which, he ventured, are "...oases in the midst of the desert...and oases not innocent of design... For here in the oases we have an end and object for the existence of the canals, and the most natural one in the world, namely, that the canals are constructed for the express purpose of fertilising the oases."

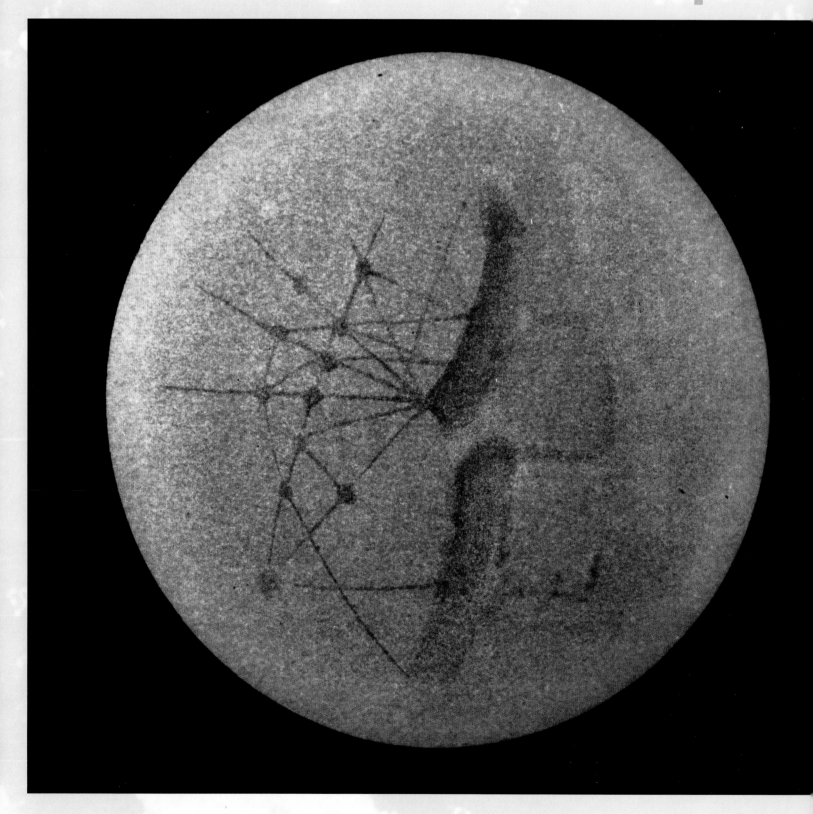

origin of the canals, but with a date determining when it took place. The date marks a late era in the planet's development, one subsequent to any the

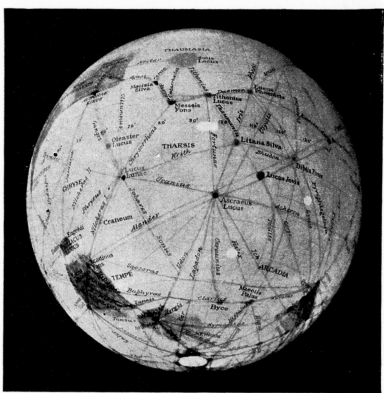

HEMISPHERE SHOWING THE OASIS CALLED ASCRAEUS LUCUS

From this radiate many canals. Also in the upper right-hand space is shown the continuation of the Eumenides-Orcus.

earth has yet reached. This accounts for the difficulty found in understanding them, for as yet we have nothing like them here.

Oases. Next in interest to the canals come the oases.

By the time his *Mars as the Abode of Life* was published in 1908, Lowell had prepared this map of canals (some double) and oases.

PART V: **1900-1950**

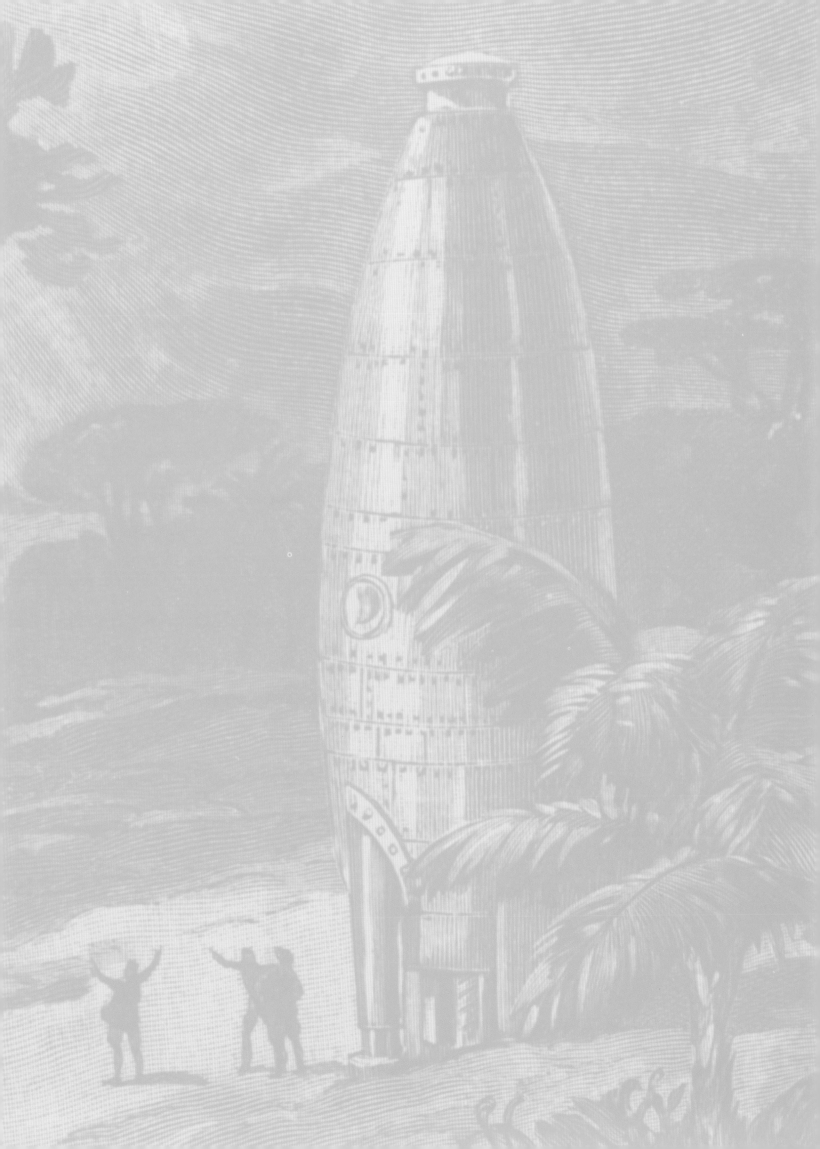

By the end of the 19th century and the beginning of the 20th, four pioneers of spaceflight realize that only with rockets can people journey to other worlds. They are Konstantin E. Tsiolkovsky of Russia, Robert H. Goddard of the United States, Robert Esnault-Pelterie of France, and Hermann Oberth from a German-speaking sector of Transylvania.

Although rockets had been around since at least the 13th century in China, the writers of lunar and planetary tales rarely think of them as propulsion devices. Off-handedly, Cyrano stumbles on the idea and Jules Verne uses them for course correction in his Earth-to-the-Moon novels. But neither views them as essential. This Chinese "fire arrow" is one of the earliest known rockets.

From the Orient, rocket technology spread south and west. Here is a rocket-propelled fireworks display of 1667 at Pleissenburg in Germany.

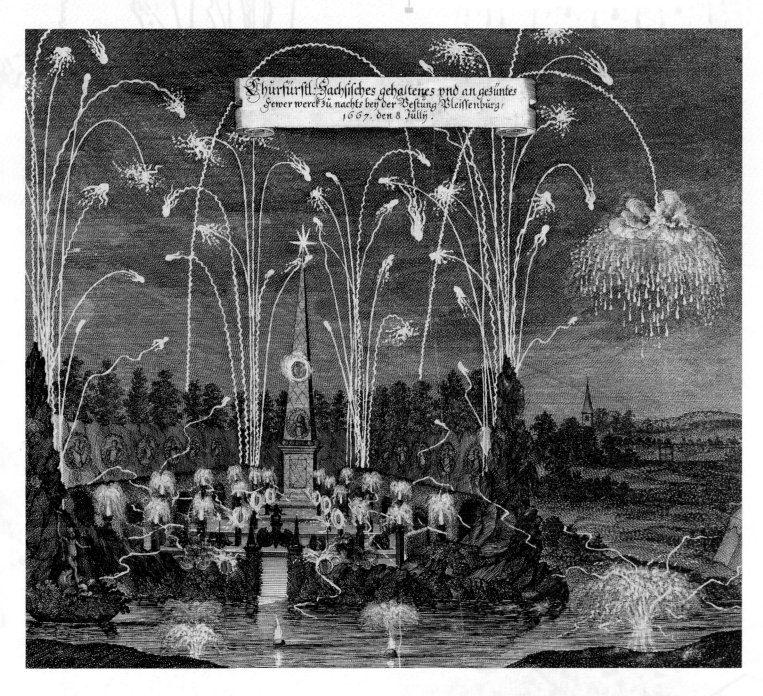

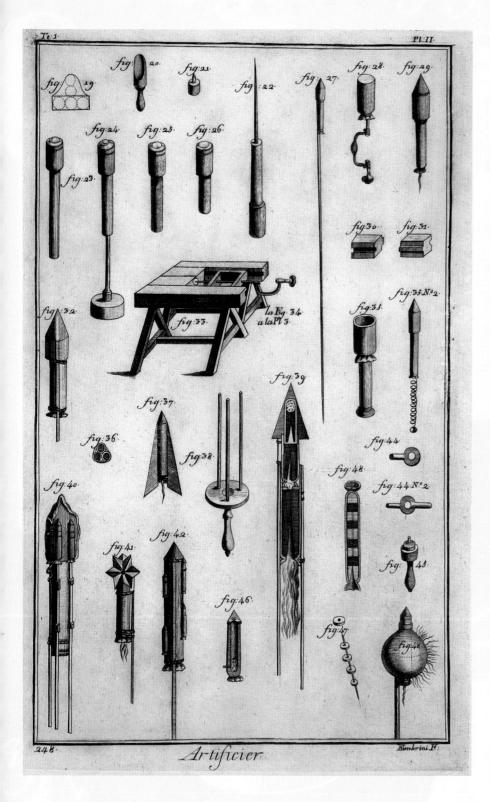

By the 18th century, rockets are being illustrated and described in pyrotechnic manuals and other sources. This image, dated 1762, is from the *Diderot and D'Alembert Encyclopédie, ou Dictionnaire Raisonné . . .* published between 1751 and 1780. Notice the delta-winged three-stage rocket at lower center.

Rockets enter military service in India, much to the consternation of the occupying British. This illustration of a Bengal Army Rocket Corps in 1817 was published two years later in George Fitzclarence's *Journal of a Route Across India*.

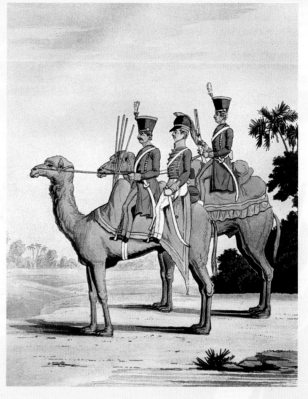

Published by J. Grant, Woolwich to illustrate the Army and Navy Register and Woolwich Gazette for 1846.

ROCKET PRACTICE IN THE MARSHES.

Indian war rockets soon come to the attention of William Congreve at the Royal Laboratory at Woolwich, England. Impressed, he quickly adapts and improves them for use by both the British army and navy. His portrait, as Major-General Sir, was painted in 1830 by James Lonsdale, a founder of the Society of British Artists.

Congreve rockets see frequent service by the British army units in European and colonial wars. Other nations soon acquire them for their own purposes.

OVERLEAF: The navy, too, find Congreve rockets helpful in ship-to-shore bombardment, illustrated by this engagement against Algiers in 1845. They are fired from small "rocket boats."

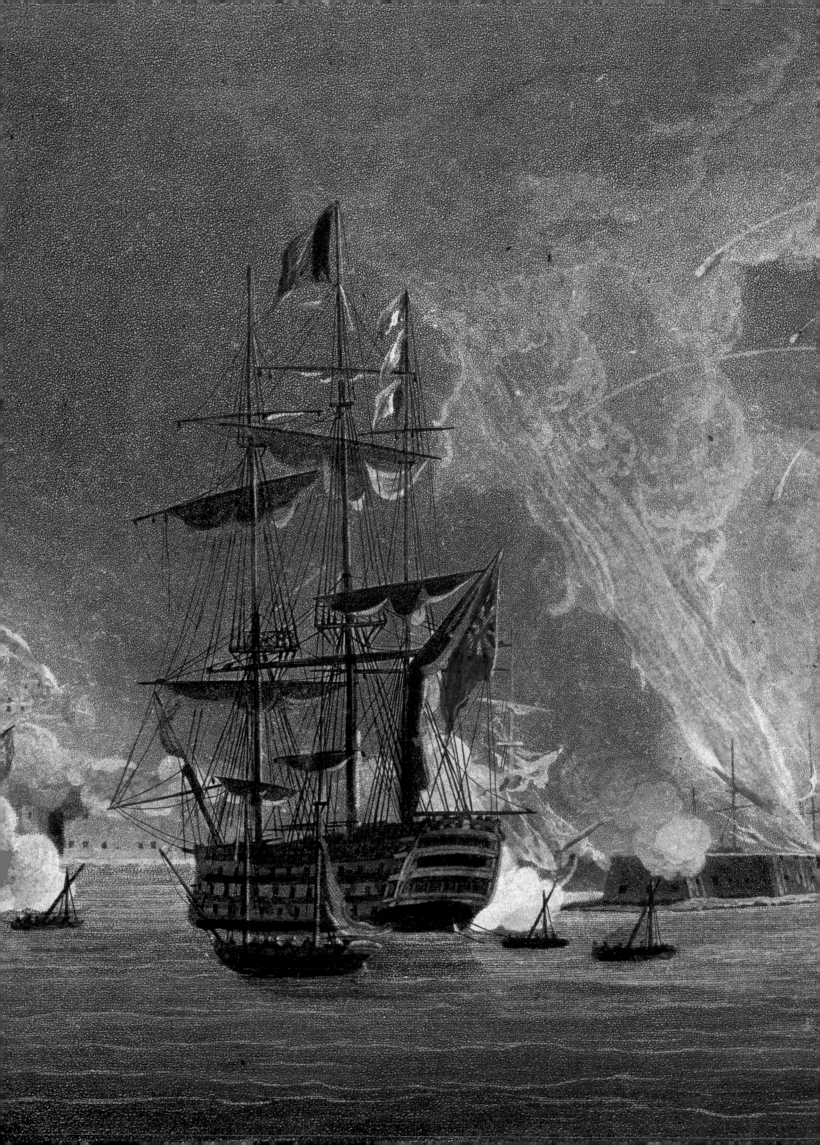

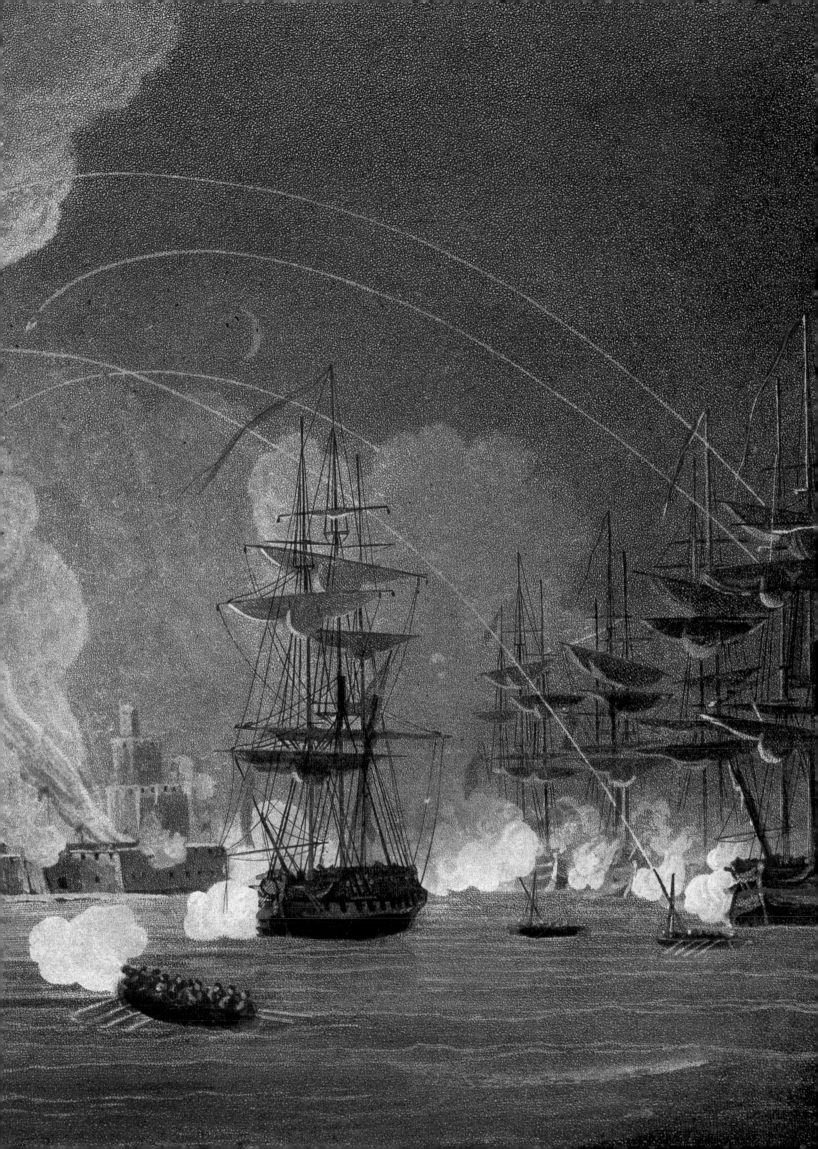

Even though rockets had been around for centuries, some time would must pass before spaceflight dreamers catch on. Compressed air launches this projectile off to Mars (*La Nature*, 1901).

That same year, H.G. Wells, in *First Men to the Moon*, introduces "cavorite," a gravity-shielding material invented by the book's principal character, Mr. Cavor. It is a substance opaque to "... all forms of radiant energy.... anything like light or heat or those Röntgen rays ... or the electric waves of Marconi, or gravitation." This image reveals the shuttered framework of the space vehicle.

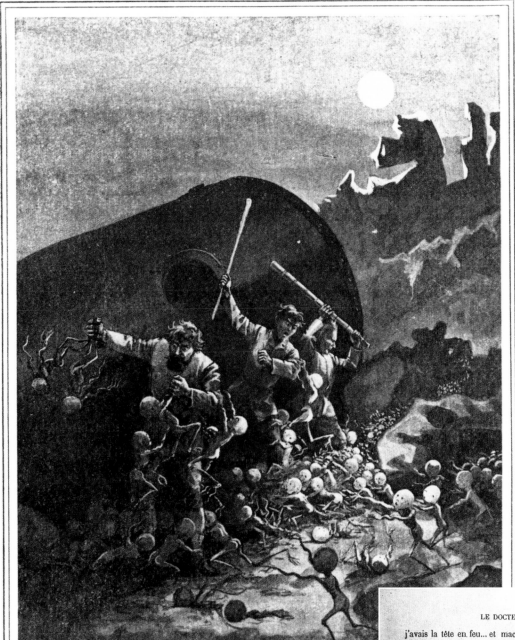

Ces nains étaient d'une structure si fragile que bientôt des cen[taines]
jonchèrent le sol (page 97).

j'avais la tête en feu... et machinalement je me dirigeai vers les décombres de mon hangar. Un plafond de bois supporté par quatre poutres s'élevait au milieu de ces ruines...

Sans songer au danger auquel je m'exposais, — je n'avais plus conscience de rien — je péné- trai sous ce dais vacillant qui pou- vait s'écrouler d'une minute à l'autre.

Tout à coup,

A l'aide de treuils et de chevalets on mit l'énorme projectile debout et, au moyen de chaînes et de cordages, on le fixa au sol (page 49).

en levant la tête, j'aperçus trois petites sphères de métal qui adhéraient à ce plafond... Je n'attachai pas tout d'abord beau- coup d'importance à cela... Ces blocs minuscules avaient sans doute été projetés avec le métal en fusion et s'étaient soudés aux planches qu'ils avaient rencontrées sur leur route... Rien n'était plus naturel.

Cependant je crus remarquer que ces sphères n'étaient pas immobiles et qu'elles sautillaient légèrement. Je me frottai les yeux et regardai avec plus d'attention.

Effectivement, elles remuaient...

Une table à moitié brisée se trouvait près de moi, je la

Another anti-gravity material, "repulsite," sends Arnould Galopin's explorers to Mars in the 1906 novel *Le Docteur Oméga: Aventures fantastiques de trois Français dans la planète Mars* (*Doctor Oméga: Fantastic Adventures of Three Frenchmen on the Planet Mars*). They are seen fending off tiny Martians out- side their spaceship. INSET: preparing the ship for launch from Earth.

H.G. Wells takes a different approach two years later in *Cosmopolitan* magazine. Tackling the subject of "The Things that Live on Mars," he postulates that "There are certain features in which they [the obviously intelligent Martians in the left image] are likely to resemble us, and as likely as not they will be covered with feathers or fur. It is no less reasonable to suppose," he continues, "instead of a hand, a group of tentacles or proboscis-like organs." Artist William R. Leigh has clearly let his imagination roam.

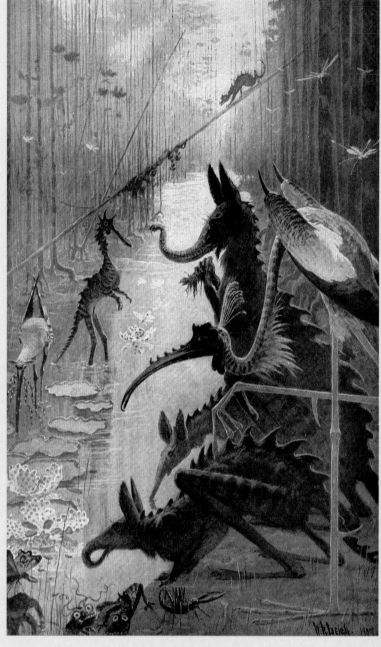

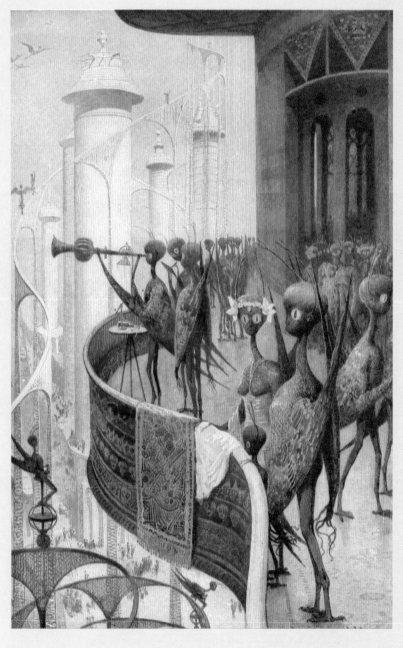

Mark Wicks dedicates *To Mars via Moon* (1911) to Percival Lowell, who no doubt was pleased to see canals radiating from the fictitious city of Sirapion. "... [T]his little book... is now submitted to the public," writes Wicks, "in the sincere hope that its perusal may serve not only to while away a leisure hour, but tend to nurture a love of the sublime science of astronomy..."

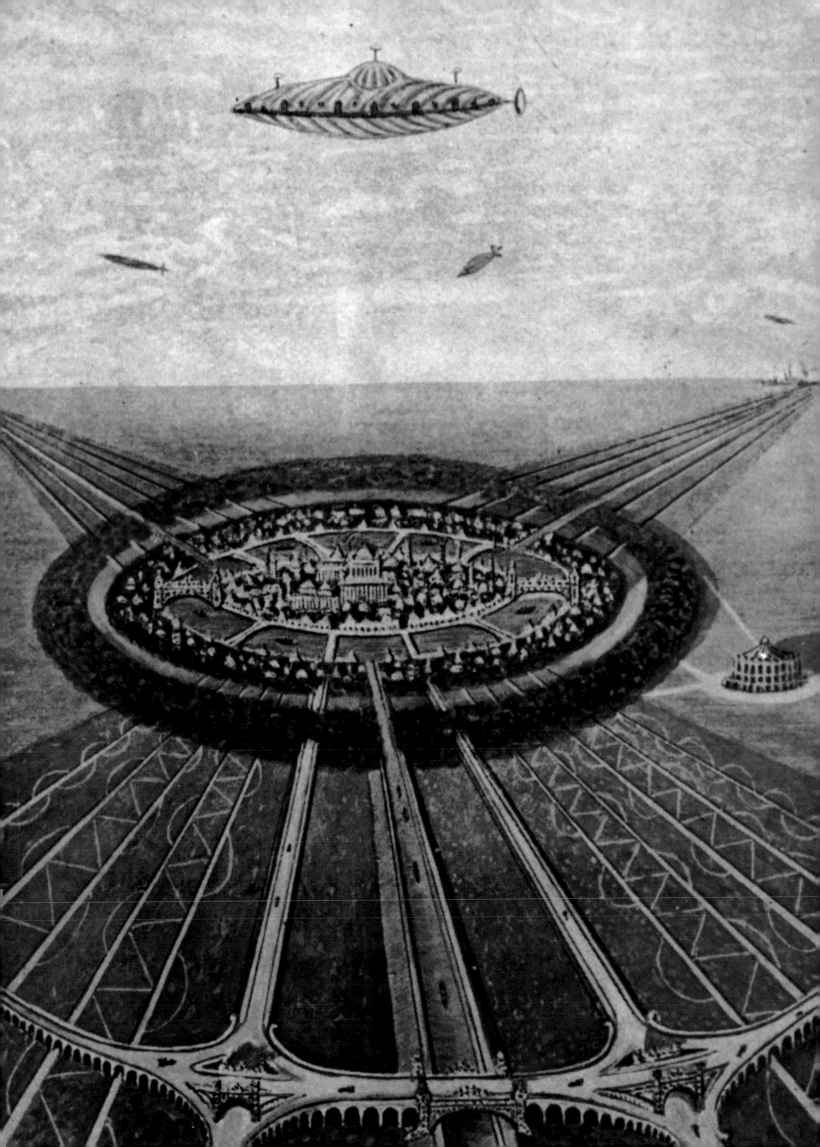

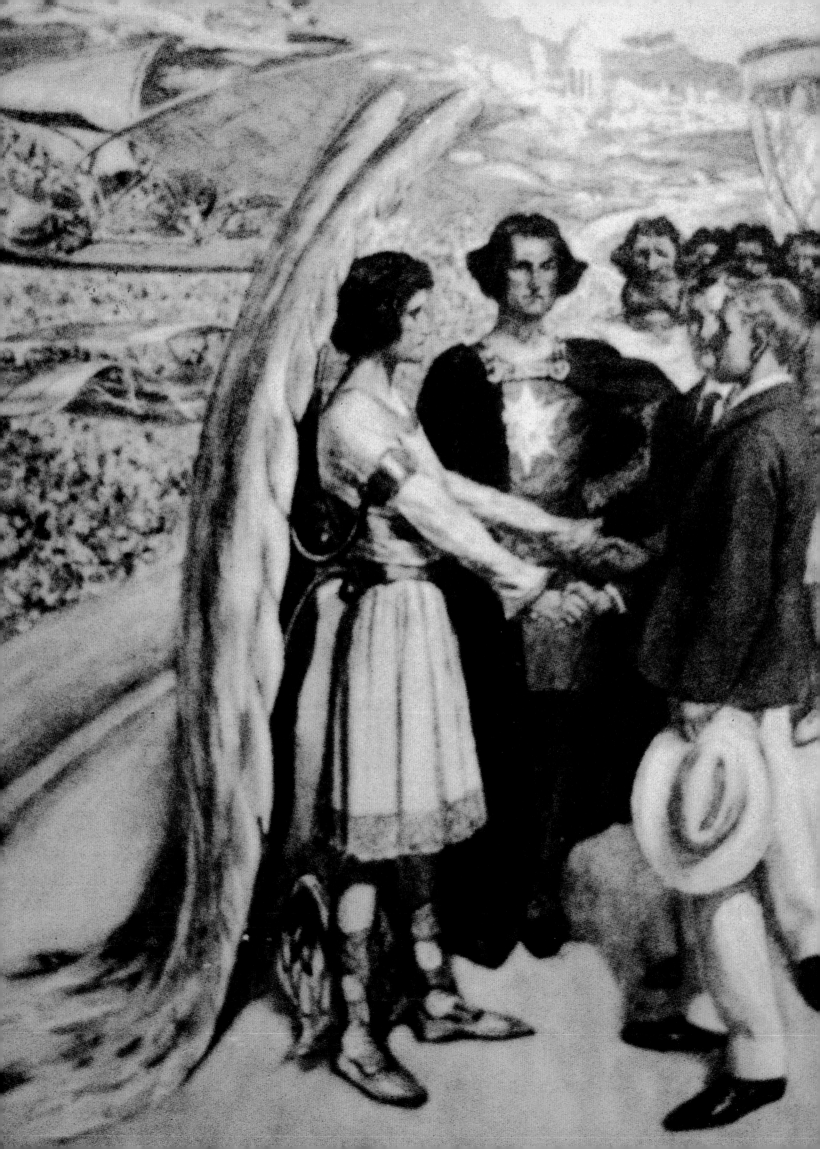

Fenton Ash (F. Atkins) provides a wrinkle by having humanoid Martians arrive on Earth and take back home with them members of our species (*A Trip to Mars*, 1909). This frontispiece by W.H.C. Groome shows how Martians attach wings to themselves for short flights or use aircraft for longer ones.

Edgar Rice Burroughs' first novel "Under the Moons of Mars" is serialized in *The All-Story* magazine (1912) under the pseudonym Norman Bean. Five years later, as *The Princess of Mars*, it becomes the first of many books set on what the Martians call Barsoom. Burroughs, like Wicks before him, is a convinced believer in a Lowellian red planet.

OVERLEAF: *On a Lark to the Planets* by Frances Trego Montgomery first appears in 1904. This colorful plate by Winifred E. Elrod from the 1914 edition reveals a busy canal scene on Mars, one of the stops young people make in their travels around the Solar System. Their conveyance: a balloon attached to a "Wonderful Electric Elephant," an unusual means of space travel, to say the least!

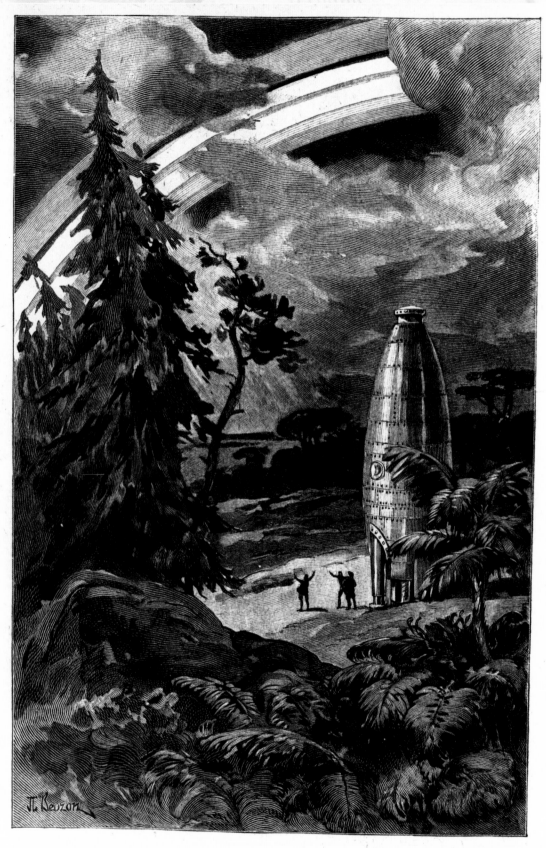

Un arc lumineux, immense, brillait sur le fond noir du ciel.

Miral-Viger's spaceship by J.-L. Beuzon stands upright under the rings of Saturn in *L'Anneau de feu* (*Ring of Fire*, 1922). The story revolves around a French expedition to Mars and Saturn whose technical passages draw on Robert Esnault-Pelterie's writings.

THE
ANTI-GRAVITATION
RAY

SEE PAGE 14

LARGEST CIRCULATION OF ANY ELECTRICAL PUBLICATION

The very next year, publisher Hugo Gernsback offers an all-fiction issue of his normally nonfiction *Science and Invention* magazine. He had been toying with science fiction in this and in his precursor magazines *Modern Electrics* and *Electrical Experimenter* to the point that by 1922 he was offering several fiction pieces. Now, in August 1923, Gernsback announces in large yellow letters the arrival of the *SCIENTIFIC FICTION NUMBER.* Cover artist Howard V. Brown was probably more than happy to accept this intrusion. The science fiction revolution has begun.

Gernsback has good reason to be pleased. His own science fiction story "Ralph 124C41+" had been serialized to great acclaim between April 1911 and March 1912 in *Modern Electrics*. It appears in book form in 1925. This illustration is by Frank R. Paul, who for years to come will remain a Gernsback regular.

RALPH'S ENCOUNTER WITH LLYSANORH' (Page 259)

Events move quickly. In April 1927, Gernsback launches *Amazing Stories* and in June 1929 *Science Wonder Stories*. Their front covers are quite familiar, having been reproduced with some frequency. Less well known are the pulps spawned in the 1930s and '40s by these initiatives. Among them are *Astonishing Stories*, *Dynamic Science Stories*, *Startling Stories*, and *Super Science Stories*.

10¢

ASTONISHING
STORIES

JUN

ROSS ROCKLYNNE

MALCOLM JAMESON

HE CONQUERED VENUS

15¢

DYNAMIC
SCIENCE STORIES

FEB.

LORD OF TRANERICA
complete novel by
STANTON COBLENTZ

MUTINEERS OF SPACE
novelet by
LLOYD ESHBACK

*PLUS OTHER
GREAT
STORIES*

A NOVEL OF THE FUTURE COMPLETE IN THIS ISSUE!

STARTLING
STORIES

MAR.

15¢

A THRILLING
PUBLICATION

FEATURING
THE IMPOSSIBLE WORLD

A Long Book-Length
Novel of a Miracle Planet
By EANDO BINDER

THE MAN FROM MARS by P. SCHUYLER MILLER

15¢ MARCH

SUPER SCIENCE
STORIES

WORLD REBORN
by THORNTON AYRE

THE LOTUS-ENGINE
by RAYMOND Z. GALLUN

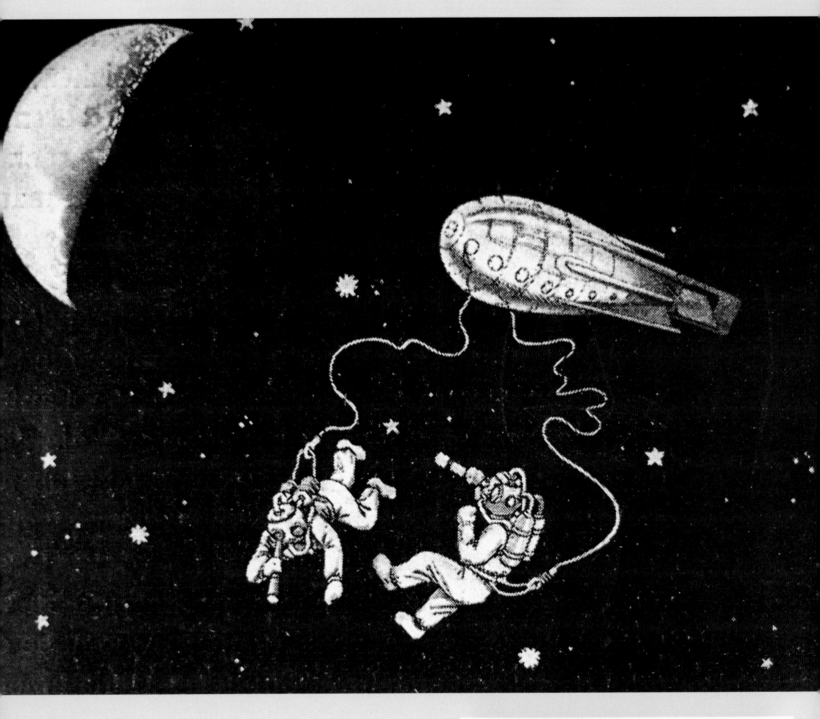

Things are happening on other fronts. In Germany, enthusiasts Max Valier and Otto Willi Gail are busy popularizing spaceflight. This image of space-walking astronauts is from the former's *Die Vorstoss in den Weltenraum* (*The Push into Space*), which goes through several editions between 1924 and 1929 before becoming *Raketenfahrt* (*Rocket Flight*). Spacesuited astronauts work on the Moon in Gail's *Mit Raketenkraft ins Weltenall* (*Rocketships into Space*), 1928.

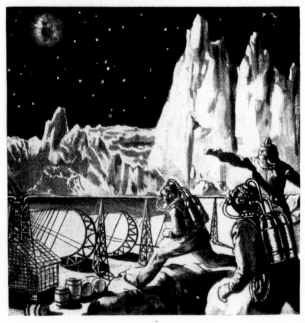

Im Jahre 3000 auf dem Mond
Ein Sonnenkraftwerk im Mondkrater
(Zeichnung von R. von Grünberg)

In 1927, Franz Abdon Ulinski presents an unusual spaceship design, one that is powered by an electron stream mistakenly believed to be recyclable—an impossibility; mass has to be expelled entirely from the craft to cause the desired equal and opposite reaction. Egg-shaped, it has three floors with the electron ejectors encircling the main structure.

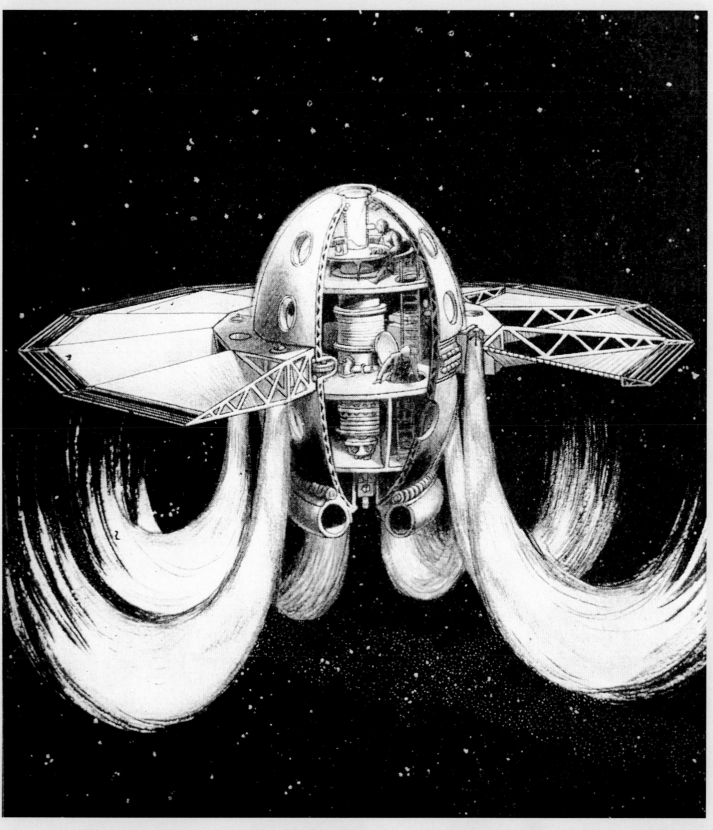

die Rakete

Zeitschrift des Vereins für Raumschiffahrt E.V., Breslau

Jahrgang 1927.

No. 1. JANUARY, 1934. Vol. I.

Journal of the
British Interplanetary Society.

34, OARSIDE DRIVE,
WALLASEY, CHESHIRE, ENGLAND.

Spaceflight societies begin to appear. The *Verein für Raumschiffahrt* is established in Breslau, Germany in 1927; the *American Interplanetary Society* in New York in 1930; and the *British Interplanetary Society* in 1933 in Wallasey, Cheshire. The covers of the early German and British journals offer stylistic spaceship designs.

приборов, но и для управляющего камерой человека. Камера имеет большой запас веществ, которые при своем смешении тотчас образуют взрывчатую массу. Вещества эти правильно и довольно равномерно взрываясь в определенном месте, текут в виде горячих газов по расширяющимся к концу трубам, вроде рупора или духовного музыкального инструмента. Трубы эти расположены вдоль стенок камеры, по направлению ее длины. В одном, узком конце трубы совершается смешение взрывчатых веществ: тут получаются сгущенные и пламенные газы. В другом, расширенном ее конце, они, сильно разредившись и охладившись от этого, вырываются наружу через раструбы, с громадной относительной скоростью. Весь запас взрывчатого вещества расходуется в течение 20 минут.

На черт. 17 показаны помещения жидких газов: водорода (Н) и кислорода (О). Место их смешения обозначено буквой А. Здесь они

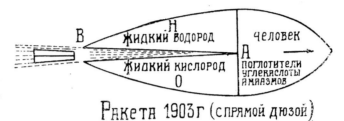

Черт. 17. Ракета 1903 г. с прямой дюзой.

взрываются и вылетают по раструбу дюз, через устье ее В. Труба АВ окружена кожухом с охлаждающей, быстро циркулирующей в нем, жидкостью (водород и кислород) температура которой 200 — 250 С.

Для того, чтобы ракета при полете не вращалась, сила реакции должна проходить через центр ее инерции. Для восстановления случайно нарушенной инерции можно или перемещать какую-нибудь массу внутри ракеты, можно также поворачивать конец раструба или руля перед ним. Если управление устойчивостью вручную окажется затруднительным: то можно приненить одно из следующих автоматических приспособлений, направление:

1) магнитную стрелку или
2) силу солнечных лучей и
3) жироскопы.

Когда нарушается равновесие ракеты, изображение солнца, полученное с помощью двояко-выпуклого стекла, меняет свое относительное положение в ракете и возбуждает сначала расширение газа, потом электрический ток и затем передвижение масс (которых должно быть две), восстанавливающих равновесие ракеты.

Жироскоп может состоять из двух быстро вращающихся в разных плоскостях кругов и также служит для устойчивости ракеты, действуя на пружинки, которые, при деформации, возбуждают электрический ток и влияют на передвижение масс.

Толщина стенок трубы в случае стали будет не более 5 *мм*, однако она может расплавиться (температура плавления 1300° Р.), поэтому следует применить более тугоплавкие вещества, например, вольфрам с температурой плавления 3200° С.

More realistic approaches arise from the minds of pioneers Tsiolkowski and Oberth. The progression of the former's thinking is seen in the three sketches dated 1903, 1914 and 1915. In fact, as early as 1883, in a paper entitled "Free Space," Tsiolkowsky demonstrates his awareness of the importance of the rocket to space travel. In 1903, the now classic *A Rocket into Cosmic Space* appears followed in 1911 by his *Investigation of Universal Space by Means of Reactive Devices.*

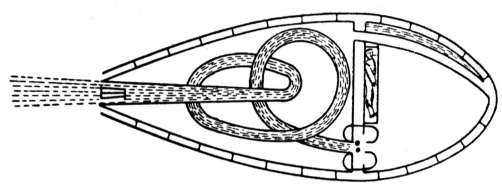

Ракета 1914г. (скривой дюзой)

Черт. 18. Ракета 1914 г. с кривой дюзой.

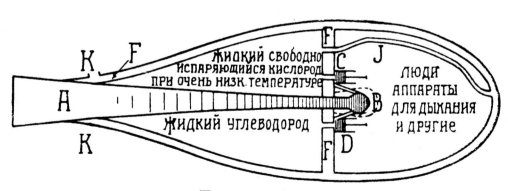

Ракета 1915г.

Черт. 19. Ракета 1915 г.

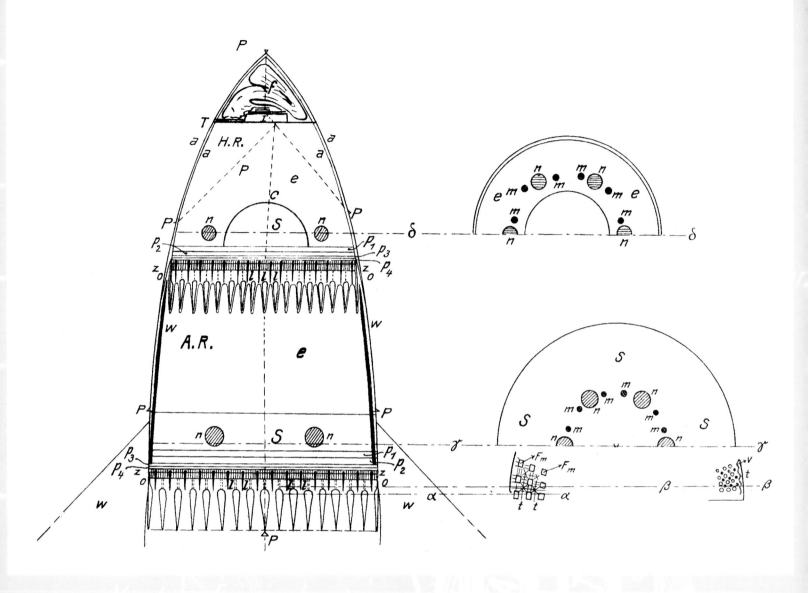

Oberth's seminal *Die Raketen zu den Planetenräumen* (*Rocket into Planetary Space*) of 1923 is followed in 1929 by the much expanded *Wege zur Raumschiffahrt* (*Ways to Spaceflight*). Letters on this cross-section of his Model E "manned space rocket" indicate propellant tanks (e and S), entrance (T) to passenger cabin (I), recovery parachute (f), and periscope (P). Model E was to be capable of orbital flight.

Abb. 94. Die gesamte Raumwarte mit ihren 3 Objekten, gesehen durch die Türöffnung eines Raumschiffes. Im Hintergrunde — 35 900 km entfernt — die Erde. Der Mittelpunkt ihres Umfangskreises ist jene auf dem Äquator gelegene Stelle der Erdoberfläche, über welcher die Raumwarte ständig schwebend verharrt (Siehe Seite 98, 99). Dieselbe liegt, so wie die Annahme hier getroffen wurde, im Meridian von Berlin, und zwar etwa in der Südspitze von Kamerun.

Equally ambitious was Hermann Noordung (Herman Potočnic) who in 1929 comes out with *Das Problem der Befahrung des Weltraums. Der Raketen-Motor* (*The Problem of Space Travel. The Rocket Motor*). His space station design consists of three units: a 100-foot-diameter wheel-shaped habitat that rotates to provide the crew with the sensation of gravity, a mirror to focus solar rays for power, and an observatory. The three units are seen through the window of an arriving spaceship 36,000 kilometers above the Earth. The wheel is at left foreground, the solar mirror at top, and the observatory at right, all connected by pressure hoses for air and electric cables. The inset highlights the habitat wheel.

Once the theoreticians had demonstrated the importance of the rocket, amateur experimenters in Russia, Germany, the United States and to an extent France begin developing and testing primitive devices. German members of the Verein für Raumschiffahrt do so at their Raketenflugplatz rocket flying field in Berlin from 1930. On the other side of the Atlantic, American Rocket Society experimenters test equally primitive rockets during the 1930s and early '40s near Midvale (this view) and Stockton in New Jersey and at Great Kills and Marine Park on New York City's Staten Island.

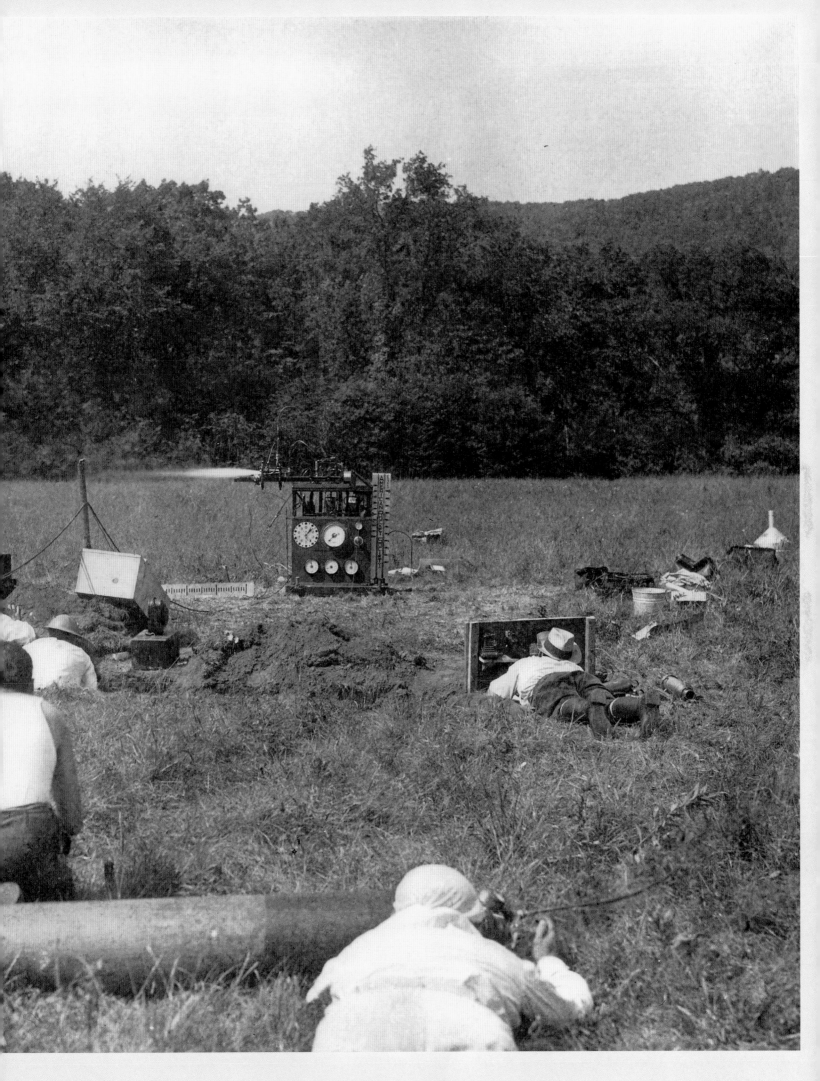

Goddard, in a somewhat secretive manner, successfully flight tests a remarkable array of rockets, first near Worcester, Massachusetts, and later near Roswell, New Mexico. This rocket, still in its service structure, is launched in March 1937 from Roswell. Goddard's early publications "A Method of Reaching Extreme Altitudes" (1919) and "Liquid-Propellant Rocket Development" (1936) both appear in *Smithsonian Miscellaneous Collections*.

While primitive rockets are being tested in the years before World War II and theoreticians are laying out plans for the future conquest of space, astronomer-artist Lucian Rudaux in France seeks to visualize the conditions astronauts may one day encounter. His paintings appear primarily in the 1923 book *Le Ciel: Nouvelle Astronomie Pittoresque* (*The Sky: New Picturesque Astronomy*) by Alphonse Berget; and, in 1937, in his own *Sur les autres mondes* (*On Other Worlds*). This view of Mars from its little moon Phoebus reaches a wide audience in the *Illustrated London News* for 18 April 1931.

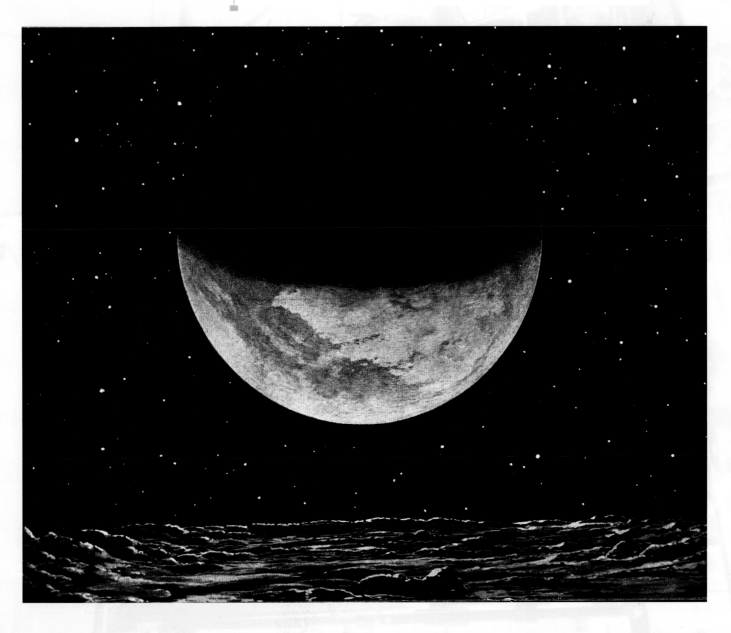

PART VI:
THE **COLLIERS** AND

Chesley Bonestell

Scant attention was paid to space flight during World War II, which began in 1939 in Europe and even earlier in Asia. But not so rockets. To a greater or lesser extent, the belligerents developed them for a variety of military purposes. Most were used for barrage attacks, especially for softening up defenses prior to major offensive action, e.g. beach landings by marines. But the down-the-road spaceflight potential of one weapon was recognized early in its development: the German A-4 long-range ballistic missile that became known as the V-2 when it entered operational service towards the end of the war. During the course of its trajectory, it soared briefly into space.

After the war, the United States Army Ordnance Corps shipped components from occupied Germany sufficient to refurbish and adapt more than seventy V-2s for upper atmosphere research. Under the guidance of Wernher von Braun and his team at the White Sands Proving Ground in New Mexico, these rockets became the precursors of modern launch vehicles.

The principals involved in the *Collier's* space series. Left to right: Willy Ley, Fred Whipple, Wernher von Braun, Chesley Bonestell, Rolf Klep, Fred Freeman, and Cornelius Ryan.

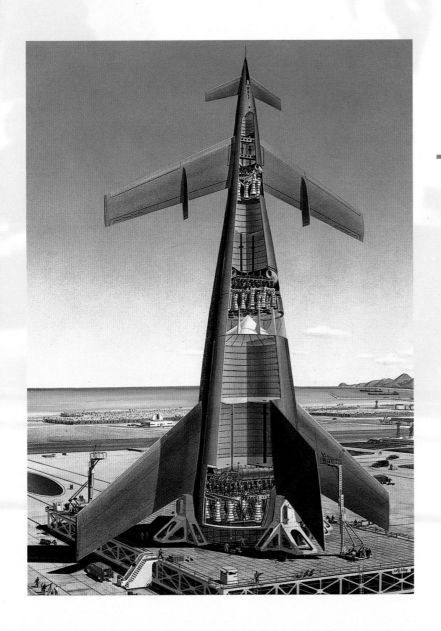

Von Braun anticipated the Apollo era Saturn V launch vehicle with this design. It was 265 feet tall, about that of a 25-storey building, and had a base diameter of 65 feet. Fifty-one engines in the first stage produced 28 million pounds of thrust; 34 in the second stage, 3-1/2 million, and 4 in the third stage plus a cruise engine, 440,000. At the end of a 56-minute flight, the giant rocket delivers 36 tons of cargo to an orbit 1,075 miles above the Earth. Its winged third stage is recoverable, an early 1950s space shuttle. In the real world of the time, a V-2 rocket had reached a peak altitude of 130 miles above white Sands. The original of this painting by Rolf Kelp is at the National Air and Space Museum.

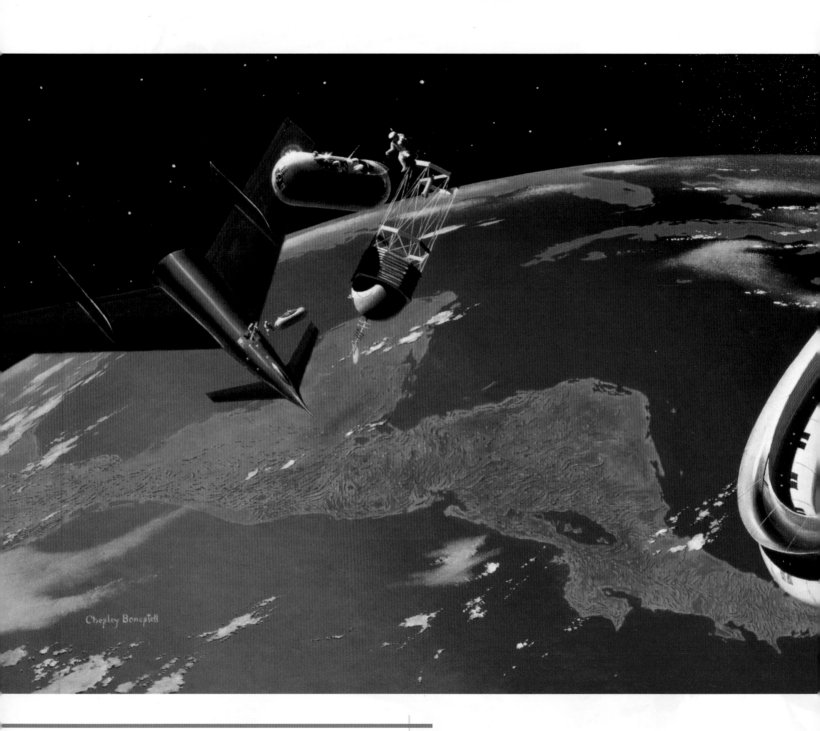

Chesley Bonestell

The completed space station accommodates a crew of eighty and rotates every 22 seconds to create the sensation of one-third "g," which is one third the value here on Earth. A winged reusable third stage at left, a space telescope nearby, and three little "space taxis" are busy at work. (Chesley Bonestell)

The third or upper stage separates from the second stage. The huge rocket's first task is to deliver components from which a space station will be constructed. (Chesley Bonestell)

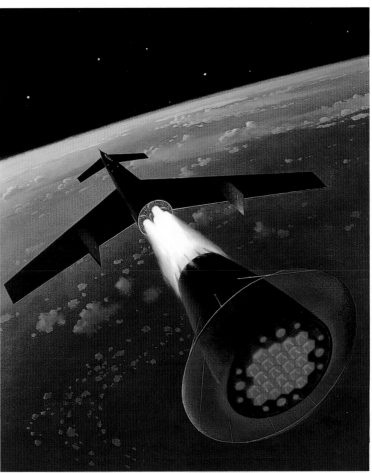

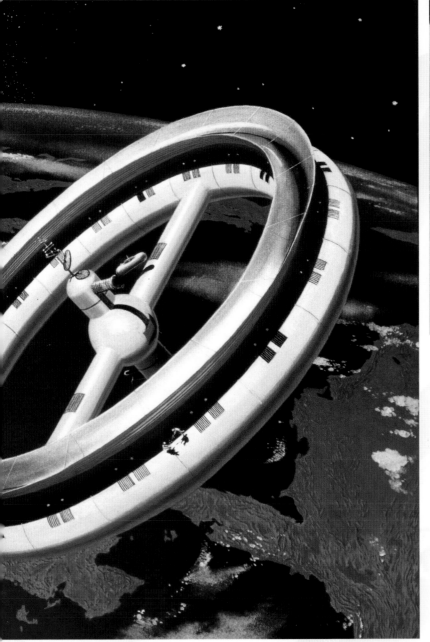

OVERLEAF: The station has three decks, the innermost offering the least feeling of gravity and the outermost the greatest. Note the solar mirror at upper right, a space taxi at lower right, and a landing berth at left. Station crew members conduct terrestrial and celestial observations, monitor the assembly of spaceships destined to travel to the Moon and Mars, and perform a variety of other tasks. The station orbits the Earth every two hours. Von Braun reckoned it could be ready by 1967 at a cost of $4 billion, which he compared to the World War II atomic bomb project's $2 billion. (Fred Freeman)

131

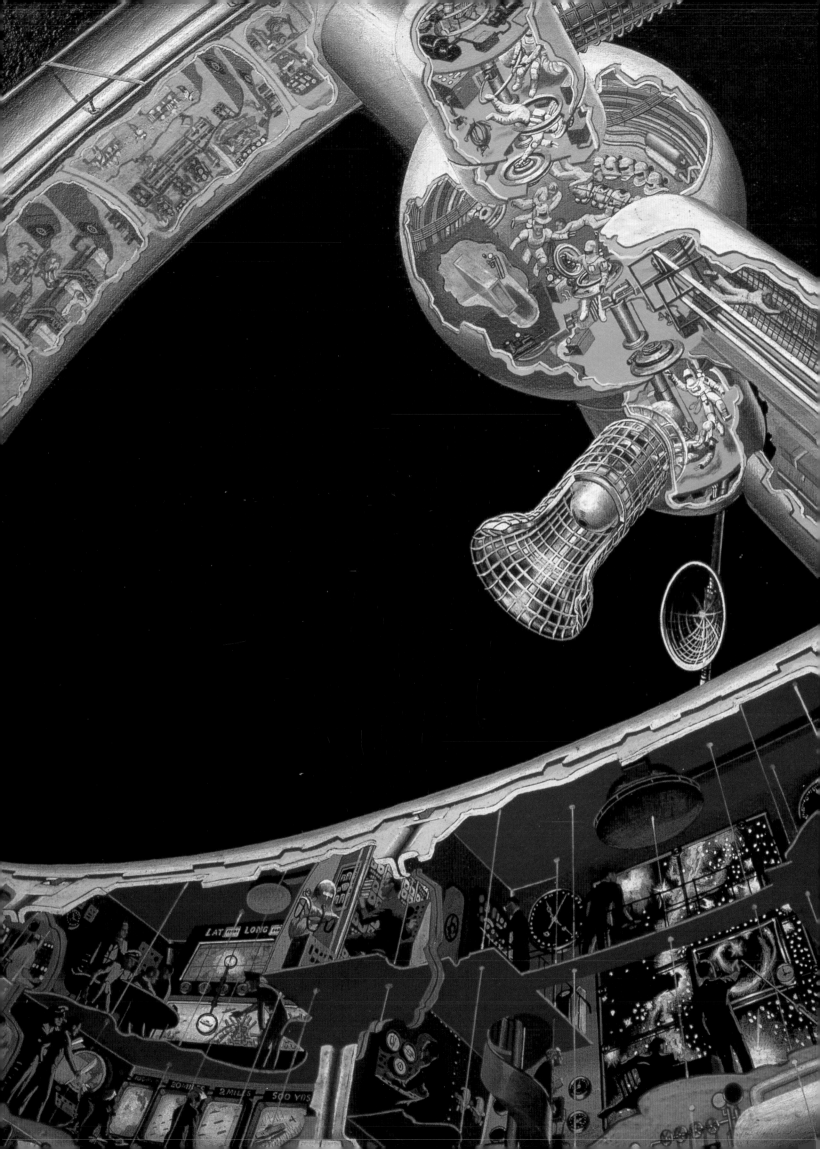

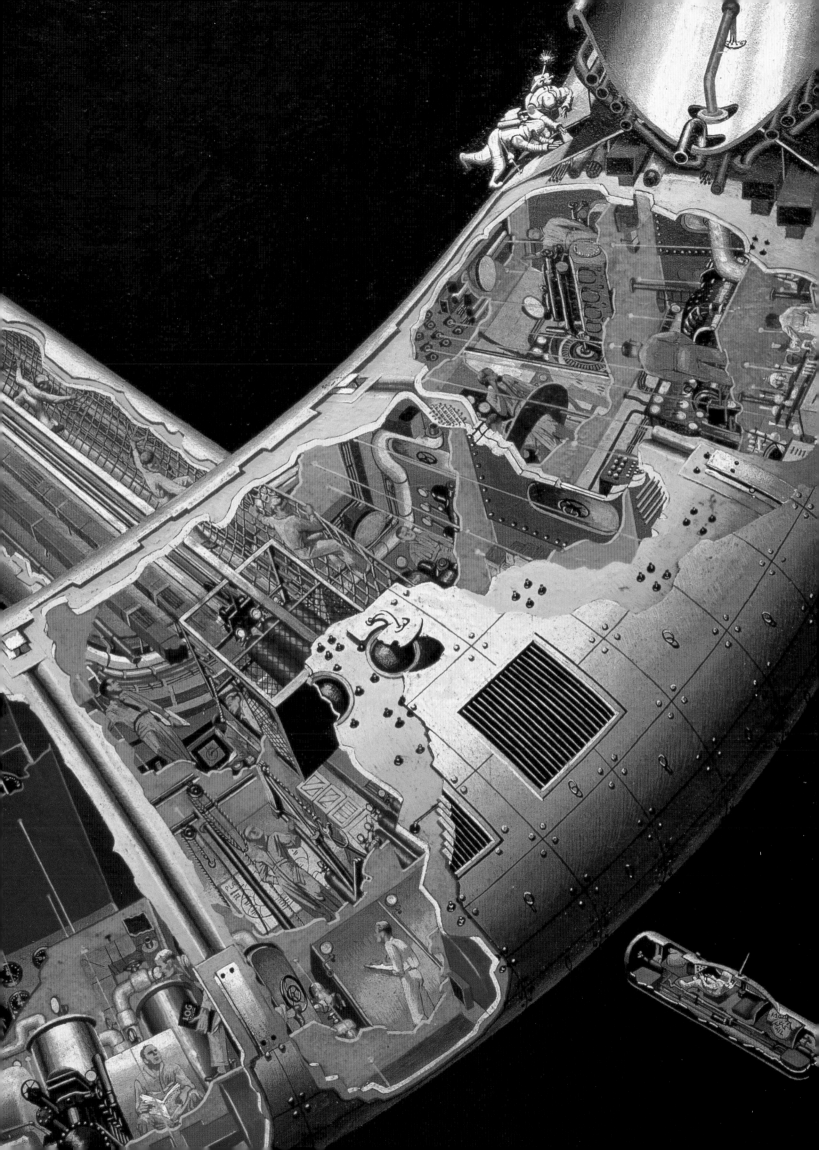

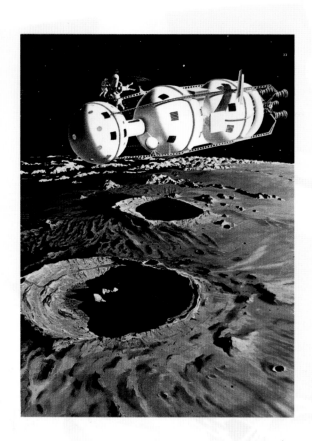

Once the space station had been assembled in orbit, von Braun, Whipple and their colleagues looked to the Moon as the next logical target. First in order was the construction of a manned lunar reconnaissance craft with suspended collapsible nylon and plastic propellant containers, plumbing, wiring, navigation and guidance systems, and the launch vehicle's upper stage propulsion system. If fact, the spacecraft is about the size of that stage minus its wings. The outbound and inbound lunar cruise each takes five days. (Chesley Bonestell)

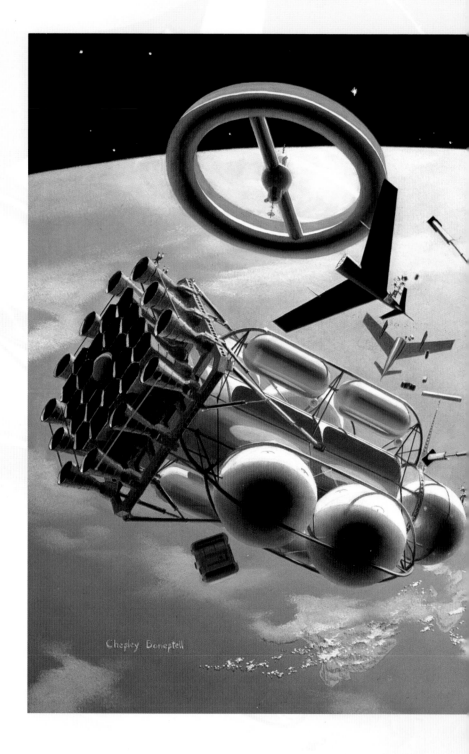

By 1977, von Braun reckoned that reconnaissance of the Moon would be completed, paving the way for a full-scale expedition to be assembled near the space station. The estimated cost: $500 million, on top, of course, to that of establishing the station in the first place. Again, on a scale surely to excite *Collier's* readers, he planned for two passenger spaceships, each manned by a crew of twenty and a single cargo ship with ten aboard. All three are 160 feet long and 110 feet wide and are powered by thirty rocket engines. (Chesley Bonestell)

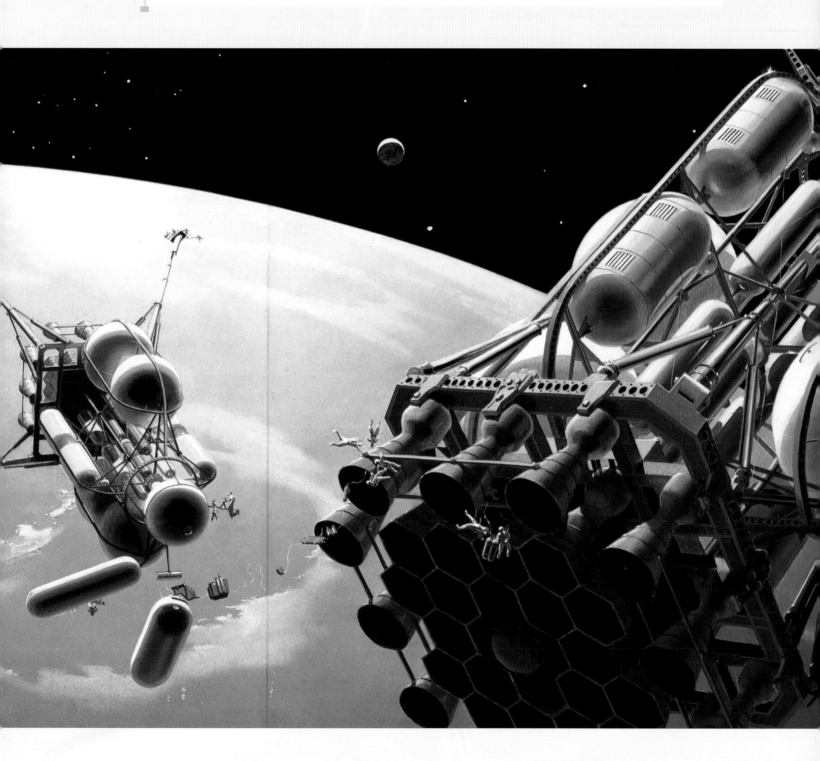

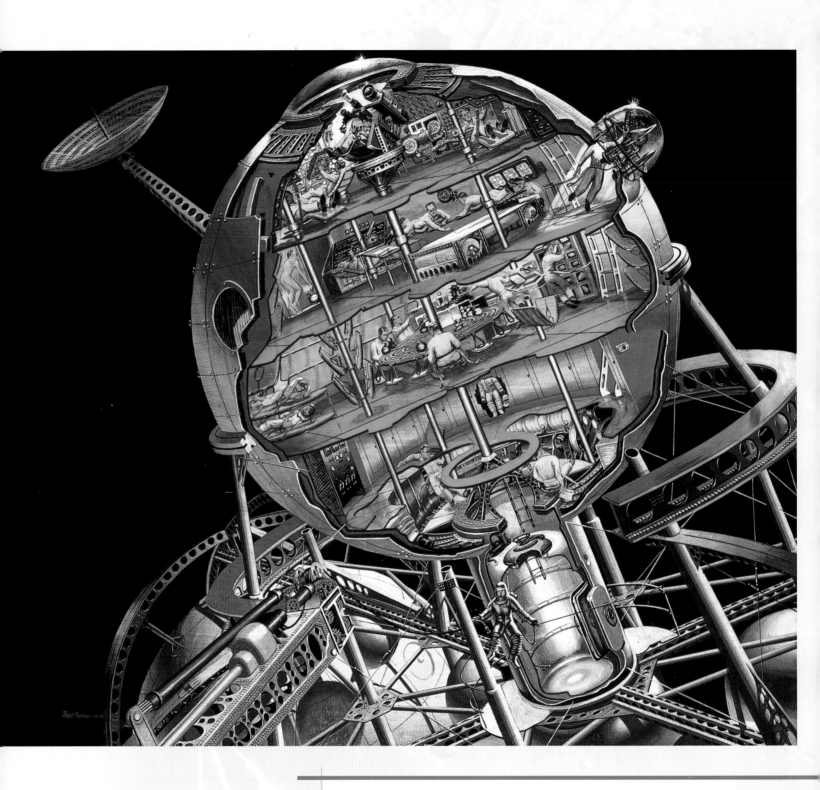

The moonships' passenger spheres consist of an upper control deck and, directly below, the navigation deck. The largest deck accommodates the living quarters. Below it is the stowage deck and at the very bottom, the engineering deck. (Fred Freeman)

The target of these three descending spaceship is *Sinus Roris*, or Dewy Bay, on the northern branch of *Oceanus Procellarum*, or Stormy Ocean, some 650 miles from the lunar north pole. (Chesley Bonestell)

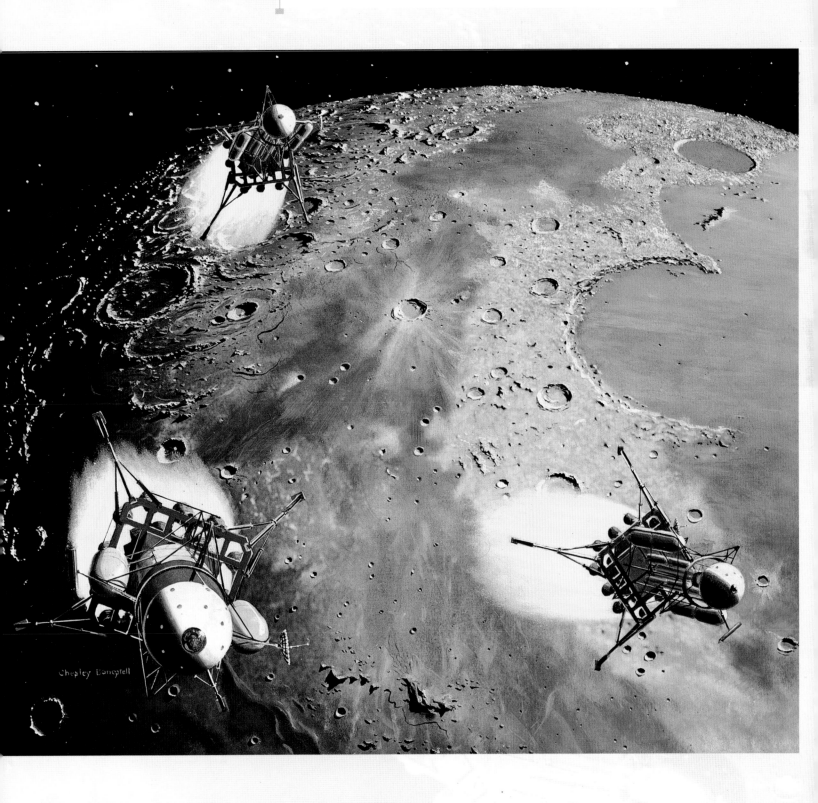

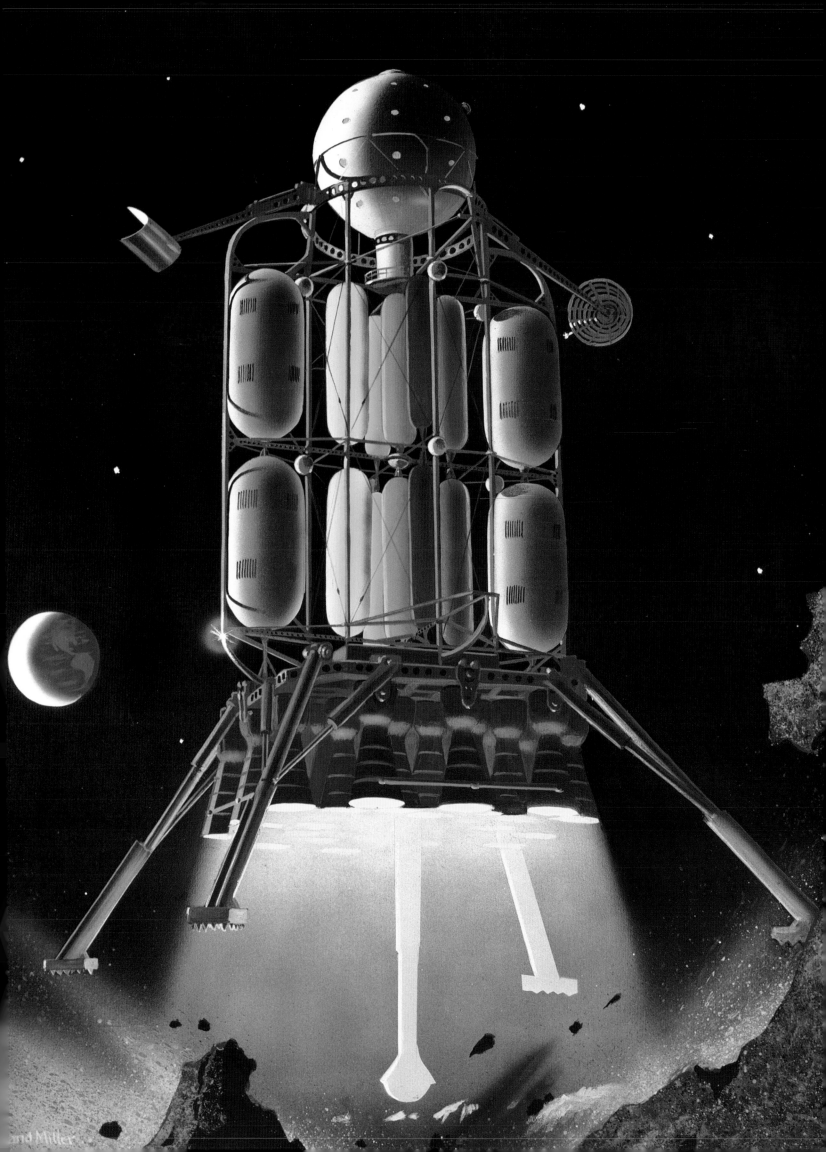

An historic moment: the first landing on the Moon. The rocket motors are about to be turned off as the shock-absorbing central landing leg (visible inside the flames) touches the lunar surface. Artist Ron Miller painted this reproduction under commission from the author from the lost Bonestell original based on the image published in *Collier's* magazine. He allowed for the poorer color reproduction processes of the 1950s by using slightly more saturated colors.

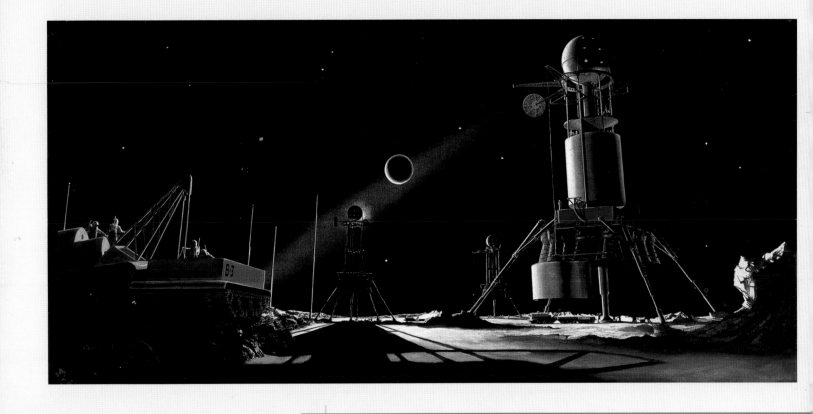

Soon after the three ships land, they are all stripped of their landing propellant tanks and movable equipment is stored on caterpillar tractors and trailers. The cargo hold of the cargo ship itself (foreground) is dismantled and lowered in sections from which a prefabricated lunar base will be constructed. (Chesley Bonestell)

The base is intended to support operations during the six-week-long stay on the Moon. The idea is to split up the cylindrical hold of the cargo ship into lengthwise halves and then lower them by crane into a chasm or crevice up to hundred feet deep. The unit in the background serves as a scientific laboratory and that in the foreground as living quarters. The tractor at the lip of the crevice is lowering scientific specimens from the surface while an expedition member descends by ladder. (Fred Freeman)

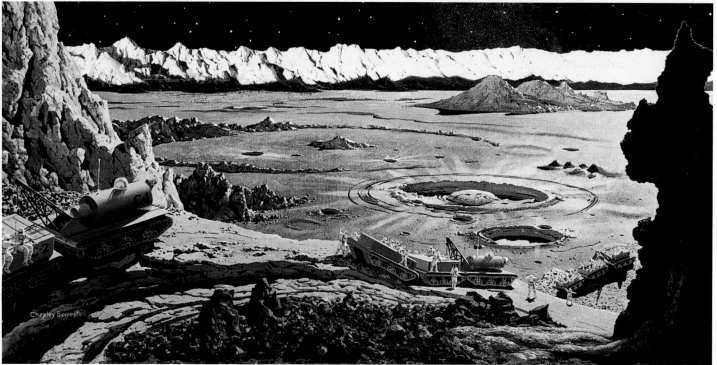

Once the base has been completed, scientific investigations begin. Most of the work is undertaken within a radius of ten miles or so from the landing site. But one long-range trek is planned. The target is the crater *Harpalus*, a straight-line distance of 195 miles and 250 by land. To make the journey, two tractors each haul three trailers with a total complement of ten astronauts. At this moment, they are crossing terrain near the plain of *Sinus Roris*. En route, they undertake a variety of experiments and install automatic recording devices that are to be left behind. The mountain range in the distance is illuminated by the setting Sun; light from the Earth causes the greenish foreground hue. (Chesley Bonestell).

The mission is over. The two passenger ships take off under full Earth illumination, bound for the space station back in Earth orbit. What is now a dismantled cargo ship (foreground) is left behind. (Chesley Bonestell)

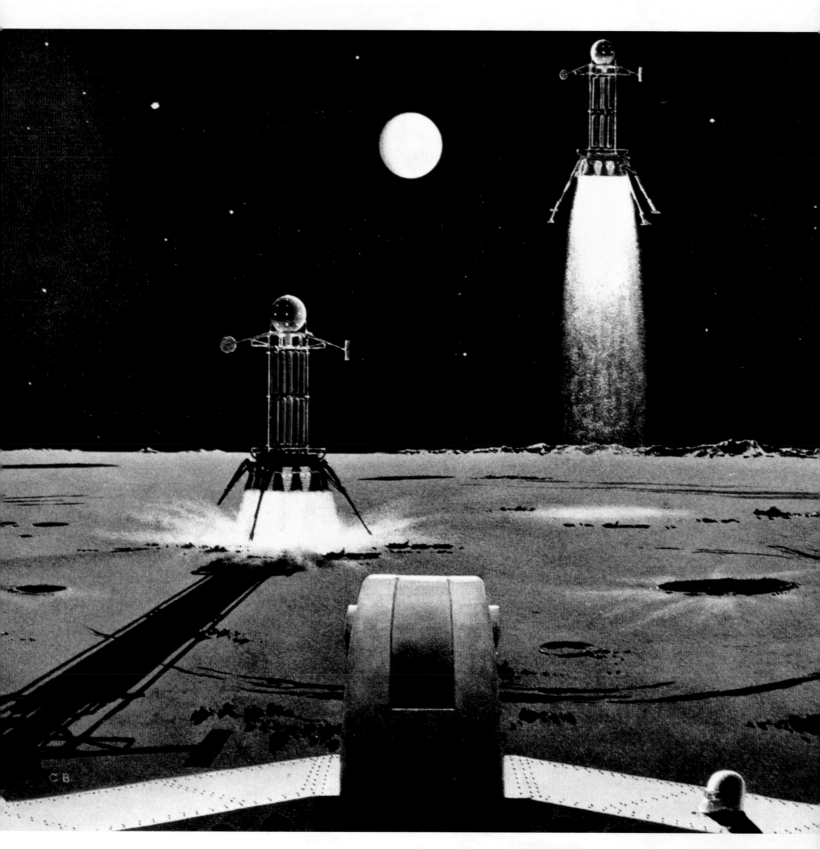

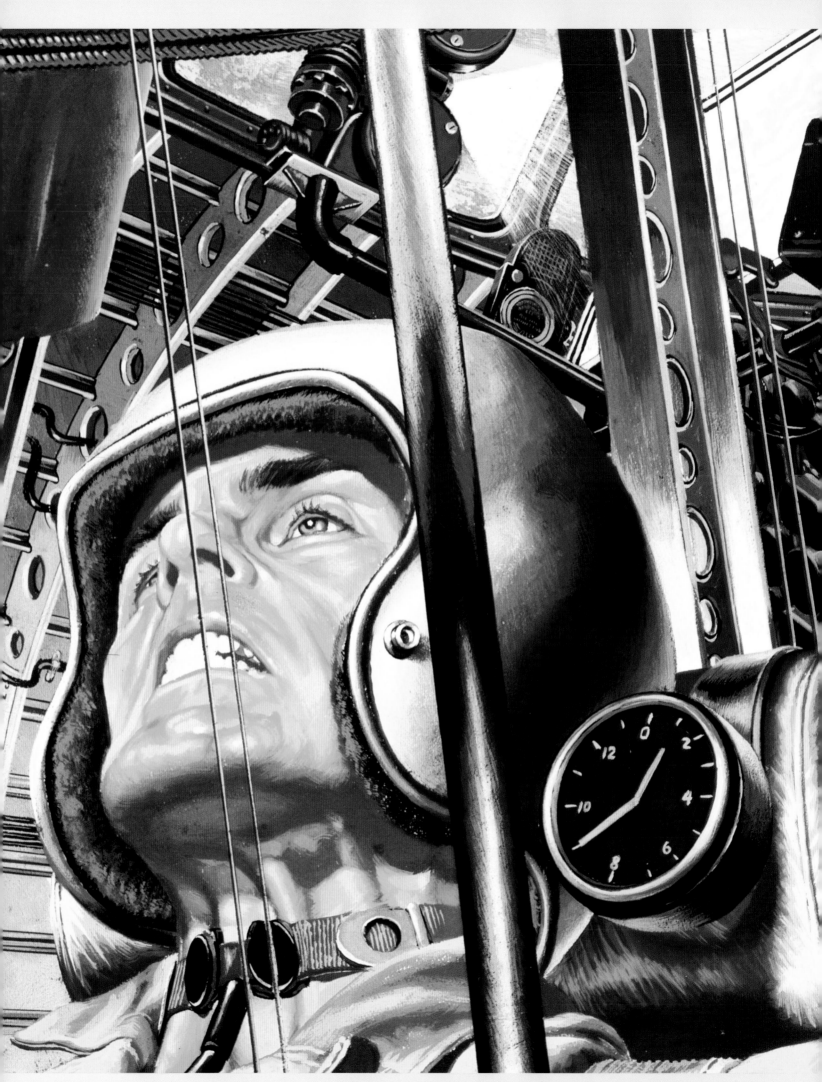

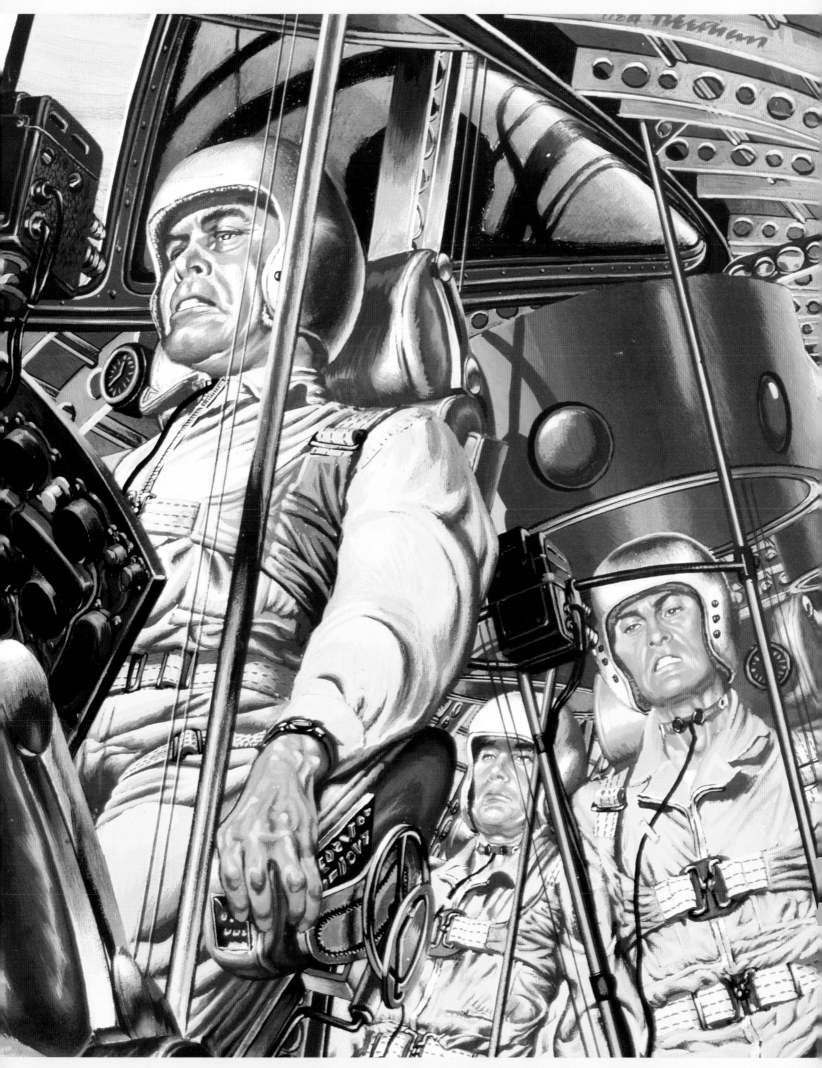

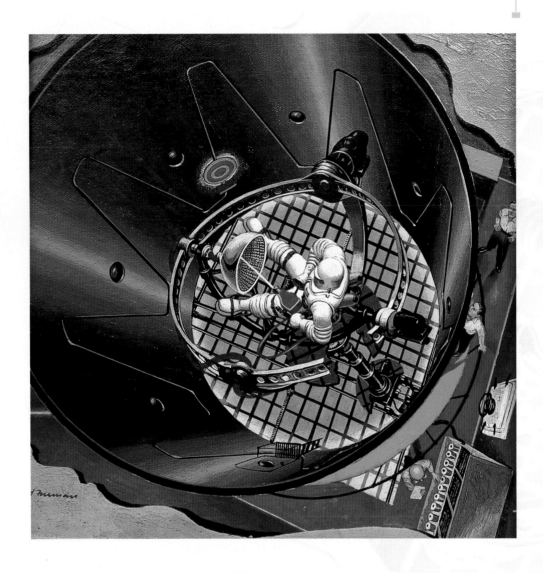

Working out in a reaction-control simulator to teach astronauts how to maneuver from one position to another in space, e.g. while assembling components in orbit. (Fred Freeman)

Trainees training inside a sealed chamber. Its purpose is to simulate isolation conditions experienced during extended periods in space. (Fred Freeman)

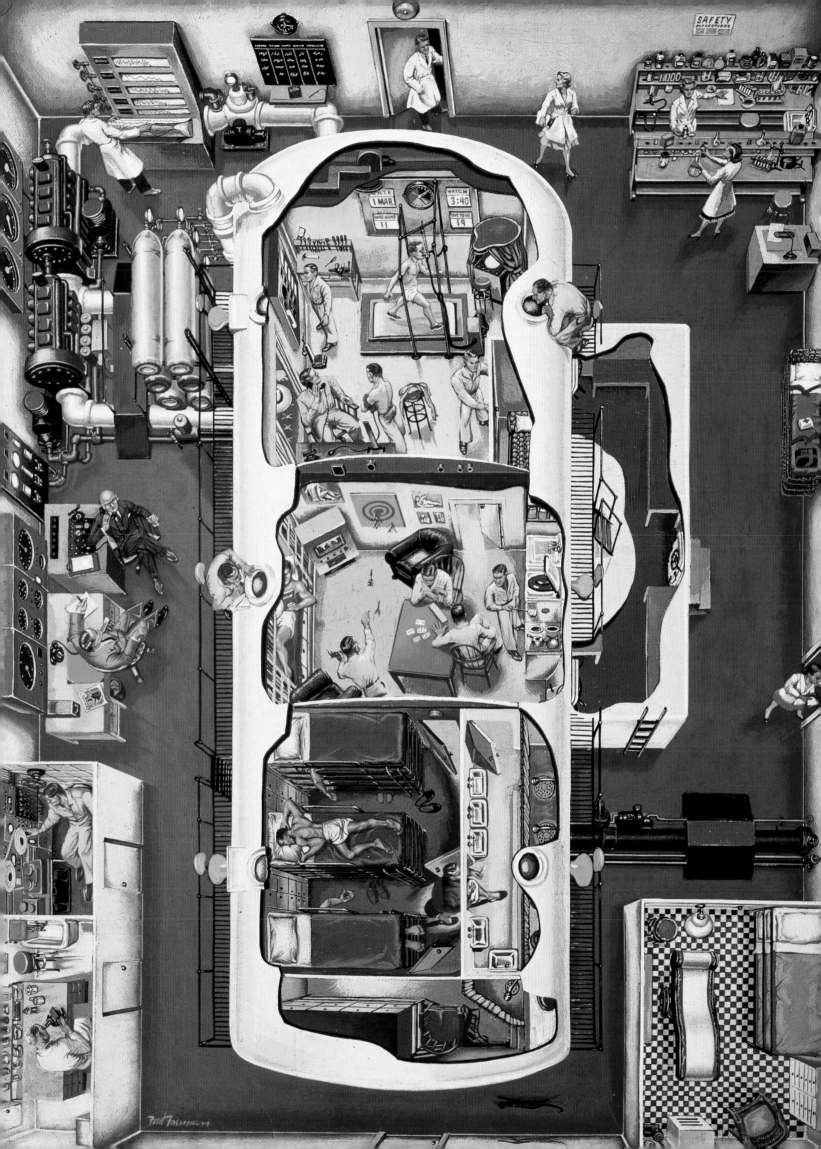

To provide safety in case of a malfunction of the reusable upper stage—von Braun's 1950s shuttle concept—crew and passengers press buttons on their chair arms. Contour seats straighten automatically and enclosures snap shut forming sealed escape capsules. To abandon ship, the crew and passengers push another button and the capsules, guided by rails, are ejected by explosive powder charges. The arrangement is seen in cross-section. (Fred Freeman)

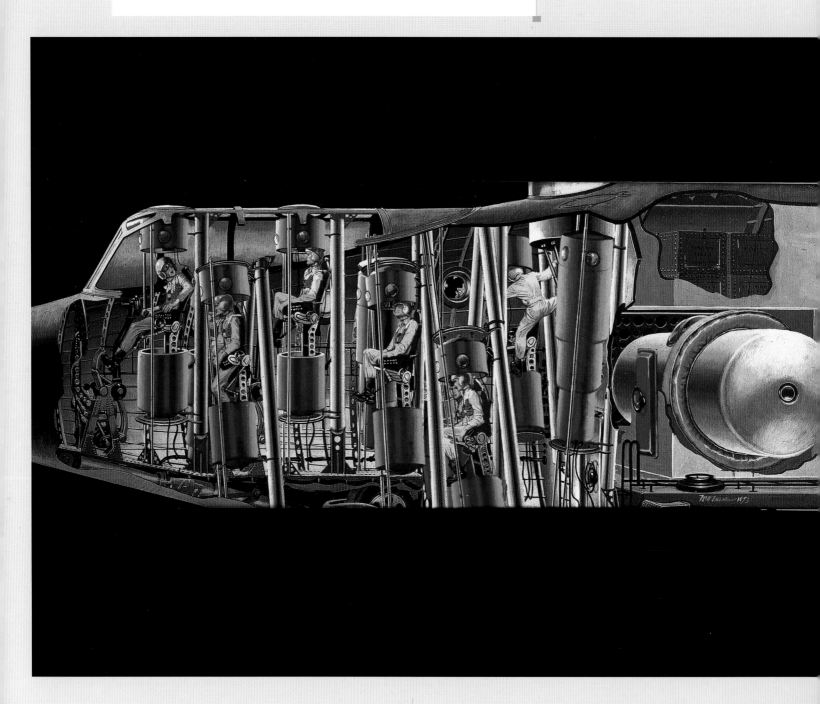

After ejection, the capsules' descent is controlled by four-foot steel mesh parachutes. At about 150 above the ground or water, a proximity fuse sets off a small rocket that further slows the rate of fall. (Fred Freeman)

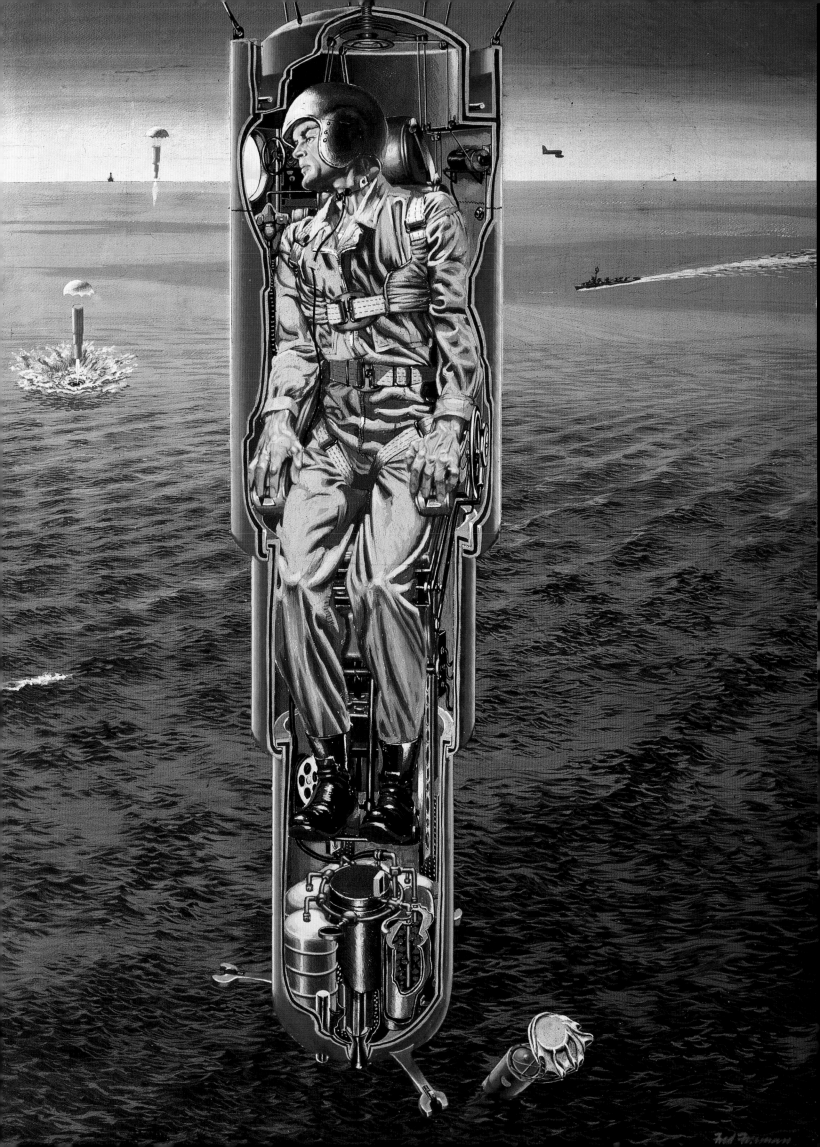

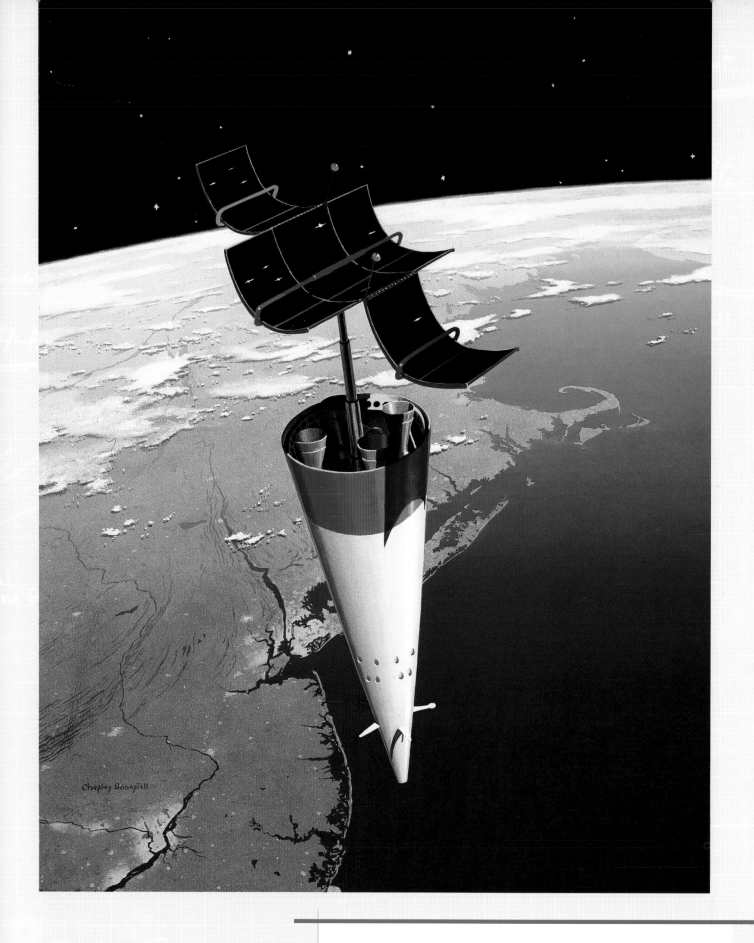

Chesley Bonestell

To pave the way for the large manned space station described earlier, von Braun proposed first placing into a 200-mile-high orbit an unmanned precursor, a "baby" space station. Over a planned 60-day lifetime, it conducts a series of internal and external observations, including the response to weightless conditions of the station's passengers: a pair of rhesus monkeys. (Chesley Bonestell)

RIGHT: One of many planning drawings of the baby station executed by Wernher von Braun.

BELOW: The finished cutaway painting of the baby station showing the two monkeys aboard. (Fred Freeman)

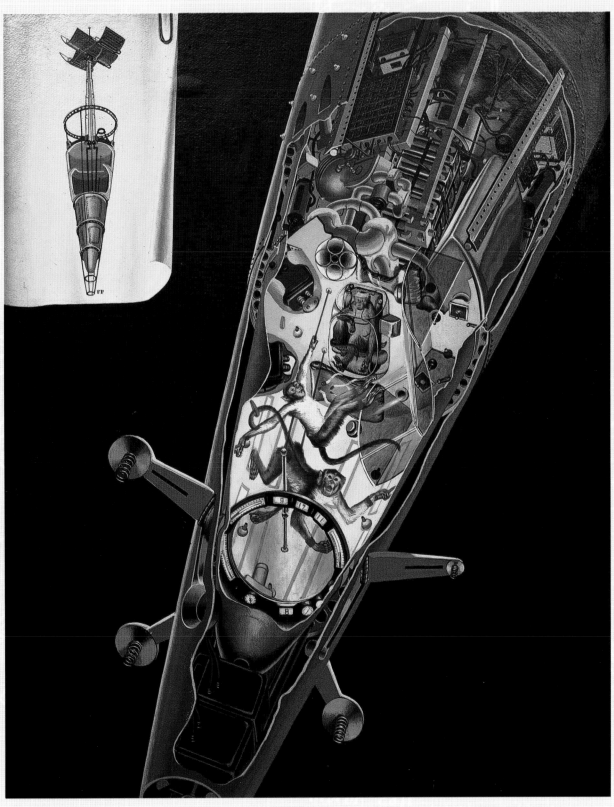

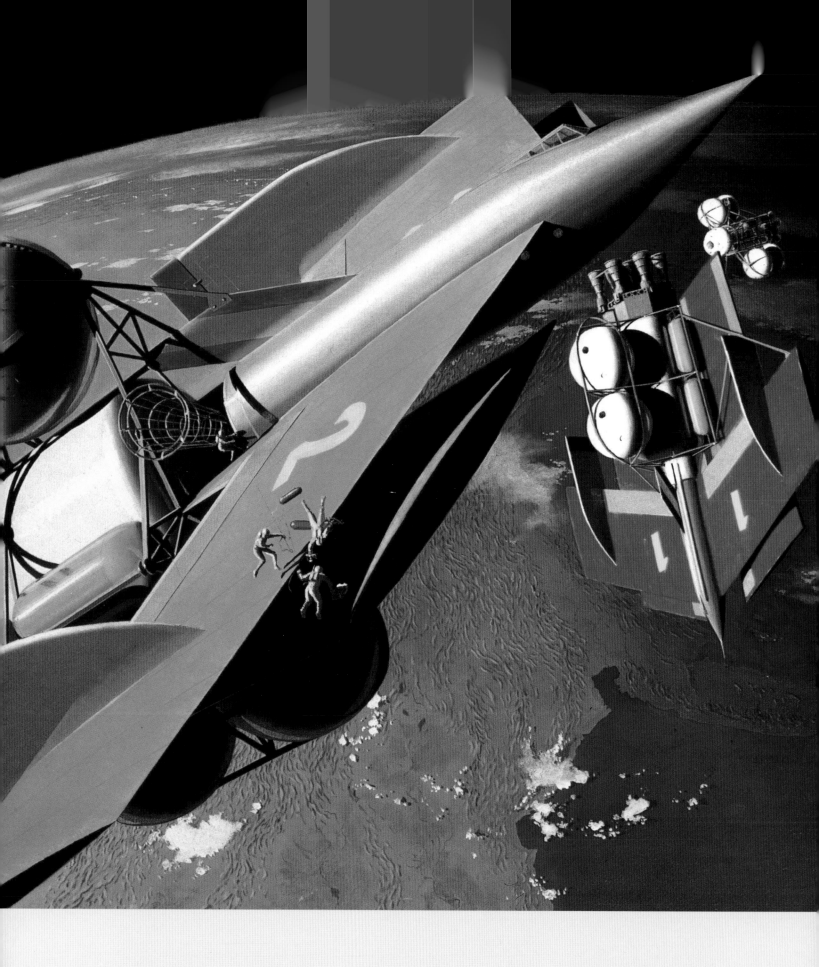

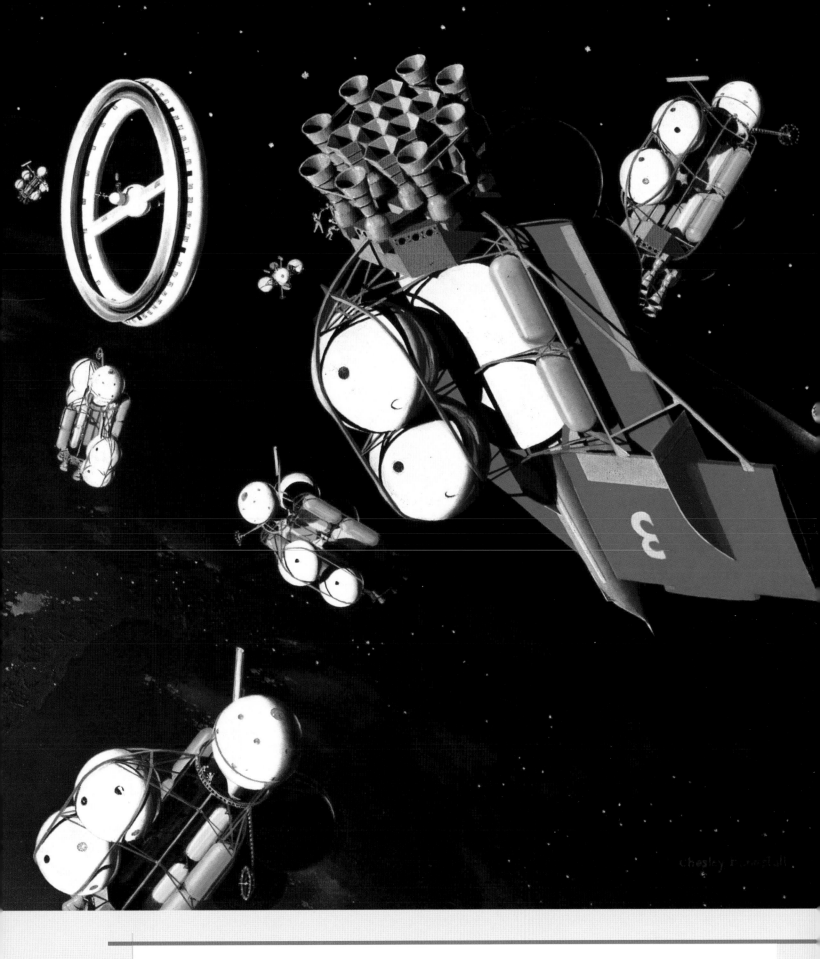

The eight-part Collier's space series culminated on 30 April 1954 by posing two questions: can we get there and is there life on Mars? To find out, von Braun proposed a flotilla of ten spaceships with a crew of 70 that would embark from Earth orbit much as did the earlier lunar expedition. The spaceships are being assembled close to the now familiar doughnut-shaped space station. (Chesley Bonestell)

After Earth-orbital assembly has been completed, the fleet leaves on an eight-month trip to Mars. Now approaching their destination, the ten ships will soon enter into a 600-mile-high orbit. Seven of them will remain there for the return journey to Earth; the other three will be prepared for landing. This painting by Ron Miller was commissioned by the author to replace the lost Bonestell original that had once appeared on *Collier's* cover.

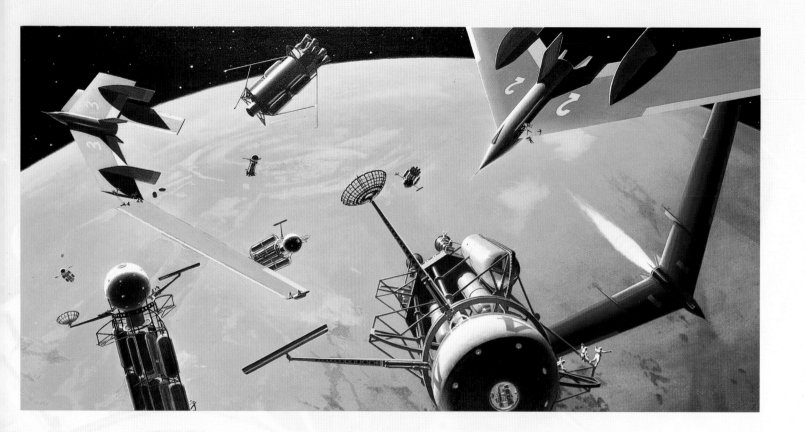

Once in orbit around the red planet, three of the ten spaceships are readied for descent through the Martian atmosphere. Their torpedo shape design incorporates landing skids and folded wings that are deployed shortly before the glide-descent onto the surface. (Back in the early 1950s, the Martian atmosphere was believed to be almost ten times denser than unmanned spacecraft later proved it to be. Consequently, we now know that large winged craft like this would not be practical; other approaches to landing would be employed were an expedition to be mounted today.) Here, the first lander, its wings fully deployed, is on the way down. (Chesley Bonestell)

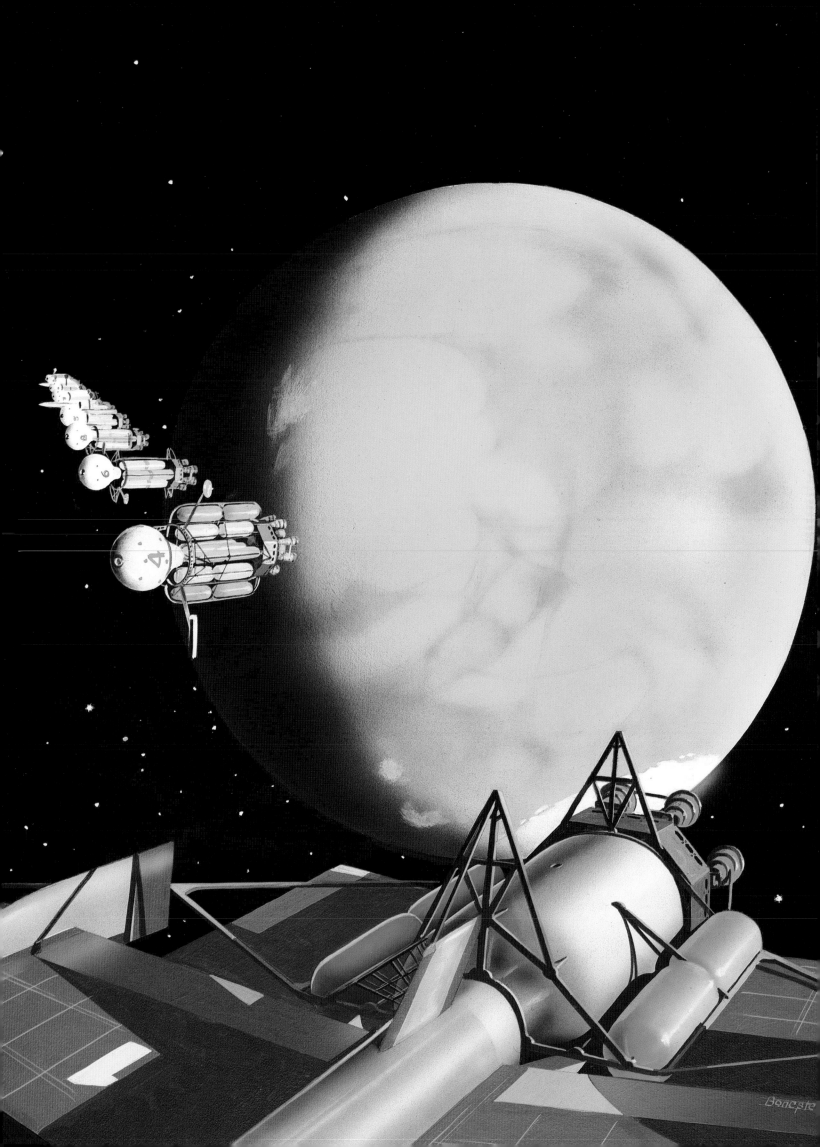

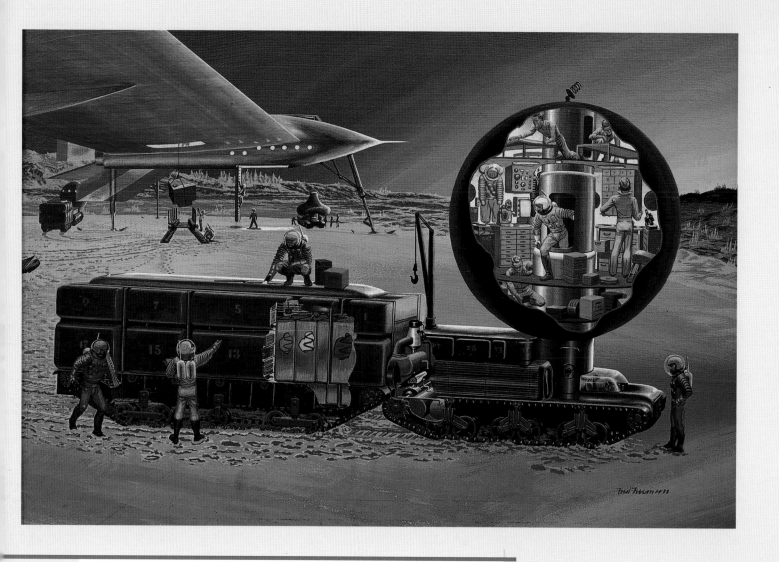

The winged lander has come to rest on a polar ice field, a location von Braun felt would be reasonably certain to be acceptably flat. The crew is readying the tractor vehicle in the foreground with its now inflated, balloon-like living quarters. Soon, the expedition will head on a 4,000-mile journey to the equator to prepare the main base and a landing strip for the other two winged landers. (Fred Freeman)

Near the end of their 15-month stay on Mars, the explorers get ready to join their comrades in the seven orbiting spaceships. The wings and landing gear of their two ships are removed and the rocket cores placed in an upright position Soon they will rendezvous with the seven spaceships, transfer themselves and the results of their exploration aboard, and set off on the eight-month trip home. The author commissioned Ron Miller to reproduce the lost Bonestell original.

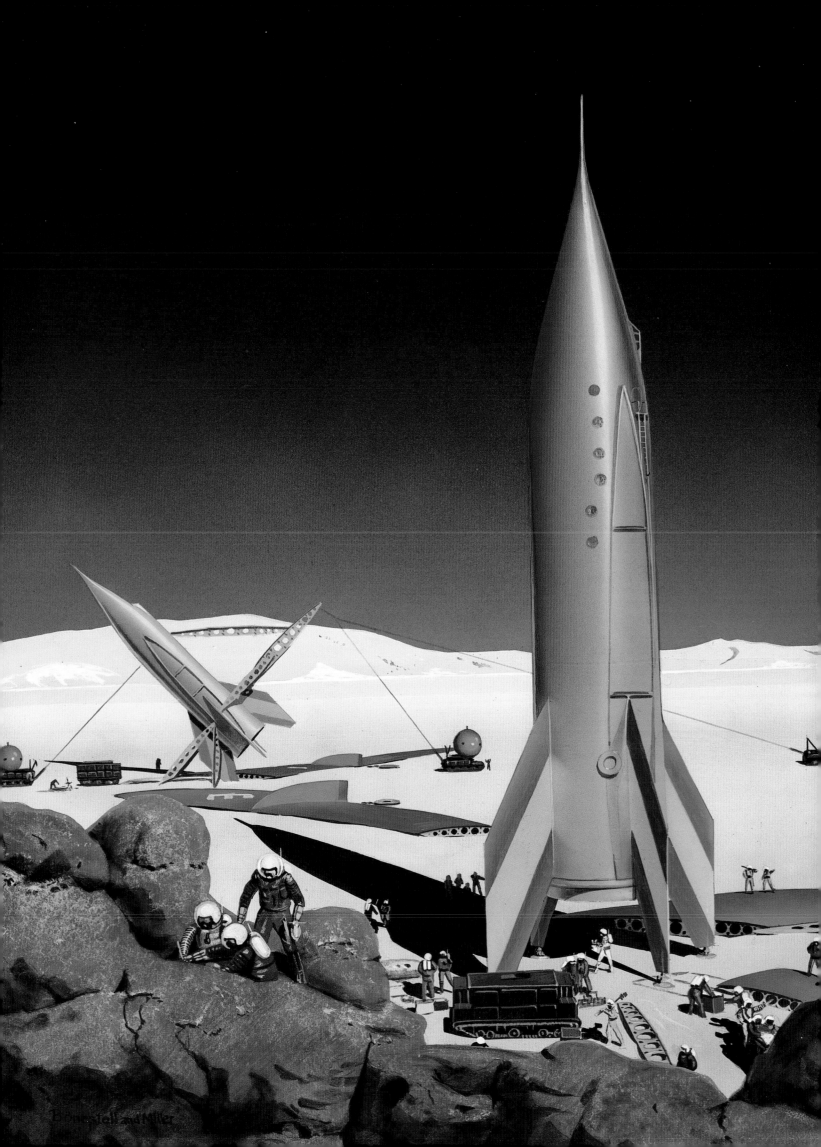

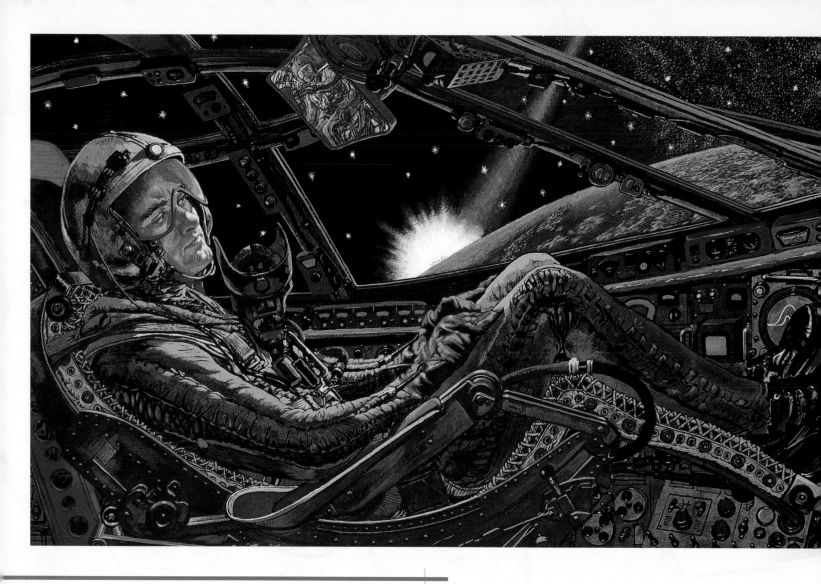

Aware of the public impact created by the *Collier's* series, von Braun next turned his attention to what was at the time termed a "science-fiction documentary–" a realistic, but fictional, story of the first manned flight to the Moon. He embarked of what started out to be a two-part story for *This Week* magazine entitled "First Men to the Moon." Published in the 5 and 12 October 1958 issues, the articles created caused such a stir that von Braun ended up writing two more ("Five Days on the Moon," 8 March and "Blast-Off from the Moon,"12 April 1959). Here, artist Fred Freeman envisions astronauts John Mason and Larry Carter in the spacecraft some 4,000 miles from a rapidly receding Earth.

Their destination is a shallow crater near the lunar North Pole where temperatures are expected to be moderate due to the low elevation angle of the Sun. Shortly after the landing, John Mason blurts out over the intercom to Larry Carter, "Let's get going. We'll be starting back in five days." He slowly descends the spacecraft's ladder, much as Neil Armstrong and Buzz Aldrin would do just over a decade later.

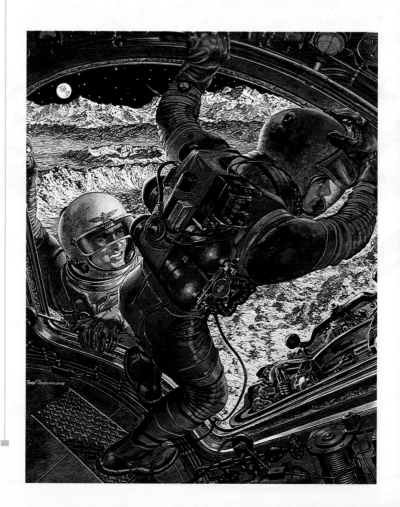

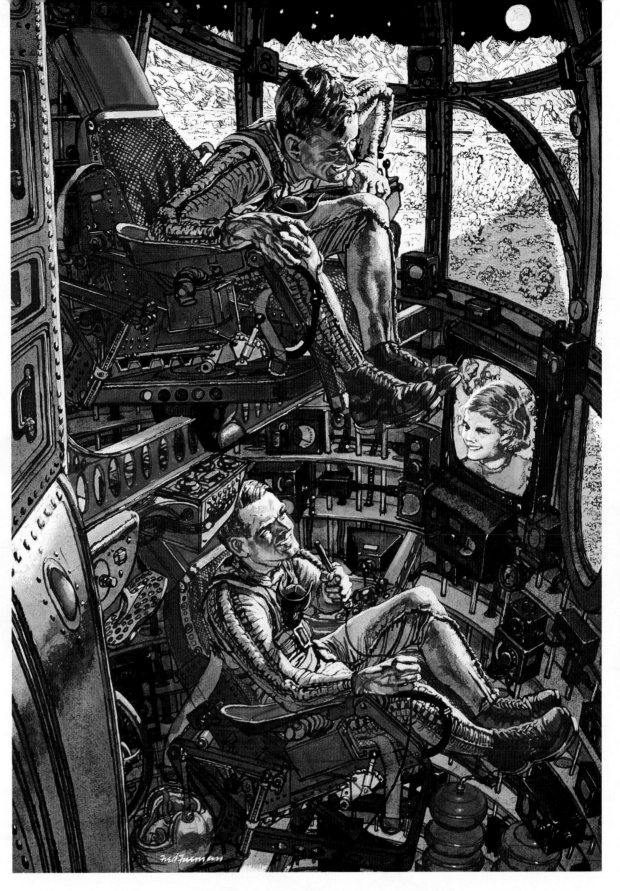

During their stay on the lunar surface, the astronauts communicate regularly with Earth; and, on occasion, participate in a special telecast with their families. The girl on the screen is a likeness of von Braun's daughter Iris.

OVERLEAF: While on the Moon, the astronauts devote as much time as possible to exploration. They collect rocks on the Moon...

…and carry out seismological experiments to reveal the nature of the lunar interior. To do this, they fire six-foot-long rockets whose payloads incorporate extremely sensitive radio-seismographs. The information is picked up by receivers located on the rim of the shallow crater where the spacecraft had landed.

En route back to their Pacific atoll landing site on Earth, the spacecraft is suddenly rocked by an explosion. "The blast," wrote von Braun, "was followed by a hissing noise, and a moment later a buzzer and several flashing red lights confirmed with frightening eagerness what was only too obvious: cabin air pressure was dropping rapidly." A small meteor had penetrated the hull. The astronauts act quickly, and soon seal the hole with a rubber and metal meteor patch.

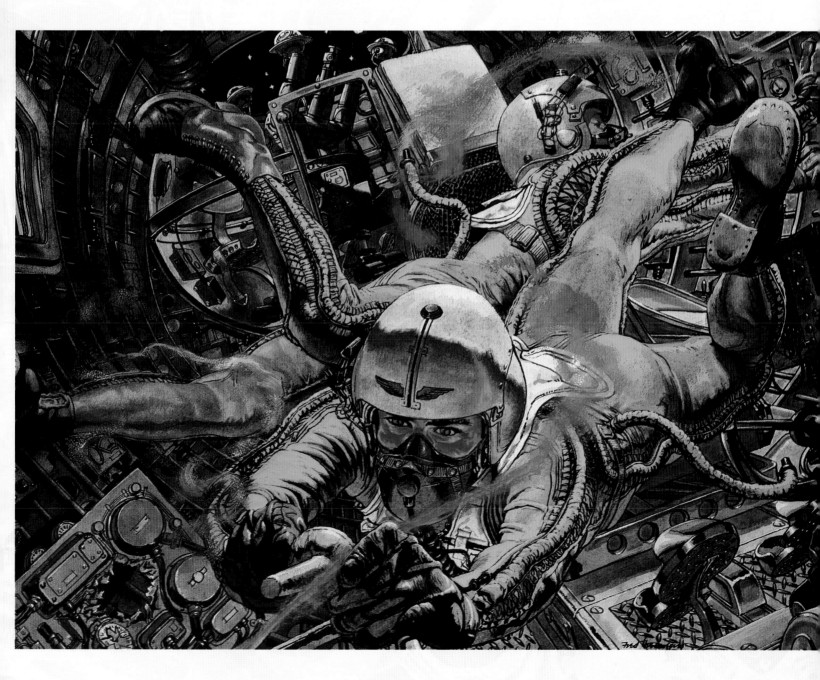

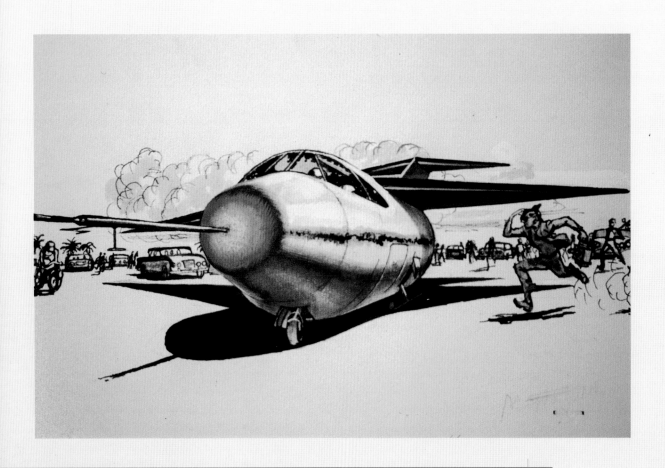

Immediately after the landing, Mason and Carter are surprised to see "a shouting, cheering" mob approaching them. Surely, von Braun's mind had gone back to 1927 and Lindbergh's Paris landing after the solo trans-Atlantic flight

The success of von Braun's lunar adventure led to a three-part novella about Mars, also published in *This Week*. "My story," he explained, "is fiction entirely—not a prediction that we shall find such peoples and such technological marvels when we get to Mars. This conception is a scientist's way of relaxing from the hard job of building the tools for the exploration of outer space with rockets. It is also a means of reminding myself—and others—that we should always keep our minds open to new worlds and new wonders in the expanding conquest of our Universe." Led by Colonel George McKay and pilot Bill Squire, a twelve-man expedition travels to Mars. There, they discover an obviously artificial, glass-like dome behind which stands a Martian.

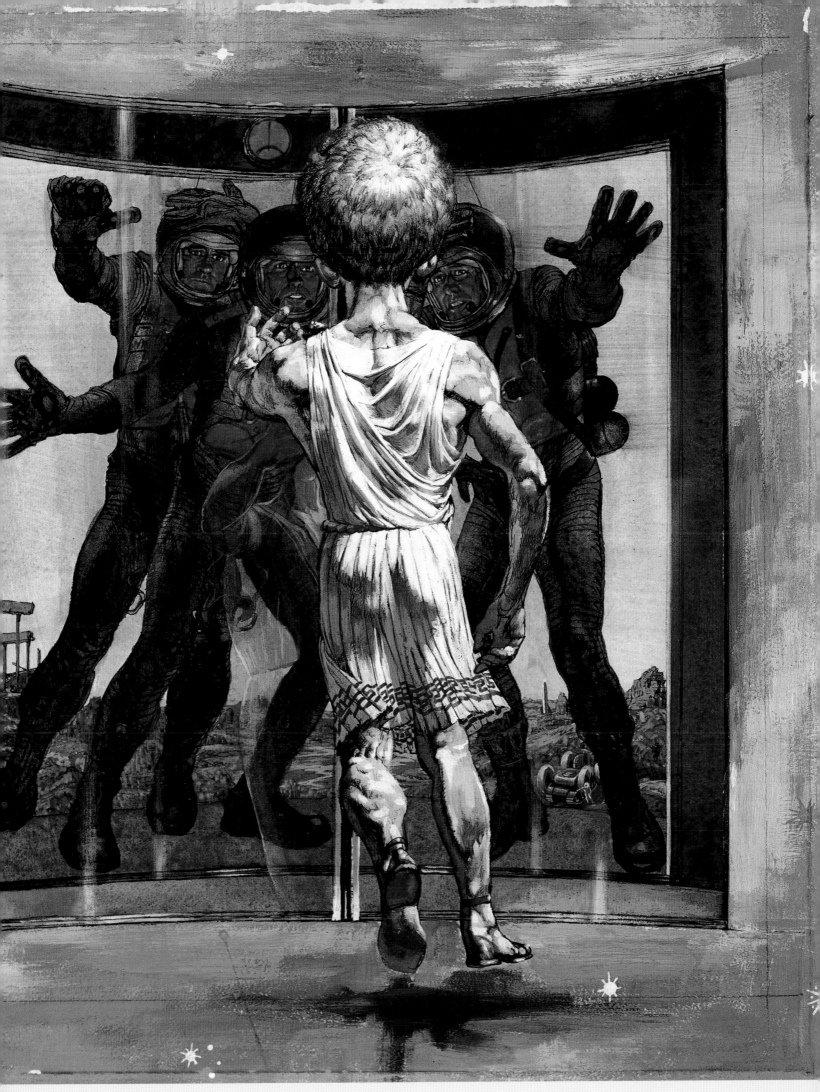

McKay, Squire and geologist Duncan Ross soon learn that they have stumbled upon a pumping station, about 2,000 miles from Mars' capital city of Ahla. As the story unfolds, they are led to a "…gleaming, vault-like chamber about 70 feet long and 10 feet high." It is a subway station. McKay mutters "The minds that could develop this subway system could have put a space ship on earth years ago. I wonder why they didn't?"

Ahla is a circular city twenty miles in diameter located a mile beneath the surface of Mars. Here, its hub is seen in cutaway. At the very top is a transparent plexidome that permits sunlight to enter.

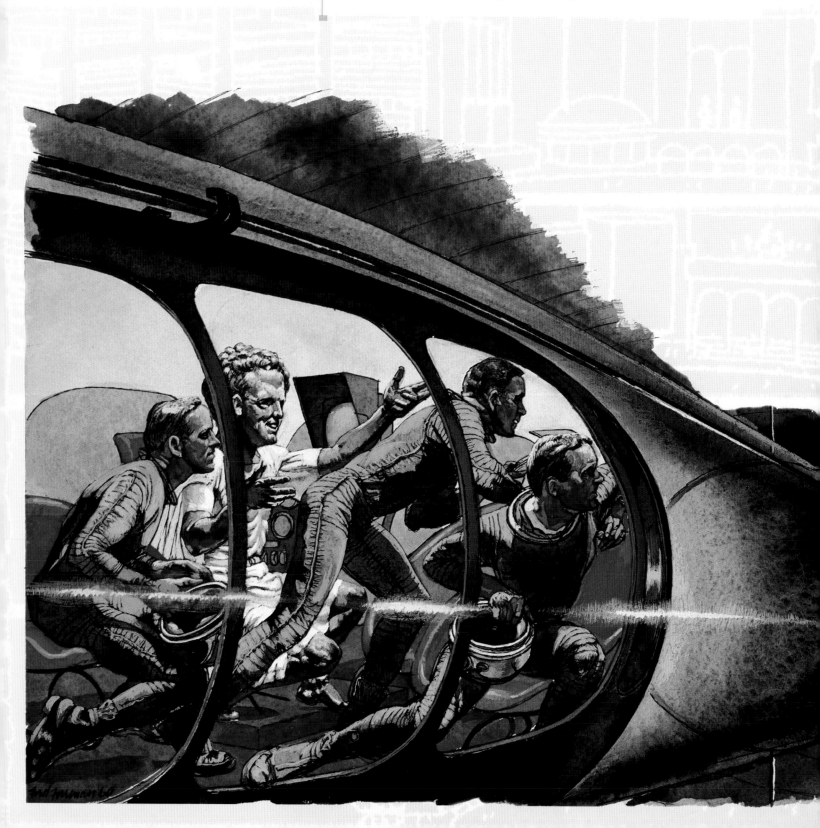

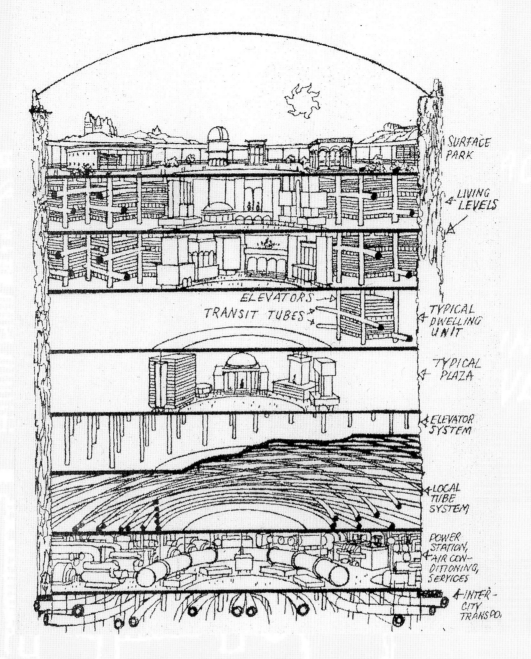

SURFACE
PARK

LIVING
LEVELS

ELEVATORS
TRANSIT TUBES

TYPICAL
DWELLING
UNIT

TYPICAL
PLAZA

ELEVATOR
SYSTEM

LOCAL
TUBE
SYSTEM

POWER
STATION,
AIR CON-
DITIONING,
SERVICES

INTER-
CITY
TRANSPO.

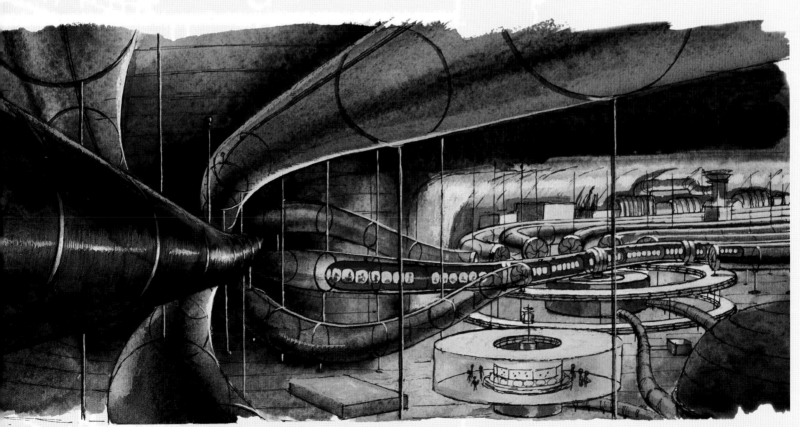

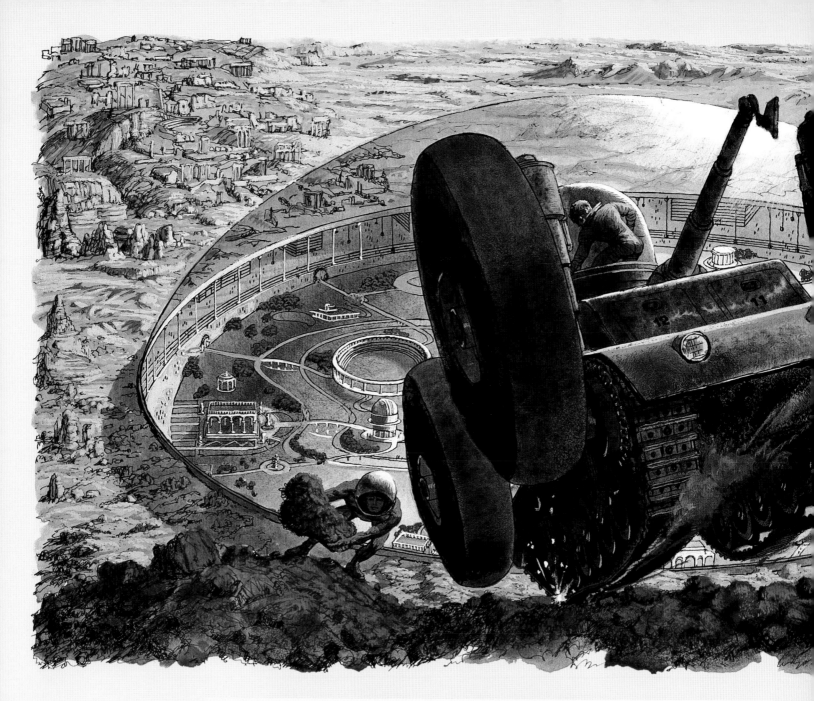

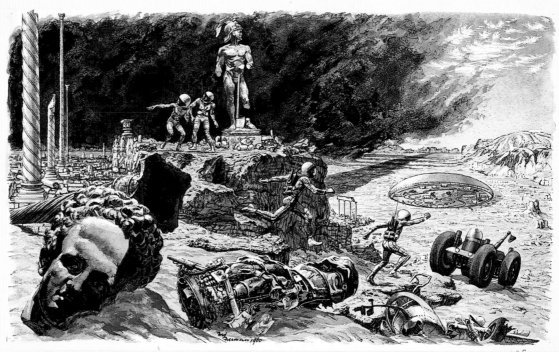

166

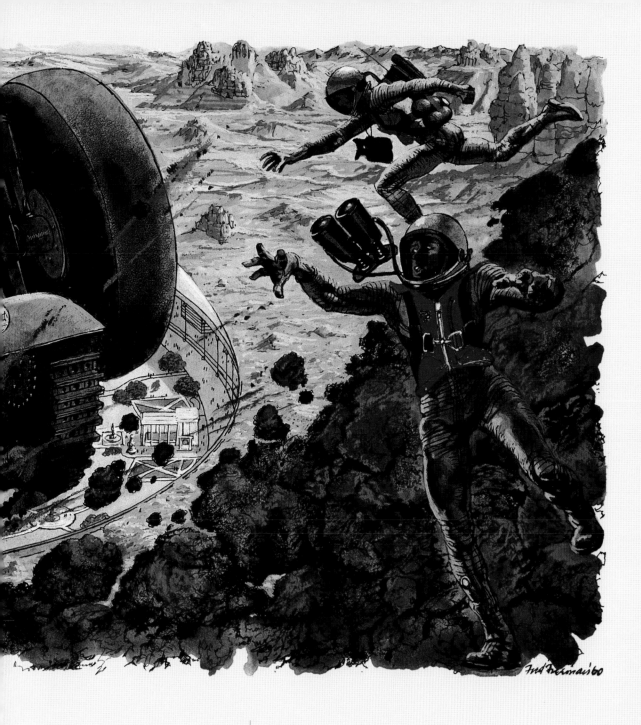

As the visitors from Earth explore underground Mars they are understandably curious about the surface, too. It turns out that eons ago Ahla and other cities existed there; but, with the gradual disappearance of the Martian atmosphere, they were abandoned in favor of underground settlements. Riding in a tractor, the explorers gaze at the ruins of an ancient city. Suddenly, the crust gives way and the tractor slides downward towards Ahla's dome. McKay acts quickly, and saves the day.

The crisis is over. Then, suddenly, a dust cloud appears in the distance. The explorers decide to call it quits for the time being and reenter underground Ahla. Their planned 449-day stay on Mars is coming to an end and preparations must be made for the return to Earth. The Martian hosts gather for the sendoff of the twelve visitors from Earth plus three Martians who will travel with them. The astronauts experienced, wrote von Braun, " . . . an immense sense of satisfaction, a deep assurance of what would come from this conjunction of intelligence between the planets Mars and Earth."

ADVANCED MISSIONS – FURTHER EVOLUTION

ESTABLISH SPACE BASE

COLONIZE THE MOON

ESTABLISH MARS BASE

UTILIZE SYSTEMS OF THE 1970'S

NUCLEAR SHUTTLE MISSION

LUNAR AND SYNCHRONOUS ORBIT

MARS

EARTH ORBIT DEPARTURE
6 MEN PER SHIP

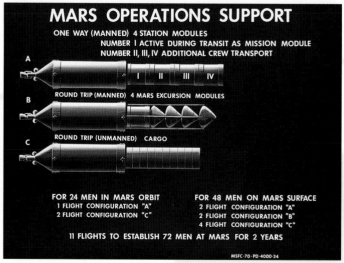

MARS OPERATIONS SUPPORT

ONE WAY (MANNED) 4 STATION MODULES
NUMBER I ACTIVE DURING TRANSIT AS MISSION MODULE
NUMBER II, III, IV ADDITIONAL CREW TRANSPORT

A

ROUND TRIP (MANNED) 4 MARS EXCURSION MODULES

B

ROUND TRIP (UNMANNED) CARGO

C

FOR 24 MEN IN MARS ORBIT
1 FLIGHT CONFIGURATION "A"
2 FLIGHT CONFIGURATION "C"

FOR 48 MEN ON MARS SURFACE
2 FLIGHT CONFIGURATION "A"
2 FLIGHT CONFIGURATION "B"
4 FLIGHT CONFIGURATION "C"

11 FLIGHTS TO ESTABLISH 72 MEN AT MARS FOR 2 YEARS

MSFC-70-PD-4000-34

Fantasies about Mars hardly satisfied von Braun and his colleagues at NASA's Marshall Space Flight Center in Huntsville, Alabama. With the beginning of the Apollo expeditions to the Moon, they thought the mandate to explore Mars, too, might be around the corner. *Really* explore, not just fantasize about the planet in tales of fiction.

Here, we have a sequence of nine color images prepared in 1969 and 1970 depicting von Braun's thinking immediately after the early Saturn-V-launched Apollo missions had proven so successful…Establish stations in orbit, colonize the Moon, and construct a base on Mars. Develop a nuclear shuttle to transport crews and materials from Earth orbit to the Moon and, eventually, when bundled, on to Mars. Departure of two spaceships to Mars, each powered by three nuclear shuttle modules to which is added a manned mission module that houses the crew and supplies. Various configurations considered. Orbital locations of the planets Earth and Mars for 1982-1983 mission planning. Maneuvers around Mars leading to a manned landing. Spacecraft on the Martian surface. Note the rover emerging from its hull while an astronaut in the foreground undertakes scientific measurements. A larger Mars base would logically follow initial exploration. And eventually, a full colony.

Active planning at NASA for missions to Mars was placed on hold during the 1970s. Von Braun died in 1977, his ultimate dream unrealized.

168

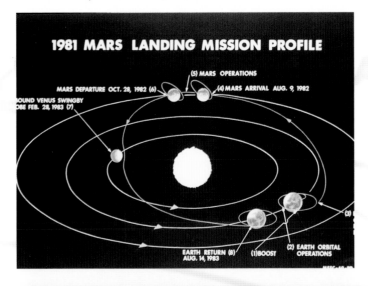

1981 MARS LANDING MISSION PROFILE

(5) MARS OPERATIONS

MARS DEPARTURE OCT. 28, 1982 (6)

(4) MARS ARRIVAL AUG. 9, 1982

BOUND VENUS SWINGBY
OBE FEB. 28, 1983 (7)

(3)

EARTH RETURN (8)
AUG. 14, 1983

(1) BOOST

(2) EARTH ORBITAL
OPERATIONS

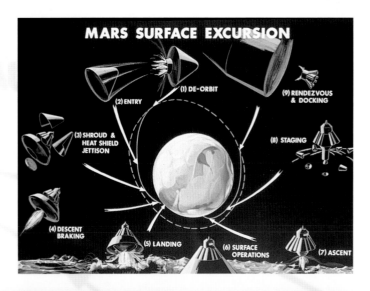

MARS SURFACE EXCURSION

(1) DE-ORBIT

(2) ENTRY

(9) RENDEZVOUS & DOCKING

(3) SHROUD & HEAT SHIELD JETTISON

(8) STAGING

(4) DESCENT BRAKING

(5) LANDING

(6) SURFACE OPERATIONS

(7) ASCENT

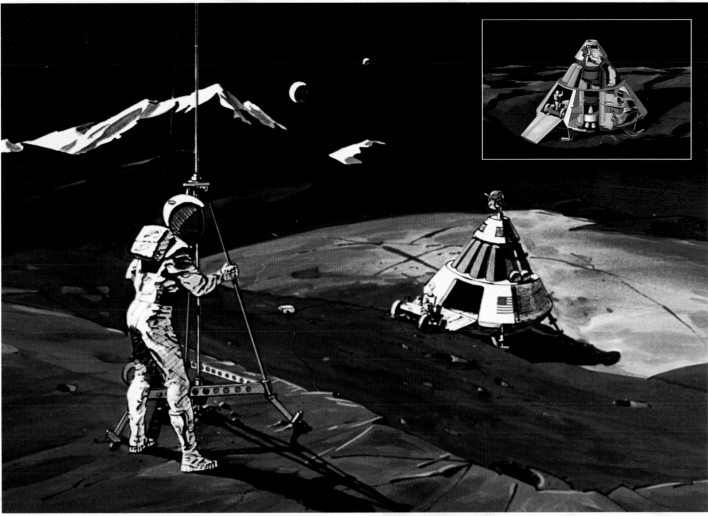

MARS BASE

MSFC-70-PD-40

MARS COLONY

MSFC

SOME FINAL THOUGHTS

As I look back at the images, I can't help but reminisce how I came about collecting them. My youthful exposure to space fiction books and pulp magazines unquestionably got me started. But it wasn't until I reached early adulthood that I started studying, collecting, and photocopying images as elements apart from the text that they supported.

Five individuals, all of whom I met in the early 1950s and who became and remained friends and colleagues, played decisive roles in my subsequent career and—perhaps inadvertently—in fostering my passion for collecting.

I met Wernher von Braun and Willy Ley at the second Hayden Planetarium Symposium on Space Travel, which was held in New York in October 1952. Years later, at the former's home in Huntsville, Alabama, I first laid eyes on several original paintings that Chesley Bonestell had given him from the *Collier's* magazine space series. I was captivated. Somewhat later, von Braun put me in contact with the artist himself, an event that would lead to the acquisition of many of his paintings—still the core of my collection. In time, I would work for the famed rocket/space pioneer—first under Army and then under NASA auspices. We went on to collaborate on several books and other projects; and, long after his death, Ernst Stuhlinger and I co-authored the two-volume biography *Wernher von Braun: Crusader for Space* (1996).

Willy Ley's collaboration with von Braun in the *Collier's* series was well known to me. Ley and I both lived on Long Island at the time, making frequent professional and social get-togethers feasible. His book *Rockets*, first published in 1944 and subsequently revised under several titles (ending in 1968 as *Rockets, Missiles, and Men in Space*) was indispensable to me and played an important role in my growing appreciation of the long history of rocketry and the spaceflight concept. Ley's other classic, *The Conquest of Space* (1949) was illustrated by Chesley Bonestell and likewise made a lasting impression. After Ley's death, with the approval of his widow Olga, I arranged for the University of Alabama in Huntsville to purchase his impressive library. To celebrate its opening, we organized a symposium featuring world-class historians of science and technology, all of whom marvelled at the library's breadth and Ley's literary contributions.

I had been in correspondence with Arthur C. Clarke since 1951 in connection with my joining the British Interplanetary Society. As a young

student, I'd briefly met him at an international congress in Paris the year before; he certainly won't remember that! I read and re-read his *Interplanetary Flight* (1950) and *The Exploration of Space* (1951, with memorable illustrations by Leslie Carr and R.A. Smith). I also loved his science fiction. Finally, during the Fourth International Astronautical Congress held in Zurich in August 1953, I got to know him—and have kept up ever since. Twelve years after Zurich, he and Stanley Kubrick invited me to collaborate on their film "2001: A Space Odyssey." Clarke's creative power, like that of von Braun and Ley, has motivated me to this day.

An exceptionally warm relationship grew up with Frederick C. Durant III, past president of both the American Rocket Society (which I had joined in January 1941) and the International Astronautical Federation. I appear to have been the only American present at the first International Astronautical Congress in Paris in 1950, where plans for the federation were first laid out. For years, we attended what became annual congresses and, through the International Academy of Astronautics, organized regular sessions on the history of astronautics. Not only do we share a strong feeling for the importance of international cooperation in astronautics, but we admire Chesley Bonestell's art and that of many other practitioners of his genre. In later years, Durant became Bonestell's confidant; and, with Ron Miller, collaborated on *Worlds Beyond: The Art of Chesley Bonestell* (1983). Nearly two decades later, they would produce a full-length biography of the artist.

Through von Braun's good offices, Carsbie C. Adams and I got to know Bonestell and, in time, were able to acquire many of his paintings. The enthusiasm the three of us shared for space art was a source of great satisfaction, particularly when Adams and I arranged for the artist's work to be exhibited in many cities in the United States and as far away as Australia and Japan. It was those joint holdings with Adams that later became the core of my present collection of astronomical and spaceflight images.

I am indebted to many others for the shaping of my vision of space across the ages. Some I have mentioned in the text at the beginning of this book, and the names of others will become evident in the bibliographic selection that follows.

BIBLIOGRAPHY

Some companion reading and viewing

This is a selected bibliography of works in my personal library that are distinguished by their images, ones that complement this present volume in that they offer a variety of visual perspectives of spaceflight. Some of the books focus on science fiction and fantasy art in general, so the reader will have to seek out images of direct relevance to spaceflight.

The Sam Moskowitz Collection of Science Fiction. New York, 1999: Sotheby's. Auction catalogue, sale 7330, of the incredible collection amassed by author-collector Moscowitz during his lifetime.

Aldiss, Brian, compiler and with an introduction by, *Science Fiction Art.* New York, 1975: Bounty Books (very large format).

Bauder, Rev. Dennis. Unpublished notebooks with handwritten captions and reproduction of Bonestell paintings indicating when and where they were published. An incredible labor of love that I must reference; two volumes.

Berget, Alfonse, *Le Ciel.* Paris, 1923: Larousse. Illustrated under the direction of Lucien Rudaux and containing many of his own earliest paintings.

Boia, Lucien, *L'exploration Imaginaire de l'espace.* Paris, 1987: Editions La Découverte.

Bova, Ben, *Vision of the Future: The Art of Robert McCall.* New York, 1982: Harry N. Abrams.

Clute, John, *Science Fiction: The Illustrated Encyclopedia,* New York, 1995: Dorling Kindersley.

Cook, Howard Lester, in collaboration with James D. Dean, *Eyewitness to Space.* New York, 1971: Harry N. Abrams. Reproductions of paintings prepared for the NASA art program.

Clarke, Arthur C., *Beyond Jupiter.* Boston, 1972: Little, Brown. Illustrated by Chesley Bonestell.

Dean, James, Robert Schulman and Bertram Ulrich, *Artistry of Space: The NASA Art Program.* Ann Arbor, Mich., 1999: Artrain, Inc.

Del Rey, Lester, editor and with an introduction, *Fantastic Science-Fiction Art 1926-1954,* New York, 1975: Ballantine.

DiFate, Vincent, *Infinite Worlds: The Fantastic Visions of Science Fiction Art.* New York, 1997: Penguin Studio. Impressive collection, organized by individual artists, with a foreword by Ray Bradbury.

Frank, Jane and Howard, *The Frank Collection: A Showcase of the World's Finest Fantastic Art.* London, 1999: Paper Tiger This unique book reproduces paintings owned by the Franks and is organized by the rooms in which they are hung in their spacious home, with a foreword by John. C. Berkey. Some traditional space art among the more fantastic elements of the collection. See also *Possible Futures: Science Fiction Art from the Frank Collection,* the catalogue of a travelling exhibition during 2000, edited by Doris Yaron, and published by The Art Gallery, University of Maryland, College Park, 2000.

Frewin, Anthony, *One Hundred Years of Science Fiction Illustration 1840-1940.* London, 1974: Jupiter Books. Its early focus sets it apart from most other works.

Gunn, James, Alternate Worlds: *The Illustrated History of Science Fiction.* Englewood Cliffs, N.J., 1975: Prentice-Hall. With an essay by Isaac Asimov, "Science Fiction, I Love You."

Hardy, David A., *Visions of Space: Artists Journey Through the Cosmos.* London, 1989: Limpsfield. Foreword by Arthur C. Clarke; strict focus on spaceflight.

Harrison, Harry and Malcolm Edwards, *Spacecraft in Fact and Fiction.* New York, 1979: Exeter Books.

Hartmann, William K., et al., editors, *In the Stream of the Stars: The Soviet/American Space Art Book*. New York, 1990: Workman. With a historical perspective by Ray Bradbury. Published in cooperation with the International Association for the Astronomical Arts, the Planetary Society, and the U.S.S.R Union of Artists.

Kyle, David, *The Illustrated Book of Science Fiction Ideas & Dreams*. London, 1977: Hamlyn.

Lesser, Robert, *Pulp Art: Original Cover Paintings for the Great American Pulp Magazines*. New York, 1997: Gramercy. With many contributors; only a portion of the book deals with science fiction art but this in itself makes it an important resource, with a contribution "The Science Fiction Pulps" by Sam Moskowitz.

Ley, Willy, *The Conquest of Space*. New York, 1949: Viking. Illustrated by Chesley Bonestell.

Ley, Willy and Wernher von Braun, *The Exploration of Mars*. New York, 1956: Viking. Paintings by Chesley Bonestell, some first used at the end of the *Collier's* space series.

McCall, Robert, *The Art of Robert McCall*. New York, 1992: Bantam. Captions by Tappan King, introduction by Ray Bradbury, profusely illustrated by a modern master of the genre.

McCall, Robert and Isaac Asimov, *Our World in Space*. Greenwich, Conn., 1974: New York Graphic Society. Foreword by Edwin E. Aldrin, Jr., now universally known as Buzz Aldrin, Apollo 11 Lunar Module pilot.

Miller, Ron and Frederick C. Durant III, *Worlds Beyond: The Art of Chesley Bonestell*. Norfolk, 1983: Donning.

Miller, Ron, *Space Art*. New York, 1978: Starlog Magazine/O'Quinn Studios. Focus on Chesley Bonestell, Bob McCall, Ludek Pesek and Lucien Rudaux.

Miller, Ron, *Dream Machines: A Pictorial History of the Spaceship in Art, Science and Literature*. Malabar, Fla., 1993: Krieger. An encyclopedia of images with explanatory text, an outstanding guide, and with a foreword by Arthur C. Clarke.

Miller, Ron and Frederick C. Durant III, *The Art of Chesley Bonestell*. London, 2001: Paper Tiger.

Ordway, Frederick I. III and Randy Liebermann, editors, *Blueprint for Space: Science Fiction to Science Fact*. Washington, D.C., 1992: Smithsonian. Prepared for a travelling exhibition of the same name; profusely illustrated, with a foreword by Apollo 11 astronaut Michael Collins and an epilogue by Arthur C. Clarke.

Poix, Pierre, *Ils ont rêvé l'espace: de Plutarque au Space Art*. Paris, 1992: Hatier.

Includes an interesting selection of early images.

Rudaux, Lucien, *Sur les autres mondes*. Paris, 1937: Larousse. By the grandfather of space art and a professional astronomer.

Ryan, Cornelius, editor, *Across the Space Frontier*. New York, 1952: Viking. Based on the *Collier's* space series with contributions by Wernher von Braun and others, illustrated by Chesley Bonestell, Fred Freeman and Rolf Klep.

Ryan, Cornelius, editor, *Conquest of the Moon*. New York, 1953: Viking. As above.

Ryan, Peter, Journey to the Planets. New York, 1972: Penguin. Art by Ludek Pesek.

Sadoul, Jacques, *2000 A.D.: Illustrations from the Golden Age of Science Fiction Pulps*. Chicago, 1995: Henry Regnery. Translated from the French; mostly black-and-white interior illustrations from the pulps, some color covers.

Schuetz, Melvin H., *A Chesley Bonestell Space Art Chronology*. Parkland, Fla., 1999: Universal Publishers. Contains a wealth of information on where and when Bonestell images have appeared over the years.

Summers, Ian, editor, *Tomorrow and Beyond: Masterpieces of Science Fiction Art*. New York, 1972: Workman. Contains a number of space concepts.

INDEX

174

Text © 2001 Frederick I. Ordway, III

Published in the United States by:
Four Walls Eight Windows
39 West 14th Street, Room 503
New York, N.Y., 10011

U.K. Offices:
Four Walls Eight Windows/Turnaround
Unit 3, Olympia Trading Estate
Coburg Road, Wood Green
London N22 6TZ, England

Visit our website at http://www.4W8W.com

First printing September 2001

Library of Congress Cataloging-in-Publication Data

Ordway, Frederick Ira, 1927-
 Visions of spaceflight : images from the
Ordway collection / Frederick I. Ordway III.
 p. cm.
 Includes bibliographical references and index.
 ISBN 1-56858-181-5
 1. Space flight in art--Catalogs. 2. Ordway,
Frederick Ira, 1927---Art collections--Catalogs. I.
Title.

N8246.S63 O73 2001
704.9'4962941--dc21
 00-050393

10 9 8 7 6 5 4 3 2 1

Design by mouse+tiger design

Printed in China